NAMED A TOP 12 NONFIC[...]
THE YEAR BY *THE NEW YORKER*

NAMED A TOP 100 BOOK OF THE YEAR BY *TIME*

WINNER OF THE WRITERS' PRIZE
FOR NON-FICTION

SHORTLISTED FOR THE WOMEN'S PRIZE
FOR NON-FICTION

———————————————

"Exquisite…Cumming's pages are themselves lovely exercises
in poetic vision and stay with you long after you finish."
—SIMON SCHAMA, *The Guardian*

"Cumming explores her passion for the virtuosic images of
everyday life by painters from Dutch art's Golden Age…and by
weaving together vivid evocations of ones that particularly move
her with brief biographies of the men and women who painted
them, she invites us to share that love."
—RUTH BERNARD YEAZELL, *The New York Times Book Review*

"If you haven't yet read *Thunderclap* by Laura Cumming—
a brilliant exploration of Carel Fabritius, Vermeer, and survival
and loss—rush out and buy it. By far the best book on art of
the Netherlands that I've read."
—EDMUND DE WAAL, author of *The Hare with Amber Eyes*
and *Letters to Camondo*

Praise for *Thunderclap*

"A superb tribute to the masterpieces of the Dutch Golden Age and the father who taught her how to see them."

—*The Telegraph*

"The book is infused with love—of parents, childhood, pictures, and words. It is at once deeply personal and inclusive. . . . A remarkable experiment in form as well as a richly satisfying extended meditation on art, life, and death."

—*Literary Review*

"Laura Cumming writes about art with a painter's precision. . . . *Thunderclap* is an eloquent homage to her artist father, James Cumming, and to the artists of the Dutch Golden Age. . . . Cumming is at her strongest when translating what she sees in art into words."

—*The Spectator*

"Through spellbinding storytelling, *Thunderclap* is as deftly told as any thriller. It is also an astonishingly rich book about the glories that are revealed to us when we look at great paintings with careful attention and an open heart. How a work of art can suddenly open our eyes in a thunderclap of clarity."

—*The Bookseller*

"Cumming's descriptions of what is in front of her eyes are often incandescently beautiful and well-informed. She has a special ability to transport her readers, presenting historical facts and scientific developments as the marvels they are. Her curiosity is infectious—you don't have to love Dutch art to love this book, though you may well come away with a renewed sense of its value. We can luxuriate in visiting the Dutch Golden Age with such a humane and knowledgeable guide."

—*Air Mail*

"Cumming's Proust-like meditations on time never to be recovered and art never to be produced lead her to her own thunderclap of insight: that art has the power to console and bring memory back to life precisely because of its ability to immortalize and make time stand still. . . . Wondrous."

—*The Wall Street Journal*

"Genre-defying . . . Cumming clearly loves the paintings of the seventeenth-century Dutch. By weaving together vivid evocations of ones that move her with brief biographies of the men and women who painted them, she invites us to share that love. Like all good elegists, Cumming brings the dead to life in the very act of mourning them."

—*The New York Times Book Review*

"*Thunderclap* combines first-rate art history with deeply felt memoir. . . . Cumming's gentle, meditative prose is itself an evocation of the hushed world of the art she loves. *Thunderclap* does what Fabritius's sibylline scenes do: It does not redescribe so much as reimagine. Good criticism, like good art, does not leave the world intact. It, too, provides a shimmering new place where we can live and look."

—*The Washington Post*

"Cumming writes with the sureness of carefully laid paint. This is not art historical scholarship of the academic kind. It is an emotionally informed approach to art, always paying attention to the fact that each person's vision is different. Cumming cannot in truth show us new definitive facts about Carel Fabritius, but she brings him out of the shadows, making us see why he is so much more than the missing link in someone else's story."

—*The Guardian*

"Part memoir, part celebration of the art of the Dutch Golden Age, *Thunderclap* stitches art history with family biography, in this case memories of Cumming's father, James Cumming, who was also an artist. *Thunderclap* is a glorious tribute to the two men who showed her the truth of the notion that paintings offer 'a land in themselves, a society, a place to be.'"

—*The Economist*

"A lustrous meditation on the lives and afterlives of artists . . . with a novelist's pace, a critic's eye, a daughter's heart. This luminous book is likely to send you, if not into a frenzy, then straight to the National Gallery."

—*Financial Times*

"Cumming is a writer of exceptional acuity, responsiveness, and poetic grace. With stellar reproductions accompanying Cumming's vibrant memories and deep musings, *Thunderclap* is an incisive and eye-opening, fascinating and amusing, loving and grateful chronicle."

—*Booklist* (starred review)

"A tender homage to art, Cumming melds memoir, art history, and biography in an elegant, beautifully illustrated meditation on art, desire, imagination, and memory. From shards of evidence, Cumming has created a nuanced portrait of an enigmatic artist whose works have profoundly affected her. Moving reflections rendered in precise, radiant prose."

—*Kirkus Reviews* (starred review)

"In this vivid history of the Golden Age of Dutch painting and elegant and luminous work, Cumming writes with deep feeling and knowledge about how 'pictures can shore you up, remind you who you are and what you stand for.' Art lovers will be enthralled."

—*Publishers Weekly*

THUNDERCLAP

*A Memoir of Art and Life
& Sudden Death*

Laura Cumming

SCRIBNER

New York London Toronto Sydney New Delhi

For
James Cumming
Ever loved

Come back! Even as a shadow, even as a dream . . .

<div style="text-align: right">EURIPIDES</div>

ONE

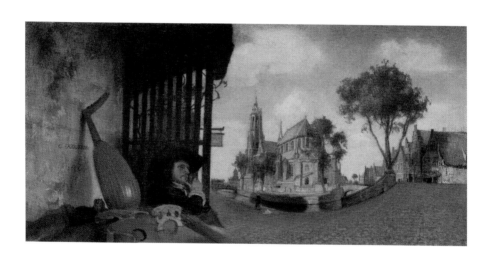

I love a painting that hangs in the National Gallery in London. It has to me the atmosphere of a memory or a waking dream. It shows a man seated in deep shadow at the corner of two streets, thumb to chin and fingers crooked as if nursing the remains of a cigarette, eyes down and pensive; waiting.

Two musical instruments lie next to him on a table: a lute, shining like a new chestnut freed from the husk, and a viola that reaches invitingly towards you as if just asking for its strings to be plucked. For you are here too, somehow, hovering on exact eye level with the man and his table. The painting, so small and mysterious, is peculiarly alive to the nearness of your presence. It puts you on the spot on this quiet day when the leaves of the young elms are just beginning to turn and the man in black sits low at the crossroads. Before him, the cobbles rise up and over the gently swelling bridge into a brighter world of red-roofed houses and church spires and dappled light elsewhere. But he remains forever on the outskirts.

Arriving in London for the first time, in my early twenties, I found a strange counterpart in this painted figure. He too was on the brink of something, or perhaps nothing at all, a loner on the edge of events. But he stayed still, never changing, ever faithful in his time and place, while I tried to make my way in this unfamiliar city without knowing where I was going or what I was doing. The waiting man became a fixed point.

The picture in which he appears is nowadays known as *A View of Delft, with a Musical Instrument Seller's Stall*. According to the writing so discreetly lettered on the wall behind the lute, it was painted by C. Fabritius in 1652. Titles are an oddly new

invention, evidently unknown or unnecessary to artists of that time, and nobody knows what Fabritius might have called his painting, if anything at all. It is true that he presents a view of the little ringed city of Delft, canal-crossed and storeyed, with recognisable streets and spires. But his vision takes you so close to this man that if he relaxed into movement and dropped his arm down across the table, with its sonorous blue cloth and its musical instruments, he could almost touch you with the tips of his fingers. I do not know why the title ignores him in favour of the place, or the stall, as if where the scene is set matters more than he does. He is not even looking at this view of Delft, though in a sense we are all gathered before it. The picture, polarised between the shadows and the sunlit stage, takes off towards the bright side, the road sweeping over the canal and into the centre of town, beneath a blue sky that casts its reflection on the waters below. Delft holds its pleasures somewhere over that bridge. But my eyes keep returning to him.

In those early days, I didn't care why the man was sitting by a table or about his instruments – the polished lute, the viola with its deep curlicues. Maybe he had made them, or was just trying to sell them, possibly both. I only cared about his darkly handsome presence, head tilted, absorbed, the timeless outsider. He looked as if he might be about to remove a fleck of tobacco with practised elegance from his lips; we smoked roll-ups back then. His preoccupation was magnetic, contemporary, the pose of thought so subtle and familiar as he waits for someone to come, for something to happen, for life to catch alight.

This painting became a kind of staging post for me on a specific journey across London. I used to walk down Charing Cross Road from the publishing house where I worked, slip through the side entrance of the National Gallery to see the art, and then catch the Tube to meet someone with whom I was having an

almost comically doomed affair. The Dutchman gave me luck, or perhaps it was courage. For pictures can shore you up, remind you who you are and what you stand for. The relationship we have with them is so singular and unique that nobody can gainsay our experience. What you see is what *you* see, yours alone and always true to you, no matter what anyone else contends. Once, I remember repeating the route on my return and glimpsing the picture twice in one day, just to cancel out the in-between time of misunderstanding and impasse. Later on, in a new job in Soho, I would zigzag through Chinatown and into the back door of the museum to look at the art at lunchtime. I even saw *A View of Delft* late on a winter's night, slipping in with a painter who had visiting rights after hours. How can it be that I did not know how he got them, did I never ask? Such mysteries we leave undisturbed like a perfect meniscus when young.

The more tortuous the relationship, the more I preferred the Dutchman. Sometimes I walked past quite fast, rapid sideways glance, just to check that he was still there among the seventeenth-century paintings. It always felt as if he might vanish if too clumsily approached. It seems to me now that this is in the nature of Fabritius's image, which has the transient appearance of a mirage. And what if it was not there one day, what would that mean? It is possible to be superstitious about pictures; people have raised them like standards in battle, prayed to them, attacked them, carried them about like talismans. We make pilgrimages to see them and are disturbed to find that they are not where they are meant to be but hanging in some other museum, on loan abroad, or just inexplicably gone. Paintings are reliable; they are not supposed to let us down. They absorb all our looking and our feelings without ever changing, unlike living beings.

I myself was faithless, volatile and confused. I was not in love, no matter how much I wanted to be. But I could not understand

why, nor explain myself to the man I was seeing. But this painted figure, who could hear nothing, was not looking my way and clearly didn't even exist, appeared to understand everything, with the magical power of images; I suppose he was literally the man of my dreams.

Of course, I did not go to the National Gallery just to see *A View of Delft*. There were other paintings, other people, other lives. But there is an analogy between art and music. You listen obsessively to a single track, torn-hearted, and then perhaps much later to the song before and the one after and eventually return to the wild blue universe of other artists altogether. But that first song still has its irreducible significance, its time-stopping potency; and so does this painting for me.

It speaks of solitude in the city, of hoping for life to begin, of waiting on the dark side of the street. Despite its exquisite depiction of Delft – the invitation to the eye to slip through the streets, past the church, over the bridge and into the twinkling town – it is the most internal of paintings to me. The man sunk in thought, and silence, beneath the ghostly swan on its swinging sign, exists outside time in his head.

We see pictures in time and place. We cannot see them otherwise. They are fragments of our lives, moments of existence that may be as unremarkable as rain or as startling as a clap of thunder. Whatever we are that day, whatever is going on behind our eyes, or in the forest of our lives, is present in what we see. We see with everything that we are.

There is no work of art so transcendent that it is not susceptible to our individuality, either, or our human frailty. In the last weeks before she gave birth to my brother, my mother couldn't look at any paintings standing up. A constant visitor to the National Gallery in Edinburgh, where we lived, she became powerfully acquainted with the Dutch art in one particular room because it had seats of exactly the right height. Her passion for those paintings turned them into landmarks, and so they would become for us too. A pair of Dutch pictures was a Sunday destination, up from the Firth of Forth to the Mound on the number 23 bus, its window steamed to silver pages for drawing, its seats a dark-red vinyl that sucked at the back of your thighs. The seats in the gallery were the same colour, but in superior polished leather. I cannot separate that colour from our love of Dutch art.

One of these paintings was a big, dark landscape by Jacob van Ruisdael planted with all sorts of charms like a Christmas pudding: running dogs, busy fishermen, twin spires, horses clattering down a bank to the massive river that runs through it all. At one point there is a gleaming white hollow in this bank, a patch of chalk ignited by a sudden ray of sunshine. This is what the Scots call a glisk, where you get a glimpse of something fleetingly

bright, except that Ruisdael holds it there before you forever. The other painting was Rembrandt's self-portrait in the gloaming, mysterious and withdrawn. My father's friend, the poet George Bruce, rightly wrote of the eyes as like two lit windows in a dark house, 'An in that hoose muckle business.'

Rembrandt paints himself on the verge of bankruptcy, widowed, pensive, painfully self-knowing. He is not yet fifty years old but seemed a frightening Methuselah to me as a child. Looking at the painting now I do not think of age so much as Rembrandt's staggering proximity, the nearness of his face, his looking and thinking so close to the edge in every respect, as if he was right up against the bars of a cell. The painting has not changed, of course, but I have.

At home, my father had a book of Rembrandt's drawings that he looked at so often the binding had split. He replaced it with black gaffer tape that my memory naturally tries to make dark red. Among those pages was an ink sketch of an infant learning to walk, its wrists gently supported by two doting women as it wavers and sways. I was not so old that I couldn't remember exactly what that felt like.

Visiting children, told that my father was an artist, would challenge him to draw a circle in one go to see if it was true; and he would oblige with a single flawless line. But then he might turn that circle into a peach, a planet or a diamond ring, whatever they wished, in a few agile marks. To see the world transformed into two-dimensional images, materialising on the page with a 2B Staedtler, or on canvas with a brush, is to witness a form of magic.

But I always knew not to ask for too much. My father was a painter, not a conjuror; art was no trick. I hoped that he would one day draw my brother or me, if only in the margins of *The Scotsman*, or somewhere in a sketchbook. I wanted to see how

he saw us, what he would make of us children. But it never happened. When I left for university, which seemed to me about my last chance of a thumbnail likeness, he gave me something else, something he prized, and which had been handed down through his family – a dictionary; words instead of images.

It was an ideal gift to wing me on my way, at least to my parents. For I was off to study literature, and here was the whole world of words in one volume. But alas I was only able to think in images, first, and so it has remained, my sense of life coming through streams of pictures before anything forms into sentences, let alone dictionary-definition language. This is only the first of the reasons why I treasure Dutch art – so democratic, so all-embracing, so infinite in its reach through everything seen, experienced, imagined, remarked upon, remembered, from the gusting ship to the herring to the girl spellbound by a letter, from the bee in the dropsical blossom to the bright canal, the energetic burgher and every single terracotta brick in a fine Dutch wall. It feels to me like the direct speech of life, the words we utter, the stories we tell. Something like a dictionary of the world in itself.

Dutch art is the first I ever knew in any degree, apart from the paintings of my Scottish father. Not just the cobbled streets and gable houses, or the skaters in the frozen waterland of Christmas cards, nor even the ruffed burghers in the black and white portraits in the Scottish National Gallery. That was not – is not – what this art means to me, so much as a mysterious kind of beauty, a strangeness to arouse and disturb, an infinite and fathomless world. For me it is the music man on the edge of existence, the glisk in the riverbank, the lit windows in Rembrandt's house of darkness.

This is the exact opposite of what I was taught at school, which was that Golden Age Dutch art was all about *things*, and

the way those things look. My father laughed when I told him what my teacher said, which was that the Dutch just loved stuff, and commissioned paintings of that stuff so they could look at it forever. Here is a Dutch tulip, red-and-white-striped, and here is a painting of it meticulously preserved for the day the real flower dies. Paintings are not substitutes, he said, they are something else altogether. A likeness is never the only reason an artist paints a picture.

Why did he paint the way he did, what was in his head? His pictures held other versions of peaches and planets than anything he might draw for a child; his art was closer to abstraction. There is a painting called *Studio and Dutch Tin* from the late 1960s where a tabletop, upended, appears flat as a flag on the canvas, the ghostly shapes hovering upon it almost unreadable as the jars of brushes and plates of coagulated paint I know they must be. The Dutch tin is pure geometry: a shining orange lozenge, national colour of the Netherlands. And almost hidden in the surface is another abstract emblem, a small X-shaped mark in palest grey, criss-crossing like the blades of a windmill.

The only trip we ever took abroad during my father's lifetime was to the Netherlands. Our one family holiday was Dutch. The nation binds us together. I can look at Dutch paintings now and know that my father saw them too, in Amsterdam as well as Edinburgh; that his eyes took them in as mine do today. They are part of his story and of mine.

I hear him through the door of the upstairs bedroom he used as a studio, absently whistling a piano piece learned as a boy in the small city of Dunfermline in Fife as he paints. I picture the old green radio he had from the fifties, poorly transmitting through a polythene bag to save it from spatters; it plays Bach, pronounced Back in my father's Fife accent. I remember the

sound he made with his hands, rubbing them enthusiastically when the work was going well, just as I do now for the same unconscious reason. What can he have seen as a boy on that windy east coast, in a house with no art books, in a city with no galleries? How did he come to painting? I have a watercolour he made as a child of the tenement wall opposite his family's council flat, every stone so beautifully depicted as if each was a sight in itself, and a drawing of a neighbour's parrot for which he won a national prize.

He believed that all children could draw. Drawing was universal. We draw on walls, on the backs of our hands, on bus windows. We draw to pass the time, to catch the moment, to remind ourselves what we saw, felt or thought. We draw to see how life appears in two dimensions. We draw to show something to somebody else – here, this is what it looked like. We draw to make a map, send a message, show the police what we witnessed; to give each other something particular, something special, to say something that cannot otherwise be said. We all do it. And we do it from the first.

Drawing comes before writing – infants do it – and quite often after script has departed (my mother could scarcely write, in her nineties, yet still she would draw). Holding a stub of crayon or chalk comes early and late. Our brains are able to read two dots and a dash as a face from the earliest age, just as it is, for most of us, the configuration of our first portrait.

But though we all draw, the belief persists that we *cannot* draw, that there is a way to do it beyond our talent or ken. My father rebelled against such orthodoxy but I believed in it, certainly in my own case. I cannot draw well enough to account for anything that is going on in my head, or the world, and so I put words to those images instead. It is what I have done, pen in hand, in front of *A View of Delft* and so many other

Dutch paintings through my life, and what I still do before my father's art.

These are the letters I cannot send them – or perhaps they are more like postcards – words about what these painters made of the mysteries of life and art, how and what they taught me to see.

Museums are cities to roam, streets of art in which visitors chance upon pictures as if they were people, or just miss them by some dumb turn of fate. You were in a hurry, the view was blocked, the museum closed early. A painting of which you had high hopes from some cherished reproduction turned out to be smaller, dimmer, duller, less fascinating in person. Or maybe you loved a painting at first sight, the luckiest of strikes in art as in life; you were open to it, coincided at just the right moment. This was *A View of Delft* for me. So much is to do with chance and experiment, like the whole adventure of life.

Hanging in the next room of the National Gallery in London is a much bigger painting by Carel Fabritius. It is a self-portrait painted two years later. The artist is himself another darkly handsome man, dressed in a fur hat and metal breastplate, standing alone beneath a smoky sky. For some reason, or perhaps it was a kind of resistance that I now cannot fathom, I did not in my twenties make much of a connection between the large self-portrait and the little view of Delft; nor did the strange associations between the two figures occur to me. The man in the self-portrait, for all his upright appearance and ostentatious dress, is peculiarly locked away behind his eyes, his pose marked by a kind of backwards–forwards diffidence, inward and oblique, as if he too is on the wrong side of life.

But at first these two paintings seemed so unalike, to my eyes, that they might have been by completely different artists; and, sure enough, his pictures have been attributed to many other painters. And this striking disparity would turn out to be

the case with every new work I came across, always surprised to discover from the label that they were by Carel Fabritius.

I used to look at Fabritius's *A View of Delft* in my twenties, for instance, with the open eyes of unmitigated ignorance. I knew the painting by heart, like a song, but about the painter I knew practically nothing. Evidently Fabritius was a seventeenth-century artist of the Dutch Golden Age because he was in the same galleries as Vermeer and Rembrandt. His dates were given: Middenbeemster 1622–Delft 1654. He could only have lived for thirty-two years at most, according to the existential arithmetic, and I casually assumed that he was carried off by some nameless illness. The picture bears the year, depicted in his eloquent hand as if it just happened to be painted on that wall. 1652. He has only two years left. The label told me nothing else.

I am glad of this restraint because my younger self would have struggled to see the picture differently if instructed to do so by some didactic wall text. Any emphasis would have thrown me. I would have tried to see what I was urged to look for in the painting; tried to see it through someone else's eyes.

For it never occurred to me, I freely confess, that the bridge or the road that sweeps over it involved any serious degree of distortion. I grew up in the twentieth century when painters all around us had no use for accuracy, precision, old-fashioned perspective and could make whatever they wanted of the world. One of my earliest memories is of seeing the Austrian painter Oskar Kokoschka's huge self-portrait in Inverleith House, in the Botanical Gardens in Edinburgh. It wasn't just that this painter seemed to be wearing a T-shirt, which was unusual enough (and seems to me still, given that the picture is dated 1937). The head was as big as a boulder, the jaw a colossal slab and the artist's arms were folded across his overscale chest as if sizing up for an opponent. I was small, Kokoschka was vast: his painted torso bigger than

the whole of me. Our seeing of the world never stands still, never stops moving between one thing and another, between this sight and that sight and the source of sight itself. Everything we look at is seen in relation to ourselves.

To me the exaggeration of Fabritius's curved street, or even the viola lying on the table, were hardly marked. Certainly not by comparison with the staggering appearance of an anamorphic skull, tilted like a ring of Saturn in Holbein's *The Ambassadors* only rooms away in the National Gallery, an act of pure creative freedom as far back as 1533. Yet scholars tell us that the Delft scene is carefully contrived to fit inside a perspective box. Seventeenth-century viewers would have looked into this wooden box through a single eyehole, whereupon all those supposed distortions would miraculously resolve.

I hated all talk of optical devices, the peepshow and the camera obscura, instruments of seventeenth-century Holland, even though I knew that Fabritius lived in that world. It was exactly the way that Vermeer's genius was so glibly explained away, as if he worked it all up by tracing the outlines of reality projected inside a dark tent. Only a dust-dry lecture attended later on, with exacting research into focal distances in relation to the novel invention of the Dutch perspective box, could convince me that Fabritius's scene might have been made for such an object, of the sort always described as ingenious, and therefore dead to me. All of this seemed and still seems another excuse to overlook, or underlook, *A View of Delft* – one of the smallest paintings in the National Gallery yet one of the greatest. Bypass it with arguments about whether the box was triangular or square, and never see the wonder of the picture itself.

Years passed and my journeys through the National Gallery became part of my writing profession. One summer's day in the

1990s, I noticed that *A View of Delft* had reappeared after a long absence. Three hundred years and more of accumulated grime and pollution and discoloured varnish had been painstakingly cleaned from its surface. The signature of Carel Fabritius was now more clearly apparent in all its filigree elegance, depicted as if actually painted on the variegated plaster of the city wall. The darkness seemed even deeper against the opposing sunlight, the man's eyes now just possibly hazelnut-brown. A pinprick of yellow stood for a door, another of red marked out a distant figure. How could he know, I wondered, exactly how and where to place them in this mysterious scene.

I imagined that I would see more paintings by him in my future as a writer on art. But although there were many Dutch shows to write about for my newspaper, some of them in this very museum, Carel Fabritius never seemed to be among them. He did not appear in exhibitions of Dutch portraits, landscapes or still lifes of lemons and tulips. He left no prints or drawings, so was never included in shows of graphic art. For a long time I could not have said what else he painted, other than the one picture which was not just famous in the Netherlands, where it hung, but all over the world: *The Goldfinch*, chained to its perch, so startling and poignant. I had a postcard of it from childhood, but I did not see the real painting until much later: another solitary being, a third Fabritius alone in this world.

There seemed to be some profound connection between the artist and his subjects (or perhaps I knew this from home); between Fabritius's art and the pattern or shape of his life.

The more I saw of them, gradually over the years, the more experimental each of the paintings appeared. Art historians, if they mentioned Fabritius at all, tended to explain him away as some kind of missing link between Rembrandt, with whom he studied, and Vermeer, his close neighbour in Delft. Yet he

appears entirely singular, independent of both, each new work an astonishing departure. Not that there were many more. His life was short, his surviving paintings few, barely a dozen, yet every one of them a masterpiece.

Of Fabritius himself, almost every trace is said to have disappeared. In his own time he was scarcely mentioned, and one contemporary description praises him as a 'perspectivist', as if getting the illusion of a scene very accurately painted was his greatest accomplishment. It is that old strain of art praise, which puts the emphasis on making things look just as they do in real life. And it is exactly how people, even today, like to play down Golden Age Dutch art, as if it were just a transcription of the visible world, proficient, but nonetheless documentary. The wildness and strangeness and utter originality, the vision and imagination: all of it seems to go unnoticed. It happens even to Vermeer, for all his transcendent fictions. The one and only mention of a visit to Vermeer's studio, by the wealthy young diarist Pieter Teding van Berkhout in 1669, comes up with exactly the same crass comment. 'Went out and visited a famous painter named Vermeer, who showed me some examples of his art, the most extraordinary and the most curious aspect of which consists in the perspective.'

Vermeer owned three paintings by Carel Fabritius. They were hanging on the walls of his house in Delft, four streets and one bridge from the crossroads where the music man sits. Three paintings out of the surviving handful: but which ones?

Almost more is known about the death than the life. Even Fabritius's date of birth was only discovered within the last century. He was born in a hamlet in the flatlands to the north of Amsterdam and scarcely ever left, except for a spell in Rembrandt's studio and a final four years in Delft. Or so it was always thought. What did he see, what did he look at, which pictures did *he* know as a child? I have wondered how he became a painter

in all this rural isolation. Nothing comes of nothing, in art, and he must have seen something somewhere. What was the education of his eye?

Surely there must have been other paintings. A woman selling a house a few years after his death petitions to be allowed to detach the Fabritius mural from her wall so that she can take it with her. There is fleeting reference in a contemporary book to a painting on the ceiling of a doctor's house in Delft, and a vanished group portrait, the only one he ever made that contains more than a solo figure. Which is exactly as Fabritius has sometimes seemed to me: a lone presence, registering only as the shadow of a foot beneath a door.

A View of Delft has the appearance of an apparition, too, shifting from bright to shade, the bridge rising towards the ringed city, shadows falling on the outskirts. It is like a vision in the mind's eye given expression in paint. I cannot understand why people walk by without seeming to notice this secretive vision when it hangs there in full public view. But this has been Fabritius's fate. He seems lost in art as he was in life; like the music man, elsewhere in his head.

Fabritius died by complete chance: the fatal coincidence of time and place. He got up one autumn morning to paint a portrait in his house in Delft, only a few streets from this crossroads, and was working in the same room as an assistant mixing colours, a churchman sitting before him for the portrait and his mother-in-law busying about in the background, the bells of the very church you see in this painting having just rung out the hour of ten, when some minutes later came a sudden explosion, deafening, devastating, rising like a mushroom cloud over the city, raising objects and glass and human bodies into the air, a devastation caused by human accident as well as invention. A sudden explosion of gunpowder: the Delft Thunderclap.

The unthinkable flash was followed by a blast so loud it could be heard more than seventy miles away on the island of Texel. Momentary silence was followed by complete annihilation. Everyone in the house was crushed beneath the roof beams, which instantly collapsed. Only Fabritius survived. Many hours later he was found, still breathing, and carried across two bridges to a makeshift infirmary. But the rescue came too late. He died just before twilight that day.

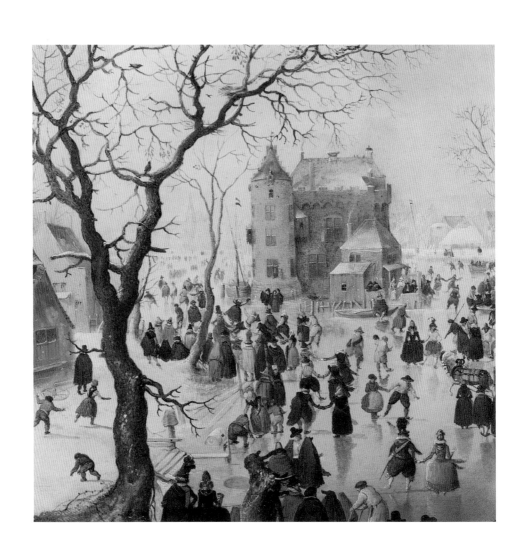

It is my first day at school, aged five, and we are in a new building with plate-glass doors opening on to a concrete terrace where pupils can play tig and plant spring bulbs in September. The walls are harled with chips of white stone that glitter in the chill Edinburgh sun. Some of us believe that these might be actual gems. By the end of the first term a large patch has vanished into the pockets of our gabardine coats, diamonds picked clean from the plaster.

On the classroom wall is a painting of people from the past moving about on ice. Some also seem to be playing, or possibly dancing; their faces are too small to tell, and are in any case mainly turned away. There are melting patches where the paint is a liquid blue and a grey spire fades out in the misty distance. The air has a strange pink tinge that makes it look even colder than Scotland. That the painting is ancient is obvious from the long dresses, but also from these colours that are so different from the lime-green and vermilion of the wooden rods with which we will be learning to count. Each number from one to ten has its own colour and length. Lime is three centimetres, magenta four, bright synthetic orange makes ten of the little white ones, which seem to have more in common with this old painting.

The teacher is going round the class asking our names and what our fathers do for a living. Mine is a painter. My mother is also an artist, but nobody ever asks about her. A house painter, asks Miss Rogan brightly? It does seem to me that he sometimes paints walls and doors, but not actual houses. No, Miss. So what kind of painter is he? The girl next to me fidgets; her name is Nara. It seems important to be precise. The only other jobs I

know about need no further explanation: the grocer, the doctor, this teacher, our postman (I will become one, temporarily, each Christmas in Leith, making the earliest delivery to the tenements by moonlight). The ice picture is no help, being nothing like my father's kind of painting at all. I am so full of pride in him, and so unable to utter. The teacher moves on to Nara.

At home, I am given a helpful phrase should this happen again. My father paints semi-figurative art. I don't catch what semi means, but I do think I understand figurative. The people in the ice scene are figures; the picture is figurative; figures are also numbers, which have their special colours, and colours make paintings. Art is life, life is art.

My father paints people on the island of Lewis as if they were one with the landscape. He paints Hebridean kitchens in the morning before sunrise, lit by a guttering oil lamp; though you cannot make this out as an object standing on the table, it seems part of the surface and the room all at once. He paints dark water, or is it flowing cloud, or is it also a range of low hills? I see these canvases coming out of his studio and know they are what he does for a job. There is some confusion about whether they are called pictures or paintings, though the man from the gallery calls them works. There is a difference. They are not images like the one at school. I have some obscure sense of a distinction that I cannot articulate.

I have told my father about the ice painting. He murmurs, eyes on the road as he drives our Morris Oxford, that it will be a Dutch winter landscape. How does it come to be here, then? I do not remember whether he turned to look at me, but there must have been some kind of hiatus while he worked out how to deliver the news that this was only a reproduction. I knew about postcards, pictures for the pocket, and Christmas cards that so often showed skaters. But somehow I had never associated them

with larger images on a wall, which I took to be real paintings. I didn't know the difference between the winter scene at school and a panel painted in oils. You looked into them all as into a story, a vision, a scene going on in some other place elsewhere. They were all part of the picture world.

Nara had a party, to which I was invited. We all were; well-wishing parents did not yet discriminate between children and we had no idea of a choice. But there were thirty-one pupils in the class and soon we were required to queue for lunch in pairs. And a shameful fear arose of being number thirty-one, a single white cube after three brilliant orange rods.

At school we were later taught, to my father's disgust, that white was not a colour. We were also instructed never to mix white or black with our paints to make things lighter or darker. Our teacher insisted we use more water or choose a 'proper' colour in the first place. When I came home after a scolding, my father took white and painted a fine scattering of snow against a night sky of black gouache. Always go your own way.

At Nara's party, in a game of pass the parcel, I won a plastic ring set with a stone of deep crimson to rival any true gem. Held to the light, it was as captivating as the stained glass of the Anglican church over the road from our house. We went instead to the Scottish kirk, with its whitewashed walls, high clear windows and blazing Sunday sermons. Scotland apparently had this pristine probity over England, where the church smelled fusty and the vicar mumbled. But England had the colours.

At home we played a memory game, cards face down, two turned over each time, hit or miss, as you tried to match up the pairs. The fascination of it remains: the picture world expanding with so many new types of image. A photograph of half an apple face up on a blue and white dish; a muzzy pastel drawing of a lemon; a print of a walnut with all of its cerebral folds. A cartoon

tiger jumps out of a window, fish float in a Paul Klee aquarium and there is a photobooth headshot of a woman so like my god-mother the card is known as Aunt Tisha. My favourite is a children's book illustration of a lively girl with blonde plaits darting through blue-shadowed snow, known to us as The Dutch Girl.

Fabritius, Vermeer and Pieter de Hooch first arrived as pictures through the ill-lit surgery of our family doctor up the road. I had decided that I was growing fat. I have no recollection of who proposed the trip, but my mother's faith in doctors was devout, only much later to be mortally tested, and she took me for an appointment to be weighed. A lifelong dread set in on that day, at the age of seven and three-quarters; but so did a dawning joy.

Evidently my mother did not trust our own scales, or recognised the power of ceremony, for we went every week to see whether there was any less of me. On one of these visits, I must have triumphed because the doctor gave me a prize. This took the form of a postcard of a painting showing a town seen at some distance across water. The sky and this water are quite dull, cloud-heavy, and yet somehow shining. A group of people on our side of the picture are staring at the view, which makes me stare too. The title is printed on a pale margin running down the right-hand side. It is not obvious to me quite why Vermeer's *View of Delft* is so riveting.

24

We return to the doctor, in my case enticed by his postcards. I have them still. The next was De Hooch's *The Courtyard of a House in Delft*, with a red shutter on the left that looks as if it is a shutter to the painting itself, a woman in a spotless corridor looking out at the town and a mother and daughter in Dutch dress. We looked closely at the brick floor of the yard, so beautifully laid, and painted; my mother copied its pattern with concrete fragments for a path in our garden.

I was alarmed by Rembrandt's *The Anatomy Lesson of Dr Nicolaes Tulp*, all the black and white men leaning over the grey corpse, grisly to me but perhaps not to our doctor, veteran of such dissections. Like Tulp, who commissioned the picture from Rembrandt, our doctor was a kind of patron and friend to my father. He came to exhibitions and occasionally bought a painting; perhaps this is why these postcards were in turn so generously bestowed upon me. I see him now, carefully winding the wire hooks of his NHS-issue specs around his red ears to examine my lower lids for anaemia, my eyes briefly reflected in his circular lenses. He could tell a mole from a melanoma and read the ridge of a fingernail for latent diabetes in a glance. A glass-fronted cabinet in his room contained an instrument exactly like the one in Dr Tulp's hand, so in retrospect it seems especially selfless of him to have dispensed an image of such personal significance to me.

I thought this must be a black and white postcard – it was not, as I later discovered on seeing the actual painting – but the next one certainly was. It showed the goldfinch on its perch. Like Dr Tulp, like Vermeer's Delft, this postcard had also come from the Mauritshuis. It seems to me now that Dr Simpson, who worked nights, made home visits, even came to the hospital in a heatwave with an ice cream for my mother the morning I was born, must have spent a hard-won holiday in The Hague. Such a souvenir

he gave to me. I kept this ghostly presage in a shoebox museum for many years until I saw the original: Fabritius's painted wall hanging on a real wall, his painted bird forever turning its bright eye upon us in the museum.

In the postcard version, the bird's shadow drifted away like smoke in the air. Bright halations surrounded its dark head. The perch appeared to be attached to nothing very much, and there seemed to be no clear edges to the scene except those that belonged to the postcard itself. It floated like a vignette, this bird on its box, or like those sequences in silent movies where everything dissolves around a central image to show that this is time past, a flashback or hazy memory. Or that it was all a dream.

There were no more Dutch postcards after this. I must have lost the weight.

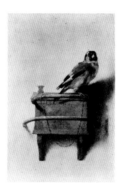

An old book of self-portraits in our Edinburgh house had a text in German. I believe it was a gift from our neighbours, an elderly German couple who had been imprisoned for pacifism by the Nazis. It held pictures larger than postcards, black and white and a mesmerising spectrum of greys, all colours from slate to pearl and charcoal. This book unfolded like a narrative, at least to me as a child. Each artist had a painting, sometimes two, with their name and dates on a page. Titian flexes impatient fingers on a table. Poussin holes up in a booth of his own canvases. El Greco, a poignant cast in one eye, holds up a heavy Bible. Time speeds forwards and there is the young Courbet apparently dying of a stab wound beneath a tree (how then could he paint the picture?) and one of de Chirico's more ludicrous self-portraits, in which he brandishes a badly painted palette (surely vital to get that right?). Above him runs the legend, in Latin, 'I seek Eternal Fame so that I may be sung forever in the whole world'. De Chirico looks like a walrus.

500 Selbstporträts gathers into a tale told through images down the centuries. What artists are like; what their lives are like; how they want to be seen and known. There is the fantastical sense of a massive group portrait, of people in rooms and landscapes and faraway countries all united in an anthology which functions almost as a flipbook, animating the artists. Even the dullest self-portrait – face, brush, canvas combination; or simply a person catching your eye almost to the point of winking – picks up life from those around it, humanity ever changing through time.

And here among the pages is Carel Fabritius: a darkly handsome young man with pronounced cheekbones and long hair

curling down over his collar. His nose is straight, his jaw strong, eyes a voluminous black among the greys. He might stand as the romantic lead in some theatrical production; and yet he appears strikingly alone. They all are, obviously, stuck in the solitary studio between the mirror and the canvas, apart from those who drag their family and friends into the picture. But where other artists speak with their eyes, their bodies or even quite literally in words, like de Chirico, Fabritius appears profoundly watchful and inward. It is as if he hardly expected anyone to be out there looking back; as if he was painting his own burdensome silence.

Even a child can tell when there is something odd about a self-portrait, and in this case the strangeness seemed to lie in the artist's place in the picture. Fabritius appeared low down. People who paint themselves almost always rise up the canvas so their eyes are near the top; Fabritius sinks towards the bottom, like the setting sun.

Then there is this wall against which he stands, all the variegations of its plaster so lyrically described. He pays as much attention to its substance – its stain and fade, its flake and viscosity and smooth paste – as to his own face, or the bleached cloth of

14. CAREL FABRITIUS (Self-portrait, 1645? Rotterdam, Museum Boymans)

his shirt, or the haphazard tendrils of his hair. It could be the living portrait of the wall as much as the painter.

And Fabritius appears reticent, standing back from the canvas and closer to this wall, painting himself at a distance. His large eyes are full of nuance: solitude, retreat, steady observation, high intelligence, suffering. A shy man, a magnificent painter – a great paradox: how to depict oneself without showing off?

On the opposite page of the book was another self-portrait, this time of a man in a flamboyant hat and doublet. This was supposed to be Carel Fabritius too, or so the caption claimed back in the 1930s when the book was published. But all the depth of soul has gone. People have argued that it is a portrait of Carel by his younger brother Barent, also a painter; or Barent by Carel; or Barent's own self-portrait. Nobody knows. But I feel sure that Carel Fabritius has no presence in this painting.

For further confusion, the next spread presents two self-portraits by Barent, at least one of which – a man in a bad wig, ostentatiously smoking a clay pipe while getting down to work on a toy easel – is so poorly painted it could be by any old hack. I am sure I never looked hard at these, and even now I would like not to see them again. It pains me to think that Barent got as many pages as his older brother Carel. Barent lived a relatively long and lucky life, had a wife and several children and produced so many serviceable works that he could command a decent price wherever he went. Some of his paintings are still in the very places for which they were commissioned: the interiors of Dutch Reformed churches. The two men, despite the chasmic distance between their abilities, have been incessantly and to me outrageously confused.

Self-portraits sometimes have as a side effect a certain frisson of recognition. Artists, looking intently at themselves, appear to be looking intently at you; and that look, no matter how different their face may be, somehow speaks of one's own experience of

glimpsing oneself in a mirror. I got exactly such a jolt on seeing Fabritius's self-portrait against the plastered wall, all of a sudden, in a slide show mounted by a far greater art teacher from Shetland in my secondary school. He was showing us paintings in a darkened room, through the mote-catching beam of the projector. He had begun with Giotto and the Arena Chapel in Padua and we were gradually moving towards the twentieth century, but with a detour for the archipelago of self-portraiture. Up on the screen, large as life, came Fabritius's great painting of himself: the black eyes, the fascinating wall.

He was here because our teacher was riffling through Rembrandt's apostles – Bol, Flinck and Dou, like a seventies rock band – and Fabritius was included among them. I had no idea that he was supposed to be wearing an antique shirt, bared to the chest, or that he had worked in the studio of Rembrandt. The others looked quite servile, at least to my teenage eyes, aping their master with raking light, glowering darkness, helmets, furs and the usual props from the Rembrandt dressing-up box. But Fabritius was not like them; he was his own troubled self. His hair looked almost contemporary to me; not exactly a Bowie cut, more like Marc Bolan, definitely leaning towards glam rock. I felt attracted and yet also disturbed.

For people in paintings can affect us like people in life. You watch a stranger at a distance trying to enter into their mind or situation, as far as you can; when they depart you continue to think of them. But paintings remain. And returning to the same painting, over and again, is to see it more clearly, sense its character more deeply, as you yourself change. Fabritius's first self-portrait was there in my life for a long time, like something deeply submerged, before I ever saw it in person. How slowly a likeness comes to matter.

The painting appeared for the first time in London towards the end of the twentieth century, in a show devoted to Rembrandt's

self-portraits. Never had so many been united in one gallery, from truculent youth to mid-life stardom in gold chains to the impassioned and magnificently defiant self-portraits of Rembrandt's old age: spotlit faces looming out of the darkness in a thousand ever-changing nuances of humanity, inward and outward. It was hard to imagine a more potent gathering of paintings anywhere in the world at that time, and at that place, than 'Rembrandt By Himself' at the National Gallery.

A penultimate room was given over to his followers, principally to show how popular (and profitable) the Rembrandt self-portrait brand had become. Whey-faced Bol, gingery Flinck and diminutive Dou, in velvet and furs, leaning on stone ledges, always imitating the master. Visitors walked on by. But there was one painting of such power it stood apart, even though the artist was only there as an understudy, and it was the Carel Fabritius.

The first thunderclap was the colour. The wall runs green to gold to tawny brown and grey-blue. The face is a great build-up of brushstrokes, short and strong, thickening around the eyes, fluid as wet plaster (like the wall) in all these hues and many more, dark-red dabs suggesting dimple, cornea and depth. A dazzling passage around the mouth runs green and pink brushstrokes right next to each other. Tendrils of hair about the forehead are scratched into the surface with the end of the brush and the signature is incised in the same way. The wall is so thick, the oil so sumptuously laid, that hairs from his brush and particles of dust from the very room where Fabritius was working are visibly caught in the surface. There are passages where the marks are so dramatically decoupled from what they describe that they seem to run wild, even though the likeness of Fabritius remains absolutely clear and present.

*

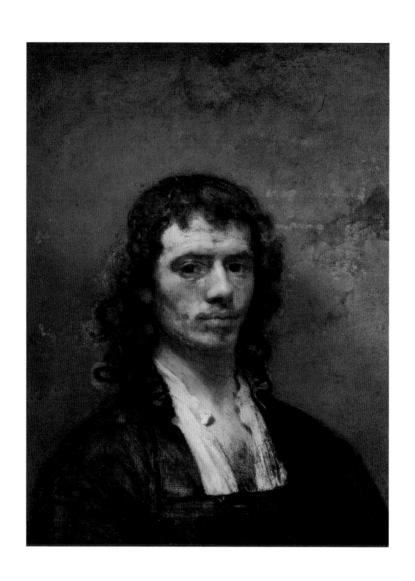

He seemed a man not of those Rembrandtian times but of an age closer to our own, more like a Romantic figure. And although everything I had found so poignant in the black and white reproduction was still present, there was something stronger and more solitary and far more complex in this embodiment of himself as a mortal being. He stood, too, in a room that was filled with the play of natural light and not some theatrical darkness like all the others. Fabritius reversed the Rembrandt convention, appearing in a modern world. It felt as if he had opened the shutters.

He is generally thought to be around twenty-five or twenty-six here, and has yet to make the move from the hamlet of Middenbeemster to the city of Delft. Although he cannot know it, Fabritius is between two lives. He has already broken free of Rembrandt, his thronged studio and heavy influence, but is yet to paint as he will in *A View of Delft*. He stands here in no man's land, in a picture so radical it is almost impossible to believe that it was made in the seventeenth century.

Fabritius was born in late February 1622, in one of the worst winters the Netherlands had ever seen. The Little Ice Age laid its fierce cold upon the land. The new canals and waterways froze solid for months and all the ploughed fields around the village of his birth, about eighteen miles outside Amsterdam, turned into dangerous ruts of sharp ice. To me, Fabritius has something of that season in his soul, what the poet Wallace Stevens called 'a mind of winter':

> One must have a mind of winter
> To regard the frost and the boughs
> Of the pine-trees crusted with snow;
>
> And have been cold a long time
> To behold the junipers shagged with ice,

The spruces rough in the distant glitter

Of the January sun; and not to think
Of any misery in the sound of the wind,
In the sound of a few leaves . . .

A man of winter, Fabritius seems used to the rigid cold, listen-
ing without resistance to the sound of the wind blowing through
the bare land. I wonder what he has seen and known. The white
paint, in this great and lonely self-portrait, lies beneath one eye
like snow upon a bough.

When I can't sleep, my mind goes skating down the surface of frozen Dutch rivers, picking up speed past windmills and spires, hurtling over crossings, racing along the polished ice beneath the rival expanse of white sky. I can't stop for the headlong rush. Further and faster and almost blindingly bright, round the bends, ducking the bridges, skirting the byways without slowing, speed begetting speed, ever onwards, just the way the sleepless mind keeps noticing its own alertness, remaining ever more viciously awake.

Sometimes the imaginary sky is tinged pink, but mainly it is the pure whiteness banned in the primary-school class. And sure enough, I know where this picture of insomnia comes from, and my coursing exhilaration too, which is the Dutch winter art of my childhood. It is the skating scene from that first day, Christmas cards through the door and real paintings in galleries of skaters out on the Low Countries ice. This is my early idea of the Netherlands. There is a kind of mist in these paintings that seems shot through with the arctic chill so gallantly defied by the outdoor figures. Sometimes you can scarcely make them out for this freezing haar, a pale vibration arriving from the distance. Sometimes the ice seems to smoke and you can see the temperature in the very painted air.

The world teems in this art of details. A magpie dives, skaters sweep and twirl, fall flat on their face or tumble backwards at slapstick angles. A scarlet sledge gets stuck; a sleigh sinks perilously low. A toff in an expensive striped jacket poses with his club, all set to take a swing in the ice game of kolf, to the admiration of his friends and the scepticism of a bystanding fisherman. Courting

couples kiss. The timid hold on to each other, as well they should, stepping carefully across the slidy surface. For there may be some treacherous thaw or dark hole that the approaching figures cannot see but we can, thanks to the painter's sense of dramatic irony.

The Dutch walk on water, frozen solid all the way down. They skate upon it for miles and miles, from town to town, without let or hindrance, talking and meeting, selling food and doing business, somehow carrying on their indoor lives outside. I believe Dutch winter paintings were sometimes transported from artist to middleman to buyer down the very corridors of ice they depict. What went by slow-stopping barge in summer got there much quicker in winter, slipping through the landscape on a sledge's waxed runners.

It does not snow in these Dutch pictures. That was Japanese art, where soft petals falling from blue-black skies appeared both still and yet mysteriously mobile in their silent descent. And it did not snow in Edinburgh either, or at least not where we lived on the brow of a hill that plunged straight down to the Firth of Forth, its wash held back only by a seawall. There was too much salt in the air for snow, observed my father, who preferred our good clean ice. If we did receive a flurry, my brother and I used to scoop some into a saucer and leave it outdoors, guessing how many minutes before it transformed into a miniature rink.

For all this ice we never skated outside, like the Dutch. The Reverend Robert Walker did in what is, I suppose, Scotland's national painting: Sir Henry Raeburn's action portrait of Walker gliding on one leg across Duddingston Loch, absolutely still and yet in full forward motion. A dark diagonal cutting through the grey light, his scarlet-laced skates etch criss-crossing lines in the surface. Walker was a member of the world's oldest figure-skating club, formed in Edinburgh in the eighteenth century, but he grew up in Rotterdam, where his father was minister of the Scots

Kirk, and learned his celebrated skills on Dutch ice. I never saw anybody skate on that loch in my life. We went instead to the indoor rink at Murrayfield, hiring cumbersome leather boots and skating until the session ended in peripheral mush. Ice was pristine white, melting to brown, or the sinister black we learned to fear when my father, returning from teaching at the art college one December night, came off his motorbike at the top of the steeply descending Mound and wrecked his right ankle.

Of true cold, it seems to me, I knew nothing except through the visions of Dutch art, which show the astonishing transformations of the Little Ice Age, when the Baltic Sea froze in mid-wave and the temperatures fell too low even for snow. Winter paintings thrived, for the first time, and what they show is out-right courage. Look at these people tumbling and skittering and even dancing, eating and holding their family gatherings in the ice-white air: everything they do is heroic.

Around this new whiteness are those weedy fronds that look like cryptic calligraphy in many paintings, usually running along the front – the footlights – as if to imply something enigmatic. It's no surprise that art historians of the past used to find hidden signatures among the weeds. I like these fronds. They are sometimes all that indicate the border between water and land, especially in the work of Hendrick Avercamp. His paintings show a frozen world, where everyone from the infant to the stout burgher is supported by nothing more than ice and the whole landscape is a vaporous whiteout. He was the artist of my classroom picture.

Perhaps it is something about the size of his brushes, or the canvas, or the quality of his pigments, but Avercamp's white is powerful and enduring while his figures appear transient, as if they come and go but the Ice Age never ends. His paintings are curious, more like episodes than landscapes, vignettes ringed about by freezing air.

I relish *A Scene on the Ice near a Town* (a title that could apply just as well to most of his paintings). On the right is a towering building with a bridge over a moat, now magnificently redundant since the whole landscape is frozen solid. This building has a beautiful rosy hue, borrowed from the pink-tinctured sky that promises more ice tomorrow. Magpies (five for silver) perch upon the parapets. Drips from the drain freeze into airy icicles. A duck clatters overhead. Curious objects dangle from the wall – a jug, a boot hanging like a Christmas stocking – and alongside are scene after scene of this outdoor life, stretching all the way into the distance where the masts of boats frozen at a tilt speak back to the past when this was all meadow and flowing water.

There are children everywhere, the rich ones clutched to their overdressed parents. A posh girl in a cartwheel ruff begs her entirely unmoved mother for a go on the ice. The poor are

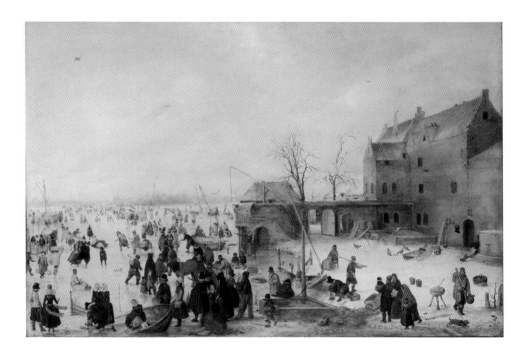

gleefully neglected to roam, one child sitting perilously close to an open fishing hole as her heedless family involve themselves in the complicated operation of putting on their skates. There is a peculiar lack of self-consciousness, or self-awareness, in these scenes. People tumble, and struggle to rise again, adjusting their clothes as if nobody was looking. They are like people talking on their mobile phones in the street. Preoccupation renders them, or so they think, invisible. I remember a boy on the bus down the Mound from school who put his hands over his eyes and shouted across to us 'I cannae see you, so you cannae see me!'

Avercamp's drawings, in colour, are as great as his paintings. A fisherman in gloves thick as baseball mitts lowers his net through a hole; nearby lies an axe, a heavy black object with which he has just hacked through two solid feet of ice. But now it lies weightless in space, only the subtlest hint of shadow indicating the flat white surface. Two teenage couples who have been out courting are confronted by their indignant parents on terra firma. The boys are awkward and oafish, the girls slightly embarrassed before their mothers, masked against the biting wind. A sleigh that has crashed through the surface is hastily sketched in red chalk. The passengers flounder among the glassy splinters as the horse bridles, still trying to drag its load. A man leans in to help, supported by another from behind, and then another; they may topple like dominoes. The scene is pure tension.

Ice is timeless, unchanging, dangerous in its fascination across the centuries. I think of Edinburgh one freezing February and Inverleith Park where we went at weekends. The playground is hard as iron, the slide so cold it burns your hands and a boy's caustic quip enters our parlance: 'This slide's no very slidy.' The shallow spreading pond where we net minnows in summer is black ice, except where it meets the edge of the concrete basin. Brown meltwater is emerging beneath the surface. Staring into this

meteorological transformation – solid to liquid to gas, as bubbles begin to escape – I fret about the fate of the fish trapped below.

We are in the wellingtons every child wore whatever the weather and I am staring as the black rubber turns opaque in the cold when there is a cacophony along the edge. A boy has gone in, crashing through the surface so that long splinters refract all across the ice, like a Tom and Jerry cartoon. I see a fish move – they are alive after all – and only then turn to the noise. The child is out of the water fast enough, though I have no idea whether he was hauled or scrambled. All I recall is that his red anorak, absorbing the water, gradually turned a rising maroon (I always remembered this when taking Covid tests). The boy from the slide was standing next to him and abruptly pushed him in. I have no idea why. They were absolute strangers.

Is it possible that we never go there again? I don't recall doing so and imagine a paralysing protectiveness on my mother's part. I am touched that Avercamp always notices the mothers.

He never painted a thaw; winter was his metier. Amsterdam-born, to a family of means, he trained in his youth with a distinguished older painter and must surely have seen the winter art of Brueghel. He often signed his paintings with a monogram – HA – that resembles one of those toy acrobats that swings up and over its own wooden arms. It isn't easy to work out his evolution as a painter because the landscapes and the people never change, any more than they did in the early seventeenth century. He paints a scene from a distance, or from a high vantage point so that you can see figures skating away into the pale horizon; yet he can also appear to hover quite close to some of the people he observes, apparently unnoticed. He surely has an alter ego in the fisherman raising a sceptical eyebrow at the sight of the plutocrat ostentatiously rehearsing his next kolf shot before an audience of hangers-on. The player is about to miss.

In one crowded scene there is a solitary figure on the extreme left. He too has a kolf club, but stands apart, turning to us with a quiet and withdrawn expression. The score is scratched into the ice by his feet, using the brush end, perhaps as a wry kind of signature. Full marks. His nose and the tip of one ear are red, and his only companion (or counterpart) appears to be the gnarled and lonely tree behind him. It is no surprise that people have discovered a self-portrait here; if you stripped away the winter scene he could be standing between mirror and easel.

In the municipal archives in Kampen, where his family moved from Amsterdam, there is just one mention: a Hendrick Avercamp de Stomme is paid 12 meagre guilders for painting horses on the wall of a town stable. Avercamp de Stomme – Avercamp the Mute. For centuries, people believed this meant that he was shy, or as enigmatic as Vermeer, until the discovery of a last will and testament left by his widowed mother in 1633. She petitions the town magistrate to permit a special annuity from the family capital after she dies for her 'dumb and miserable son'. Hendrick is both unable to speak and quite possibly ill. He did not survive her for long, dying in his forties the following year.

Nowadays Avercamp would be described as non-verbal, deaf as well as mute. And perhaps he was sealed up in silence; maybe he spoke with notebook and chalk. In the thousands of superlative

drawings, he is always noting down what he saw, figure by figure, group by group, observing body language with such intensity; the human race on skates. His paintings were loved, and he was so prolific that his art is ubiquitous in the world's museums; taken for granted, like so much Dutch art, seen but overlooked.

The picture on the classroom wall was painted from up above, looking down on the rolling ice, where people strike out on their skates in long, confident strikes, gliding across the slippery floor into the distance with an elegance they may lack in the melted world, when the short, dark days of devastating cold are over. Anecdote lies next to comedy: a woman doing the family washing in an ice hole appears not far from a near-miss between slapstick skaters. But almost all of the people in the picture are seen from behind, their backs turned away from us, and from the painter. Not only is Avercamp watching them from up above, he is not part of this world, cut off from the throng and out of view.

The original painting was not square, as I saw it in Miss Rogan's reproduction. I had no idea of this, and neither did anyone else at that time. It was only in the 1980s that specialists discovered that the canvas had been carefully folded to transform it into a square. The painting is in fact round.

A roundel, a circle, a painted disc; it takes in the world just the way the eye does, a circular vision fading out on the periphery. Round paintings have this metaphorical association with the very organ vital to their making, and our appreciation. The round vision: the entirety of the world, and the eye that sees it.

A man who ground circular lenses for spectacles in the city of Middelburg, in the spit of land known as Zeeland that reaches into the icy North Sea, applied in 1608 for a patent for his new device 'for seeing things far away as if they were nearby'. His long wooden tube involved both convex and concave lenses, so that the world was not turned upside down on the retina. He only managed to magnify the distance by a factor of three, which would seem a modest feat today; reminiscent of early steam trains that did not reach speeds much greater than a bicycle. But he was awarded his patent, among a flurry of other applications, and the far-seeing invention began to appear throughout Europe.

Perhaps Avercamp is perched on his incline a year later, in 1609, telescope in hand, looking down on all those people near and far. But his painting has a resemblance to the swarming visions seen through the amazing new invention of microscopy. This time the inventor was Antonie van Leeuwenhoek, a draper in Delft who wished to examine the quality of his threads more clearly than a magnifying lens would permit. He began to melt glass into the finest pinpoint rods, tipped with tiny spheres, to create spectacular close-ups, achieving magnifications of up to three hundred times, and some believe five hundred in his later years. And what Leeuwenhoek could see through his minuscule filaments of glass were the new discoveries of sperm and bacteria and even the vacuole of the human cell.

Leeuwenhoek was evidently close enough to Vermeer to be named chief executor in the painter's will. And it is in this document that three paintings by Fabritius appear; Leeuwenhoek must

have seen them with his own eyes. In 1654, he was living with his uncle in the next street to Fabritius when the gunpowder exploded. The house was so damaged it took almost a decade to rebuild, but Leeuwenhoek escaped the blast and lived for another seventy years.

Dutch flags flutter, Dutch colours, blue, white and orange, pick their way through Avercamp's painting. The whole crowded nation is here in compendium, and in microcosm. All these people, alive to the exhilarating cold, thriving outdoors in the blanched light upon the spangled ice: an extract of life seen as if through the eye of a microscope.

The village of Middenbeemster is small and spruce, an ordered community built on land claimed from the deep-brown waters not long before Fabritius was born. It has a dozen perfectly straight streets centring on a Dutch Reformed church with high, clear windows. The interior is as bare now as it was then, a ship of perfect whiteness. Two chambers off the entrance are decorated floor to ceiling with blue and white picture tiles of the kind still manufactured in Delft today. The spire rises sharp as a tack above the outlying flatlands with their long avenues of tall trees, through which you drive as if gliding along a motion-less canal. Scarcely anything has changed.

The polder spreads out in snowbound winter like a great sheet in the bleaching fields of so many Dutch paintings, all those rect-angles of white linen laid out to brighten in the sun's purifying rays. Leeuwenhoek sold bales of it in his shop and I suppose that Fabritius's shirt in the self-portrait must have been cut from exactly such cloth, bleached in the Middenbeemster meadows. Church vestments still survive from those times, their fabric pale from the brilliance of a seventeenth-century sun.

The painter was born here because of the spirited ambitions of his father, Pieter Carelsz, who moved from the nearby town of Purmerend in his early twenties to become first schoolmaster of this experimental hamlet. The timbers of the building were still young. Soon he was appointed sexton of the new church that was slowly rising up just behind the schoolhouse. Its records, writ-ten in his careful hand, declare that he himself has inaugurated these mortal accounts. They tell of the births of many children,

including eleven of his own with his wife Barbetje; they also tell of premature deaths.

Carel is their firstborn, baptised in the church on 28 February 1622. There is then not another word about him – no mention in the records, not a document of any sort – for another nineteen years. Somehow, during this time, and in this handkerchief of land, he was becoming an artist.

Pieter Carelsz was himself a Sunday painter. There exists a written plea to the members of Middenbeemster council that he be granted 'permission to devote his spare time outside school to his duties as a painter'. This is permitted, with the grudging caveat that 'the same shall not disadvantage or hinder the school and his pupils'. Three of those pupils – his own sons Carel, Barent and Johannes – became professional painters and he must have been their first art teacher. Whatever Pieter himself painted is long lost, except for a crude panel from that time – on wood – which is surely by his hand, for it is a picture of his church soaring up towards a fanciful angel in a sky of stiff clouds. It is still hanging on a wall of the very building it depicts, the church in Middenbeemster.

What was Fabritius's childhood picture world in this waterland village: the Delft tiles in the church, the engraved illustrations in books, his father's art? This can hardly have been all. Pieter Carelsz must have known a growing number of families, and Barbetje too, since she was the district midwife. And perhaps some of these families had pictures in their homes. Even as early as 1622, Dutch people were buying Dutch art with a zeal seen nowhere else in Europe, not just merchants and bankers and burghers, but brewers and drapers and carpenters. Pictures were bought and sold everywhere. English travellers could not believe their eyes, seeing them for sale in outdoor markets.

But if Fabritius saw paintings, how did he keep them in his

46

head? It is staggering to think of those days before the camera's mechanical eye, when there could be no fixed recollection of the images people saw except through the vagaries of memory. Mature artists could at least make copies of paintings, it is true, and rapid impressions of pictures seen at auction. Rembrandt drew a quick ink sketch of Raphael's portrait of the writer and diplomat Baldassare Castiglione turning gracefully towards the viewer when it surfaced for sale in Amsterdam in 1639, a drawing that became the prototype for a self-portrait begun only weeks later.

Rembrandt was apprenticed as a boy to a series of senior painters in Leiden. Vermeer's father was a picture dealer. Both saw paintings from a very young age. But what Fabritius saw in his early youth is almost beyond reach; it feels like an unknown picture world. I hardly know what my own father saw, either, before he applied to Edinburgh College of Art on the eve of the Second World War. He had never been abroad and scarcely crossed the waters of the Firth of Forth from Dunfermline to Edinburgh. He must have studied prints, and I know he revered Giotto; I still have the black and white monograph he chose for a prize at the High School. But I do not know what else he can have seen before departing for college at the age of sixteen.

The next news of Carel Fabritius comes in May 1641, when he and his younger brother Barent are officially confirmed into the church behind the school. After each name is written the surname Fabritius. This is the Latinised version of the Dutch noun Timmerman, meaning carpenter; Pieter Carelsz signs himself thus in the front of the book. Nobody knows why, for he wasn't a carpenter, nor are the professions of local people given anywhere else in the accounts. Perhaps the father of so many children was thinking of Joseph, carpenter father of Jesus; or perhaps he was somehow involved in working the wood of the new church. At any rate, generations of scholars have persuaded

themselves that Carel Fabritius was originally a carpenter planing beams and turning newel posts because he took his father's name. Dutch artists did every job going, it is true, working as dyers, frame-makers, floor installers, glaziers and goldsmiths to support themselves. But I do not think that Fabritius worked on windows and doors, still less whole houses, before becoming one of the greatest innovators in Dutch art.

Carel and Barent were confirmed on that May day in 1641 by a new minister not many months arrived from Meerkerk near Utrecht. The Reverend Tobias Velthuys was a bachelor of twenty-five, younger son of a prosperous family, who wrote letters in Latin and styled himself Velthusius. He had brought his unmarried sister Aeltje with him to keep house. The parsonage stood next to the school, where the whole of the Fabritius family was somehow accommodated next to the classroom. Three months after his confirmation, the banns of marriage are published between Carel Fabritius and Aeltje Velthuys. By the end of September, he had married the girl next door. It seems most likely that the new couple moved away fairly soon to start their married life in Amsterdam, where Fabritius is known to have joined the studio of Rembrandt.

The first grief comes in August the following year. Pieter Carelsz records the death in the church register: 'The 10 of August, my son's young child buried in the churchyard.' Eleven months after their marriage, Fabritius and his wife have lost their firstborn; the records do not say whether the infant is a boy or a girl. Perhaps it was two or three months old at death, maybe more, possibly conceived before they were married. For only seven months later a new baby is born, a little daughter christened Catrina in Amsterdam's Nieuwe Kerk in March 1643. Catrina's parents are recorded as living in Runstraat, 'at the sign of the Dutch Garden'. Runstraat – Cow Street – is one of the Nine

48

Little Streets that run off Prinsengracht in the centre of Amsterdam. They are hardly close to the place where Carel is working, namely Rembrandt's house in Jodenbreestraat. He will have to cross six bridges to get there. But Cow Street is comfortable and couthy. It is no stretch to imagine that Carel and Aeltje are living in a house lent to them by her brother Abraham, a thriving silk merchant, who owns three separate properties in Amsterdam.

But where Aeltje lives is also where she will shortly die. It is not known exactly when, but an 'inventory of the goods of the late Aeltje Velthuysen, resting in the Lord, formerly the wife of Carel Fabritius, painter' is signed as soon as 24 April, a month after Catrina was born. Given the speed with which this document was drawn up, it seems likely that Aeltje died during or soon after the birth. And the new baby did not live. For Aeltje's inventory refers to only one surviving child, a daughter also named Aeltje after her mother. Perhaps this other child, evidently born before Catrina, was the twin of the infant lying in Middenbeemster graveyard.

Three babies were born and two died, all in little more than a year. And Aeltje herself, married to Carel in a village wedding in the late summer harvest of 1641, was dead only eighteen months later.

The inventory of Aeltje's goods gives no mention of her age, but what it does lay out, in shipshape Dutch fashion, is an elaborate list of rings, chains and other gold possessions showing that her family was well off. She has paintings; some are hanging in their house in Runstraat, others are for some reason in her brother Abraham's house: a still life of a breakfast table, a painting of a hermit, another of a slaughtered pig, several portraits and a number of tronies – expressive heads of anonymous people painted for an open market. Not a single artist is named, and historians have chased their tails trying to match the pictures

49

to actual works by Fabritius. It seems so likely that he must have painted some of them, and been about to paint others. For the inventory lists bare primed canvases, all ready for painting, and by whom if not Fabritius?

It is strange that all these pictures and blank canvases are said to belong to Aeltje and not to her husband. It is as if someone is trying to protect the Velthuys estate; or maybe to shield Fabritius or their daughter from some future financial liability. But perhaps there is another reason. It has been proposed that the Velthuys family was paying for Fabritius's training with Rembrandt; or that Fabritius was in debt to them, the pictures a kind of surety. What it indisputably suggests is that he was financially insecure, or careless, or too shocked or broken to handle his late wife's affairs; certainly that he had little or no money.

Fabritius, profoundly bereaved, returned to his childhood home a month later, taking the child Aeltje back to live with his family in Middenbeemster. Perhaps he had the support of his midwife mother. Hardly had he any time to mourn when his brother-in-law, Reverend Velthuys, took it upon himself to draw up a scheme for Fabritius and the child. The contract was signed by Velthuys and Pieter Carelsz, presumably on behalf of Fabritius, who does not appear to be present that summer's day in Purmerend; the document is still there in the Waterland Archive.

The two men 'have amicably reached an accord' that Reverend Velthuys will take everything his dead sister left, estimated to be worth around 1,800 guilders. He will pay Fabritius 5 per cent interest on this lump sum per annum – 90 guilders – to be spent entirely on Aeltje, as long as the father of 'the aforementioned child was not in debt to the child's mother and that the father, Carel Fabritius, would provide for that selfsame child food and drink, clothe her and fit her out in linens and woollens and let her learn some art or craft'. If she dies, half the money will be

given to Fabritius and half returned to the Velthuys family, as if they had as much claim on her estate as he did.

It is also agreed that Fabritius is to sell eleven paintings in Abraham's possession for the benefit of the child. Portraits of the Velthuys siblings top the list: Abraham, Aeltje and their younger sister Grietje, her likeness valued at 40 guilders, more than Tobias Velthuys's monthly earnings and no small sum when a flower still life could be bought for less than seabass. Surely some or all of these portraits must be by Fabritius, though not a single one of them has ever turned up. How tragic for him to sign away the rights to a portrait of his own dead wife. Clearly the Velthuys family was less interested in keeping the art than increasing the child's financial security. This document shows considerable concern for Aeltje's future and little faith in Fabritius's earning power. It seems possible that he was faltering, losing his step, ill of mind or body in his bereavement.

But all of these complex discussions and arrangements and the travelling to Purmerend by horse or barge or carriage to get a legal document witnessed by a notary – all of it was very soon redundant. Three months after Fabritius returned to Midden-beemster in 1643, his daughter Aeltje died. He had lost every member of his young family, one after the other, by the age of twenty-one.

Pieter Carelsz writes again in the ledger of life and death. 'The 27th August, my son's child buried under the letter C No. 10 in the church, bell rung.'

I don't know what pictures Fabritius saw, what poetry he read, whether he was tall, as I imagine Titian, or short like Goya. He does not leave any letters in which his voice can be heard. But I know, and you do now too, that he walked through the dew-silvered fields of Middenbeemster in freezing winters and high green summers, a level landscape that has not changed at all. I

know the cold white light in which he knelt down to pray in that church, and exactly where he stood to bury his young children, one in the graveyard, the other beneath flagstone C No. 10. And I know that when you look at his first self-portrait, you are looking into the eyes of a man who has suffered all this, who lives with the burden of such sorrow.

The myth of Fabritius the humble carpenter from the sticks transformed by a touch of Rembrandt's magical brush stuck fast until the discovery of his earliest known painting in the twentieth century. It shows the parable of Lazarus, raised from the deepest pit of death, his dazed face ringed in an eerie white glow. The picture was lost until the mid-nineteenth century, when it surfaced out of nowhere in a church in the centre of Warsaw. In those days it was thought to be the work of an eighteenth-century Rembrandt imitator, a German hack who never developed a style of his own. Not until the painting was cleaned in 1935 did a signature emerge through time's filth: 'Car. Fabr.', inscribed on the side of Lazarus's stone tomb. The painting was hanging in St Alexander's Church in the hallowed ground of Three Crosses Square. This beloved monument, with its famous white rotunda, was blown to pieces by German bombs during the Warsaw Uprising of 1944. Somehow the painting survived – perhaps removed in secret – as so many heroic Polish citizens did not. It is now in the city's national museum. The church itself rose again, every stone of it rebuilt from the ashes.

No paintings by Fabritius have been discovered before this haunting resurrection, quite possibly painted when he was around twenty-one. The dead man is just returning to life and sight, his eyes slowly beginning to focus in the brilliant light of this incomprehensible miracle. Standing on the perilous ledge of the tomb directly above him, Christ raises one arm as if to spirit Lazarus upwards out of the grave, and all around them bewildered figures raise their hands in astonishment. That the painting emerges from Rembrandt's studio, and influence, is obvious

enough in the tawny gloom, the fantastical costumes and theatrical gestures, the anomalous hint of a parasol that appears in Rembrandt's own works. It feels as if the models, apprentices and assistants from that crowded house in Jodenbreestraat are all there, on and off stage. By general consent, the picture was painted sometime between 1641 and 1643, the years in which Fabritius is thought to have been in Rembrandt's studio. Clearly he was already a long way towards master painter. He must have arrived with extraordinary gifts of his own; and he would leave with his originality undiminished.

That building still stands, all five floors of it, and is now the Rembrandthuis museum in Amsterdam. There is nothing to compare with the immediacy of being there: the chance to look out of the studio windows and see the same streets that all these young artists saw, the same water flowing away into the Dutch distance, the same light in which they worked every day. To clamber up the steep wooden stairs to the room where Rembrandt slept with his wife Saskia, and where he drew her in a quick-fire sketch in their bed. She has just raised a pensive hand to her cheek; his hasty strokes record the movements of her arm like stop-motion footage.

Six of the nine rooms in this high house were devoted to art. Students on the top floor, assistants in the main studio, buyers in the hall, where there is a special viewing throne for patrons by the front door. Even now, the scent of linseed oil drifts through the building, the wooden etching press is still cranked into daily use, the props box remains stuffed, and the large room in which Rembrandt kept his art collection still contains 'a great quantity of horns, shells and coral branches, casts taken from life, and many other curiosities', as described in the inventory made after his death.

The studio where Fabritius worked is nothing like the lonely garret of romantic tradition, but an enormous room warmed by a

pair of towering stoves. On the floor above, Rembrandt's protégés worked in the kind of cubicles you still see in art colleges today. The drying lines for hanging up his newly minted prints are still there, and the tables for mixing expensive pigments. Rembrandt, who bought Dürer, Holbein and Titian, who couldn't resist a stuffed crocodile or a priceless conch, was nothing if not spendthrift.

Even if there were no other evidence than *The Raising of Lazarus*, and a couple of other early paintings, we would know that Fabritius worked with Rembrandt. But there is written proof too, in a book by his fellow painter Samuel van Hoogstraten, who worked there at the same time in 1643. 'Mijn meedeleerling' is Hoogstraten's phrase for Fabritius – my fellow student – although in fact Fabritius was altogether more senior.

Hoogstraten was probably around fifteen when he came to study with Rembrandt, though apprentices were often younger. Boys, usually aged between ten and twelve, would be apprenticed for a fee to a master painter in whose workshop they might also live. They could spend years learning how to stretch canvas or grind pigment, like trainee hairdressers washing the locks they are not allowed to cut. Eventually they would progress to the study of drawing, often from the examples of their masters, though sometimes from the live models that painters like Rembrandt employed; and finally to copying, to the painting of hands, backgrounds or drapery and perhaps even to the painting of their very own works. Fabritius had clearly mastered all of this before he ever reached Rembrandt's studio, and a certain clue to his status as a senior assistant lies in the very unusual fact that he was allowed to sign his own painting of Lazarus. It would be some time before Bol or Flinck were granted the same liberty.

Rembrandt drew Saskia van Uylenburgh for the first time three days after their engagement in 1633. His future wife, aged twenty-one, is a picture of spirited allure. Her eyes glow with

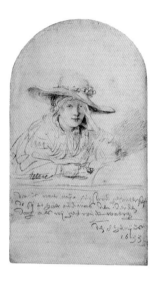

adoration beneath the brim of a wide straw hat, her hair is wavy, lips moist, the cheek resting against one hand is warm and supple and Rembrandt draws the tiny dimple in her chin with infinite tenderness: no mean feat, considering that he is not using fluid ink or soft chalk but a hard silver stylus on parchment to commemorate this June day. In her hand is a flower, round her hat more blossoms, perhaps gifts from her lover. Soon she will marry this prodigy, who is sitting so close on the other side of the table – the most famous artist in Amsterdam.

Saskia is posing in the gallery of Hendrick van Uylenburgh, her much older cousin and Rembrandt's principal dealer. The painter is actually living on the premises. Several of his early masterpieces had already been painted in this grand four-storey building by the Amstel canal, including *The Anatomy Lesson of Dr Nicolaes Tulp*, that shattering vision of medics in white ruffs leaning carelessly over the poor dead body. This first huge commission had already brought its maker wealth and renown; and, once married, Rembrandt and Saskia did not stay with Hendrick for long. As soon as he had mustered the colossal sums required, Rembrandt bought the ruinously

extravagant house next door. There he would draw and paint Saskia over and over again in the short years of their marriage.

Saskia having her hair combed, in bed, asleep or looking enticingly back at her husband; Saskia seen from the inner courtyard, beaming from a casement window. Many pen and ink drawings, dashed off with intense concentration, were found in a folder after the artist's death. They are like the pages of a private diary.

Saskia was educated, fearless and wealthy. She grew up in the Friesian town of Leeuwarden, a miniature Amsterdam of humpbacked bridges and narrow streets that resembles cobbled Delft. Her father was a leading lawyer, town mayor and founder of the local university. Their house is still standing, a veritable mansion only steps from the bustling lace shops and dairy market. But Saskia lost her mother at seven, her father at twelve, and spent her teenage years with an older sister. Still she did not just accept the first proposal from some wily old Frieslander offering protection in exchange for her money. She waited, she studied, she spent time with artists and intellectuals; on her journey to Amsterdam to visit Hendrick in 1633, Saskia's companions included Govert Flinck, who would be a guest at her wedding.

Her character is apparent in her choice of Rembrandt, the son of a miller, rebellious, wild, at least as theatrical as his early self-portraits suggest. He had already painted the unprecedented *Self-Portrait with Dishevelled Hair*, which she would have known since he kept it among his studio works. Here, Rembrandt is a lone soul in the forests of the night, eyes blacker than the darkness around him. He has positioned himself at the exact boundary between that blackness and a shaft of light that ignites his smooth cheek and a flash of white lace collar, showing off his superb gift for flesh and fabric. But his features are hidden in shadow, allowing his true face – his true identity, you might say – to remain beyond reach. The dazzle is in the staging, and yet the

staging is all concealment. You have to search for Rembrandt; and when you find him there is a second shock: he is looking straight back, already holds you in his sights.

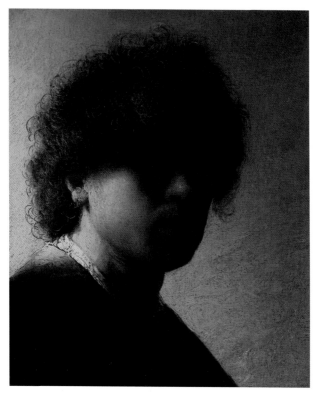

To see Rembrandt's self-portraits, scattered across the Netherlands, is to see that he scarcely looks the same from one painting to the next. His hair is tawny, brown or auburn, his nose waxes and wanes, from bulbous potato to sharp nib; he is head in air, and suave, he is down and out, and flaccid. These paintings give a true sense of inner mutability, of a personality – and appearance – that is ever changing and never fixed: the qualities that make Rembrandt so human, so proverbially Shakespearean.

And what is so revelatory about his depictions of Saskia is that he accords her the same grace. His young wife never looks the

same from day to day. That first drawing gives some rudimentary characteristics: small, ripe mouth, the slight double chin that will become considerably more pronounced, lively round eyes and soft tendrils of hair. But in the paintings this hair may be long and fair, or strawberry-blonde, or even quite red. She looks alert and flirtatious in an early drawing; stouter and more beady in the famous etching where they are both reflected in the same mirror together; he confidently looking up to get his image, she sitting just behind him at the table, watchful in velvet. She is having her hair done by a maid, she is exhausted in bed, possibly from pregnancy, illness or both. In one sheet of studies, she appears five times – young and fair in the middle, with light eyelashes; more careworn and heavy-nosed below. What did she actually look like?

There are so many Saskias. She is an expensively dressed Dutch wife, reading, lolling, looking down at some unseen object in her lap. She is got up as a goddess in a flowing gold dress. He draws her in pearls, strings of them in her hair, round her neck, dangling from her ears. Perhaps this is how she looked on their wedding day. They travelled to Friesland through landscapes of windmills and pollarded willows. His mother signed X with her mark, though she did not attend. Saskia's relatives went from cautiousness to undisguised horror when he bought their expensive new home; he even had to sign some legal promises to keep them happy, all of which were broken.

Saskia looks pregnant in the goddess portrait, painted the year of their wedding in 1634, and so she was: with their first child, who died at birth. The next two babies lived only days. Their beloved son Titus survived, and would himself become a pupil in the studio. But Saskia did not live to see this; she died at the age of twenty-nine, only a few months after his birth, of consumption or possibly the plague. Titus grew up knowing his mother only through his father's art.

59

Rembrandt was twenty-eight when he married Saskia; thirty-six when she died, leaving him with a baby son and a sorrow so destructive he gave up painting in oils for several years. This is its own kind of silence. The measure of his loss is apparent, too, in the nature of all these images of Saskia and their happiness. Here is the artist's heart.

Rembrandt began his greatest portrait of Saskia soon after their marriage, but he did not finish it until long after her death in 1642. And what a magnetic painting it is: Saskia in red velvet and gold, beneath a vast and voluptuous hat, suddenly seen,

for the first and last time, in profile. How delicate she looks, the lower lip much more subtle and sensuous, the face full of shrewd and steady intelligence. It immediately confirms the remark made by the notary Saskia summoned just before her death to witness her will: that she had lost neither her wits nor

her sense of humour. She is no longer sick, pregnant or tired in this painting, but restored to her spry young self. After her death, Rembrandt put a sprig of rosemary in her hand: rosemary for remembrance.

The young artists in the studio painted Saskia too. In Govert Flinck's portrait she appears pasty, plump and auburn, though the lovely mouth with its slightly protuberant lower lip is immediately recognisable from so many other images. It seems entirely possible that Fabritius himself was involved in at least one other portrait, where daylight glows through the scene, casting its warmth on her impish eye, white shirt and pearls, as well as the beautifully painted wall behind her. Saskia was there in the house when Fabritius arrived in 1641; the following year she would give birth to Titus, and die.

What Rembrandt endured is exactly what Fabritius would suffer too. He also married a woman from another world, a much wealthier class, whose family were so exercised about money that they went to law about his finances. But he did not even have eight years of married life with Aeltje and not one of his babies survived. There are no folders of drawings that take us into his marriage, or his apprentice years with some earlier painter unknown; or back into his precocious village youth. His singularity is not fully visible yet. And here he is in Rembrandt's own house, employed like so many others, past and future, to paint exactly like the master. But Fabritius had a life before Rembrandt and he does not follow in dutiful subservience; even now he is beginning to go his own way.

I have wondered whether Fabritius also painted a posthumous portrait of his wife, smuggling her into a workshop production. There is a very strange painting from around 1643–4 titled *Hagar and the Angel*, in which a dark-haired woman with soft and beautiful features crouches on the ground in sorrow. Her face is downturned and shown only in profile; she might be in her late

twenties (Aeltje's age is unknown). She does not see the angel who appears next to her, clothed in white with outstretched palms and glowing eyes that appear supernaturally sightless.

The picture appears to swither between two different times and two different minds. It is almost schizophrenic. There is the extraterrestrial visitor from the Bible story, drifting in space, almost untethered from this scene, an imaginary angel swathed in fluctuating shadow; and there is the sorrowing woman in the foreground who is painted in a completely different register, that of this world, of real time and actual humanity.

The angel is a Rembrandt; the woman, to my mind, belongs entirely to the advanced art of Fabritius.

In the 1960s, my father was chosen to represent Scotland at Henry Kissinger's International Seminar at Harvard. Countries across the world were asked to send a writer, a politician, a scientist and so on, as a kind of global School of Athens symposium. There he met a Dutch economist, Frans Winkler, head of a Dutch bank, and they became lifelong friends, appreciating each other's deft conversation on the humour of James Thurber, the poems of Rilke, art, money and the wonders of the new electron microscope. One by one, my father's paintings went to live in the Winklers' elegant house on the outskirts of Amsterdam; and we went too, for our first and only trip abroad, when my father was given a small grant to study Dutch painting, to visit the Rijksmuseum and Rembrandt's house. Our parents drove in shifts from Edinburgh to Harwich to catch the overnight ferry, the vessel opening like a whale to swallow the car, the four of us sleeping in bunks in the deep hull next to the thrumming engines. I never hear Brian Eno's immortal anthem 'The Big Ship', so melancholy and majestic, so soothing and hopeful, moving ever forwards like the tide of time, without being back in that cabin once more, trawling slowly across the Channel towards the Dutch dawn.

Straight out of the port at Hook of Holland, we go to visit two sights. One is Madurodam, advertised in those days as Dutch culture in miniature. I am seven, my brother nine. We wander among model bridges and canals, tiny seventeenth-century houses with diamond-pane windows, courtyards into which we looked down like Gulliver peering into Lilliput. I remember fields of dwarf tulips, clockwork windmills, a Dutch

guide with neat blonde plaits explaining the waterway systems, the futuristic genius of Schiphol airport, the bicycles and dykes and novelty of a new queen, whose palace appeared in miniature not far from a scale model of the Frans Hals Museum, its red-brick almshouses stretching round a cloister of bonsai trees. Look through the windows and you could see thumbnail replicas of Hals's portraits – or could you? Did I really kneel down and hold my eye to the window to see his paintings of drinkers and drapers and diplomats, the cavalier (supposedly) laughing with all his force of personality? Or am I confusing this with a doll's house my mother made, decorated by my father with tiny versions of paintings in balsa-wood frames? I wish I knew now what I saw then, so that I could look down into the past as if it too were a model museum.

In Rotterdam we went to the dark-brick Boijmans Museum where my father was to look at Rembrandt. My mother notes in her diary that we walked through the seventeenth-century galleries to see his beautiful portrait of Titus, looking up from his homework, trying to figure out the answers; so handsome and so perpetually anxious. Soon he will become another hesitant young pupil in Rembrandt's studio. The centre of Titus's face often received so much attention from his father – loving, questioning, revising the paint over and again – that you could, it was said, almost pick these portraits up by the nose. There are other studio assistants – the usual line-up of Bol, Flinck and Dou – and that first self-portrait of Fabritius. So perhaps I saw it. For I stuck tight to my mother's side as a child, always wanting to see what she saw, and what my father saw too, to try to look through my parents' eyes.

In Amsterdam we were amazed to find the shops and houses tiled with blue and white pictures of Holland, from the whole of a landscape to the bleaching fields laid out with linen, the

tulips and the racing skaters. Even the spotless fish and chip shop where we bought apple fritters and cones of mayonnaise for dipping the chips was tiled with these pure, clear images. Every Dutch child could grow up surrounded by wall-to-wall depictions of their own nation, and so it had been for centuries. These pictures were humble, simple, definitive in a very few strokes. At the Rijksmuseum we saw a painting by Pieter de Hooch in which the identical tiles appeared all the way back in 1640: the cow by the water, the bend in the river, the avenue of receding poplars. Almost as soon as Delft began to glaze and fire tiles, Dutch artists began to depict them, slipping these extra pictures into their paintings. De Hooch, in his benign and reverent way, even took it upon himself to imitate the manufacturing method. He scores grids into the wet pigment to mark out the grouting, as if he were laying actual tiles to a wall. Then each miniature square is individually painted, blue over white, and finished with a translucent glaze, exactly like the real tiles in a Delft workshop.

Before me now lies a tile exactly two inches square. It shows a windmill on the edge of a river, beneath a high sky dotted with V-shaped birds. There are tall trees, a low house and the distant arms of a fractional windmill. The clouds are high and vast, grass gives way to reeds by the water, where ripples are indicated with nothing more than undulating lines of blue, darkening to ultramarine. A patch of this river is left white, to indicate the reflected sky above. I treasure this Holland in miniature. It was given to me by the Winklers in a box containing six squares of chocolate all wrapped in paper printed with the same image (or so it seemed). Five squares were real, edible, finite; this was the sixth: the gift of a permanent picture.

And a picture of a painting, as it turns out. I always thought it was just a generic Dutch landscape, but lately I have looked

harder and realised that it is a diminutive reprise of a Jacob van Ruisdael.

I loved his glisk in the National Gallery in Edinburgh and it turned out that Ruisdael painted many others. His very first landscape, made at barely eighteen, is a thrilling play-off between light and dark. A dense, black mass of houses, trees and mills blocks out the setting sun on the right, which suffuses the left of the picture with opalescent radiance. Flakes of golden light glimmer through the leaves. Water lies in bright traces on the darkening fields and, in the murky foreground, a second mother-of-pearl sky appears, reflected and miniaturised bright in a pond. Two figures hurry home before night descends. It is always later than you think.

Ruisdael is a master of the unexpected. He paints the bleaching fields like nobody else. Where others focus light directly on to the strips of white cloth, in a Ruisdael you come up over the brow of a hill and look down upon them in a sunless hollow. The linen looks eerily pale, the workers like spectres in the gloaming.

Clouds go up in staggering diagonals that escalate right out of the frame. A sail far out at sea receives a shaft of light, so you're suddenly zoomed out there to conditions on the ship. There is a huge sunspot in Ruisdael's most famous painting, *Le coup de soleil*, but it falls on nothing in particular, forming a beautiful gold blank in the landscape. And nearby, as if to show the world's infinite variety, some nude bathers are braving a storm-dark river.

The scene feels real and yet ideal, vividly faithful but also half imaginary; Jacob van Ruisdael made things up. He is not known to have travelled beyond the German border, yet there are Swedish waterfalls and Italian ruins in his art. The wildest of all his paintings, *The Jewish Cemetery*, collages a real graveyard with a fiction of rainbows, ravening clouds, black water and stricken oaks. And yet people still persist with that old cliché about Dutch artists that all they ever do is replicate what is in front of their eyes.

Everything Ruisdael painted is charged with the sheer exhilaration of being outdoors in the world, and in his imagination. Constable, who loved his art, and absorbed its lessons, had its essence so well. 'So true, clear, fresh & brisk as champagne . . . it clings to my heart.'

Since I had never travelled anywhere before, nothing I saw had anything with which it could be compared, except for the familiar sights of home. Everything in Holland stands out in memory like a comet. There is the colour orange, which appears in paper cones and hard plastic chairs, in the signage of streets

and museum tickets, in the great roundels of cheese and the curious Hundreds and Thousands we are encouraged to sprinkle on slices of Gouda at our boarding house, then roll up like miniature carpets and eat. There is the plate glass and low-rise modernism of the architecture in the new offices and suburbs, the old Dutch gable façades rising up the sky, step by step, the bright bicycles running up and over Amsterdam's curvaceous little bridges; none of it at all like Edinburgh.

I am bought a velour T-shirt with a white zip that ends at the neck in a bright plastic ring. The colours match those of Delft tiles. My mother has a short Op Art coat. I suppose they had such things in Scotland, but to me these are Dutch fashions, to go with this old-new country where they have Rembrandt and Vermeer but they also invent motorways that run across water, and space-age floor lamps that ascend upwards in white glass moons.

At the Winklers' home, we are served blood-red meat followed by fresh redcurrants on Delft plates and my brother and I hardly know how to eat any of it. A company chauffeur in polarised sunspecs is bidden to drive us across the polders to Volendam, where people apparently still wear clogs as a matter of course and fishing boats dance on sprightly brown waves just as they do in the Rijksmuseum. There, the self-portraits of Rembrandt, from our old book, turn from reproductions into actual paintings.

One Sunday we are walking through Amsterdam in the early-morning silence. The streets are narrow and still. We pass the back entrance of some kind of industrial building and from its shadowy door a man bursts forth clutching a magazine cover, still wet from the press. He sees my brother, then aged nine, and runs straight across the road to give it to this young boy: the first shot of Neil Armstrong in his spacesuit on the craterous grey rubble,

pale against black eternity. The epochal moment is passed on to the future generation by this great-hearted Dutch printer. 'Man op de Maan!' Language glides. Even I know what that means.

The surface of Holland is smooth by comparison, its staggering flatness some kind of aspect of its own modernity. You do not have to trudge up and down hills with the wind whistling up your skirts the way you do in Edinburgh. The paving stones meet; the tiles fit; the beautiful old bricks are perfectly laid. When the driver takes us to a complex of open-air swimming pools, they are as regular as the rectangles of linen laid flat in those painted bleaching fields. What would it look like from far above, half land and half water, this extraordinary place? The bottom of one pool is blue, the next red and the third white: a shimmering Dutch flag.

These pools in the Amsterdam suburbs are intensely exotic because they are outdoors. The heat is spectacular that summer, the moon a fiery peach by night, briefly shattering the association between this country and ice. But visions of winter always seem to prevail, and not only for me. A footnote in my school edition of *Twelfth Night* suggests that Shakespeare had heard tell of the Little Ice Age when he wrote the play around 1602. I love Fabian's great jibe at the lovelorn Sir Andrew Aguecheek: 'you are now sailed into the north of my lady's opinion, where you will hang like an icicle on a Dutchman's beard'.

My brother and I have been commuting up and down the swimming pool for hours, occasionally awarded fritters by my mother. I see her distracted in a deckchair. Suddenly a tannoy clears its throat and everyone freezes, straining to hear. It is my name being called, and that of my brother. We are to come to the lifeguard immediately. Blue water chokes us, and when we reach the man on his towering seat, we are sternly told to get dressed as fast as we can. My father is in hospital. It may be a

heart attack. He is suffering so much pain he cannot speak. At
the immaculate Dutch hospital we wait, and wait, swinging our
legs against orange plastic. Eventually somebody takes us away
to our boarding house, ignorant and frightened. The only sight
I had of my father was of his prone body laid out on a kind of
table, suddenly glimpsed through swinging doors. A crowd of
medics stood around him while he held still, with absolute forti-
tude, eyes closed. Somebody approached his torso with a syringe.

They are the doctors from the postcard, leaning over the
corpse in Dr Tulp's ineffably strange anatomy lesson, staring
hard at the anatomy book as if it were more real than the body.
The flayed hand of the corpse turns palm upwards as if making

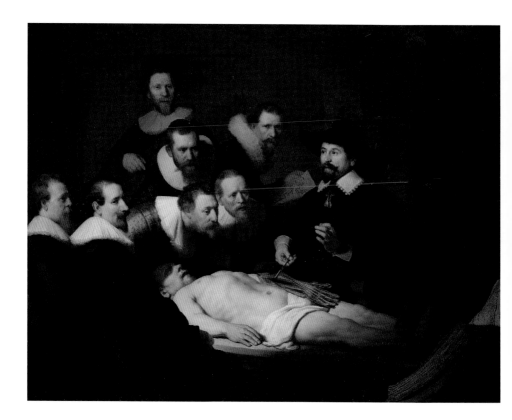

a point, Rembrandt's point, if you like – that only we see the body as if it were an actual human being.

How did my father survive, where was my mother, how long did it take, why did nobody ever say? I know now that he was crippled by an attack of gallstones and that these were somehow made to pass miraculously fast by the doctors in this greatest of nations. How this was achieved I do not know. I don't see him again for several days, as it seems to me, and when I do he is going out to look at Dutch art.

Some days later my brother, mother and I are gliding through the landscape in a silver car driven by the silent chauffeur from the bank. The roads are straight and new, polished by the summer sun. We are going to see the Zuiderzee; the rhyme and rhythm becoming a song as we ride. The driver glances at us in the rear-view mirror, inscrutable behind his dark glasses. In my eight-year-old mind he is some kind of secret policeman.

We drive up through the Beemster, passing close to the village where Fabritius was born, periodically accompanied by the sight of glittering water as the car rolls through the flatlands. Eventually the sea appears on both sides of us and I thrill with fear at this perilous tightrope. We are only inches above a vast and volatile element that could rise up and wash us away, upon which this land seems to float. How is it possible for the road to stay up? How did they build it, this slender strip of concrete stretching out before us with nothing but sea on either side? The chauffeur stops for us to get out, and we too find ourselves walking on water.

The sun beats down on the brown ripples. The chauffeur waves his arms for us to swim, perhaps with the idea that this is the only way we will truly understand this feat of reclamation. My brother and I jump in, thinking it will be something like the swimming pool. We are startled, plunging into darkness then gasping up for air, thick fronds tangling round our thighs to drag us back down. There was no bottom, no purchase for our feet other than the rocky sides of the structure that held up the car and upon which we grazed our knees struggling to get out. People drown in seas, and even in ponds. Does the chauffeur

laugh? He is leaning against the car, smoking, eyes hidden, his head backlit, a dark vignette ringed by the sunlight. We children both remember the sight. It does not occur to me that he speaks no English and we speak no Dutch, therefore he could hardly warn us not to leap. We sit on the road to dry so that his leather seats will not be damp. But he smilingly gestures at us to get in. None of us owns the car.

With what astounding ingenuity the Dutch have created land out of liquid. More than half of the country's surface lies below sea level and yet is somehow solid ground. The Dutch have drained lakes and rivers, tidal inlets and lagoons, poldering land that was once beneath water then damming their polders with dykes. Such attempts they have had to make to predict the rising storms that might overcome the inlets they were trying to drain when they began this great endeavour in the seventeenth century; such incredible ingenuity during decades of war, releasing the floodgates to inundate fields and block marauding armies.

In Middenbeemster there is a statue of Jan Leeghwater – Low-Water – the engineer who supervised the Beemster polder in 1612, the first in the world to be created by draining a lake with the power of windmills alone. A fanciful bronze beard flows down over its ruff in two aptly rushing torrents. Leeghwater is said to have invented a canvas and metal diving bell that allowed him to stay underwater for up to thirty minutes, singing songs and drawing on parchment; a waterproof artist.

One of his contemporaries, the artist Jan van Goyen, looked out over the liquid expanses of the nation's landscape and painted them again and again. Van Goyen is the great waterman of Dutch art. No other artist makes so clear the perpetual proximity of the Dutch to water, the way people stand on the wet verges, or knee-deep in the shallows. The way boats skirt the reeds, or drift close to watching dreamers, their feet invisible

among marshy bulrushes. People sit in fishing smacks, drifting their nets through the water, or lean together in long boats ferrying them across estuaries in an atmosphere of drowsy calm.

Sometimes Van Goyen painted tantalising dunes, the sea implicit just over the sandy horizon; sometimes his luscious brown mud presages a bend in a river just around the corner. But there is always an atmosphere of vaporous moisture. The air is crisper for clear days, when every little speck of brilliance is apparent even at a distance; a more syrupy gold in autumn or winter. But there is scarcely any image by him that doesn't contain – and even seem filled – with actual or airborne water.

People wanted these diaphanous scenes, these watery nowheres. Close study of Dutch inventories, themselves so

detailed, shows that Van Goyen crops up in the collections of Dutch citizens more than any other seventeenth-century artist. Even copies are proudly listed in wills, and forged Van Goyens certainly changed hands. Just over 1,200 paintings survive to this day, and he must have painted many more.

A river landscape, an estuary, a waterfront view of Dordrecht: these are the inventory descriptions; and of course, we might jeer, they are all so alike. If ever you want to think of Dutch art as a commodity, then Van Goyen might be your man. In the National Gallery in London, fully three paintings seem to have the identical composition – magnificent sailboat keeling on the right, pearly water, fishing smack with passengers low down in the water in the foreground on the left: one composition, three variations, and there are many others. But they are never the same in their every lyrical nuance.

Van Goyen was constantly in debt, and always trying to make money. He bought and sold paintings, arranged lotteries, organised auctions; he once speculated on a consignment of tulip bulbs in The Hague, disastrously, paying with 900 guilders and two of his own paintings. When the bulbs arrived next season, their value had plummeted and Van Goyen's fortunes went with them. His art seems to have fallen away for a while, in the late 1630s, as he tried buying land for new houses, some of them even designed by himself. They too failed, possibly because the land was only recently reclaimed: a property development on a flood plain. Yet Van Goyen is heroically resurgent. He returns to painting with ever more sonorous landscapes into his final years. In the 1650s he had to sell his own collection of paintings and yet was still a massive 18,000 guilders in debt when he died in 1656, presumably from all his wild schemes. He left six houses to his widow, but she was forced to sell them, along with practically

everything else. And even then, unbelievably, she lived out her final years in a poorhouse.

Van Goyen came up with the brilliant expedient of eking out his paints with turpentine and then using the dilute substance very sparingly to make more pictures with less paint. And the true beneficiary of this thrift is his art. His paintings of limpid skies over liquid stretches at midday, or seas by twilight, have a mistiness running to white chill in winter, or humid blur in summer, when not a breath stirs the sails of the ships, all of it achieved through this nearly diaphanous paint.

On small strips of canvas, often not more than a few inches high, he was able to conjure immense landscapes stretching away towards a sun sometimes obscured by clouds, so that the viewer is looking directly into soft Dutch light through exiguous layers of paint. These paintings are never just transcriptions of nature; the colours are not brighter in the foreground, as they would be in reality. All is cast in this muted glow, what the Dutch art historian Henri van de Waal called *stemmigheid*, a mood of subduedness. In the late works that I have seen, peace descends upon the scene, as the waters slow to a halt, clouds lie motionless in their mirrored surface and people pause to watch this calmly beautiful world.

A portrait of Jan van Goyen exists, showing an appealing sharpness of humour and intellect. He wears a sweeping black hat and cloak and his body forms a solid dark pyramid against the airy background. The painter turns his head to look at us, open, relaxed and unaffected, with his ever-ready acuity and cheer. It is no stretch to believe that he is a good companion to the man who is painting him that day, so lightly, as if in homage – his fellow artist Gerard ter Borch.

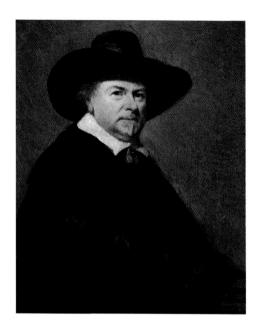

Van Goyen was friends with Ter Borch, who knew Vermeer, who knew De Hooch and so on and on in an ever-widening circle of professional acquaintance and friendship. Yet Carel Fabritius does not appear within it. Apart from Samuel van Hoogstraten's memory of their time with Rembrandt, he is never mentioned anywhere as a living, speaking being, always the silent outsider.

Fabritius seems to live below the level of common knowledge. Nobody even knew when or where he was born until a Dutch historian discovered his name in a Beemster archive in the twentieth century. From the death of his last daughter in 1643 to his departure for Delft seven years later, what he did, where he went or how he made a living is anybody's guess. For years there appear to be no paintings at all, other than a handful of weak mythological scenes quite possibly begun before his young family died. That first great self-portrait bears no date – although it is generally held to be from the year 1648 – as if he didn't care about the passage of time, or its public proclamation, or was talking only to himself.

He surfaces momentarily, just once, in the spring of 1646 acting as godfather at the baptism of his baby sister Cornelia. Fabritius is twenty-four years older than this newborn. He promises to undertake these godly duties standing in the very church where his firstborn is buried beneath a flagstone; Cornelia would have been younger than her own nieces and nephews had they lived. Here he is again, with all his brothers and sisters and their ageing parents who keep on having more children when his have all died, face to face with Reverend Velthusius across the font.

Of his younger brother Barent far more is known. Barent moves to Amsterdam, and then Leiden, where he can hardly rest for commissions and sells so many paintings he is not far behind Van Goyen as the city's most popular living artist. There are numerous Bible scenes and a self-portrait in which he appears dressed as a shepherd, looking down on us as if standing directly above his sheepish flock.

An image in the Louvre of a young painter at his easel is thought to be by Barent – his signature appears on a canvas propped against the wall – and its subject is said to be Johannes, youngest of the three painter brothers. A palette hangs from a nail on the wall, above mock graffiti: a cartoon head, huffing and puffing, done in the red chalk you see in Dutch church interiors where some mischievous child is drawing on the walls. On the floor is a litter of clay pipes, as if the tyro was so absorbed in his work he had dropped them without noticing. Johannes is mainly known for still lifes of eel, whitebait and red-spotter flounder, and this youth is certainly not painting fish. But what strikes is the devoted attention paid to the variegated wall, as if in tribute to their older brother Carel.

Fabritius never joined the painters' Guild of St Luke in Amsterdam, so he could scarcely have been living there during those years, for the closed shop system required membership if he was to sell any art. And there is no record of a Guild membership anywhere else. Amsterdam was close enough to be reached by horse or barge from Middenbeemster, in any case, if he wanted to be connected to painters, or dealers, or models, or the sellers of canvas and pigment. My sense is that Fabritius stayed at home.

At home and perhaps withdrawn in grief or depression, certainly removed from the world in which he had so briefly lived as husband and father. There is no testimony of friendships or connections with other painters; no companionable portraits like Ter Borch's homage to Van Goyen; no requests to estimate paintings, as so often with Golden Age painters (Vermeer, summoned to The Hague to look at some supposed Renaissance masterpieces, famously described them as trash). And there seem to have been only two patrons in all that time, right at the tail end of those years. The first was an Amsterdam silk merchant named Abraham de Potter, lifelong friend of Pieter Carelsz and

godfather to Johannes, who may have contributed to Carel's early picture world, perhaps bringing portfolios of prints to Middenbeemster when he visited, or inviting the family to stay with him in the city.

Abraham de Potter lived in Nes, a narrow old street that is now part of Amsterdam's theatre district. He also owned land in the Beemster. So did Fabritius's only other patron from that time, a member of the immensely rich Deutz family. The Deutzes were dealers in every kind of luxury from nutmeg, cloves and tobacco to taffeta and lace. They imported Italian art, antique busts and Chinese vases and collected paintings with extraordinary rapacity. Rembrandt, himself a collector to the point of financial ruin, bought paintings from the Deutzes; and many of his pupils sold paintings to them, including Jan Lievens, William Drost and Govert Flinck, who is recorded as paying visits to the colossal Deutz home in Amsterdam to see their art after church on Sundays.

The Deutzes had a country estate in the Beemster, where they bred horses and pigs and brewed beer in industrial quantities. Balthasar, one of their eight children, was posted there. His mother's household accounts record a newly discovered payment of 25 guilders 'to Fabritius, painter, for the portrait of my son Balthasar'. The date is 11 July 1650, when Balthasar would have been twenty-four and Fabritius twenty-eight. There is an earlier payment of 78.10 guilders from the previous October, presumably the first of two instalments. Either the Deutz family are late with their final payment, or Fabritius is working slowly, taking over ten months to finish a painting that is now lost, perhaps by accident or through some carelessness on the part of a family so rich they scarcely noticed a Fabritius among the Renaissance portraits. The loss seems grievous considering how few paintings by Fabritius survive, and how haunting this one might have been

at a time when his art was reaching a pitch of intensity and pro-
fundity all at once.

The De Potters were connected to the Deutzes through the
silk trade; and perhaps both families knew Abraham Velthuys
too, fellow cloth merchant and brother of Aeltje. They were all
men of wealth, somewhere between patricians and plutocrats,
philanthropic in their involvement with Amsterdam charities
and guilds. And they all had one man in common: the strug-
gling Fabritius. For whatever the fate of all those paintings in
Velthuys's possession that Fabritius was supposed to sell, accord-
ing to the contract, they clearly did not bring in enough money.
Perhaps Fabritius was no good at selling pictures, was reluctant to
part with them or had run through whatever cash they made (or
indeed, had given it to the Velthuys family). He scarcely seems
to have been above the breadline and in 1649 was the beneficiary
of the large and presumably vital sum of 620 guilders, loaned to
him by Jasper de Potter, Abraham's son.

Every guilder was still outstanding, plus interest, when the two
men renewed the agreement four years later. The contract was gen-
erous and good-hearted, Fabritius required to fulfil his debt 'only
as soon as it was possible for him to do so'. Which would turn out
to be never. So there seems every reason to believe that the great
portrait Fabritius painted of Jasper's father might be inflected with
gratitude for the family's benevolence; and the commission might
have been another way for Abraham to support his old friend's son
in return, to give him deserved patronage and *raison d'être*. What
a painting De Potter got for his kindness either way. This is what
was made, what survives from all these blank years.

Abraham is magnificent, solemn, severe. He sits comfortably
for this young man whom he has known since boyhood, hands
patiently folded over his copious black robes. Around his neck

is a pristine ruff, folded with all the intricacy you might expect from a dealer in expensive fabrics, and painted with the corresponding refinement of an artist paying devoted respect. The face is all eloquence, the heavy lids grown loose with the years, a touch of moisture in the other-worldly eyes. The balding head is majestic with knowledge. His fine dark hair, receding, ripples over the ears and the back of the neck, stray tendrils laid out against the pale wall. Salt and pepper in the beard continues through the moustaches, finely brushed into curls, one of them exquisitely silhouetted against the ruff.

The painting is unhurried, moving through a soft paste here and there, pensive, deliberate, gradually unfolding. It slows the viewing eye to the point of relish and wonder. There is a strange strength to the picture, and to the ruddy freshness and solidity of the face, that seems to have accumulated through slow time. You might think of Édouard Manet.

Abraham de Potter is fifty-six years old in this year of 1649. So runs the inscription. The last digit of the date is hard to read even now. The painting was bought for the Rijksmuseum by the Rembrandt Association in 1892 and was thought, yet again, to be a portrait by Rembrandt. In those days it was darker than it is now, more than a century later, and nobody had noticed – or perhaps been able to make out – a group of marks in the upper-right-hand corner. These only became clear during a bafflingly belated cleaning that revealed the original brushstrokes beneath the old, discoloured varnish. This deep portrait of a prudent man suddenly became a great Fabritius because of the discovery, during conservation, of a painted nail projecting from the plastered wall. A nail that tells you that the picture looks like reality but is yet a perfect illusion. It has no significance beyond itself, speaks of nothing other than the art of painting. It could almost be a trademark.

And what it draws attention to is the inscription and the painter's signature right next to it; the nail pins them to the picture, and the imagination, and of course to the wall. Abraham has a better wall, even, than Fabritius in his own self-portrait. It is an exquisite piece of painting, taupe and gold and with a glassy halation around the figure, and all ending in the upper right, once again, with a fantastic passage of crumbling plaster painted in scumbled brushstrokes. It is as if Fabritius has simply wiped his brush over the surface with suave abandon while somehow conjuring a passage of old plaster. The special effects are all openly declared, yet the illusion is complete.

Another painting is known from that same time. It is the so-called *Family Portrait*, signed and dated by Carel Fabritius in 1648. Some people have guessed that the figures in that enormous picture must have been members of the De Potter or Deutz families. But there is no way of knowing, for Fabritius's grandest project remains a chimera. It showed three generations of figures in the great hall of a house, descending a staircase, playing on the steps, and seated pensively at a desk in the foreground. A ghost of the picture survives in a watercolour sketch and a pencil study, by two different nineteenth-century artists. The sketch was done on the spot, in front of the painting in the Boijmans Museum in Rotterdam; the watercolour was made from memory. The two versions do not correspond; they are the pictorial equivalent of hearsay. But they are all we have, for the painting burned to nothing on a February night in 1864, when a fire tore through the museum. Nobody could find a crucial key. Two-thirds of the paintings were destroyed.

The *Family Portrait* was eight feet wide; *A View of Delft* is barely twelve inches. Fabritius never seems to have worked on the same scale. He painted no similar pictures, had no definitive subject or style, and was invisible as an artist specialising in

fish or flowers, seascapes, ice scenes or seascapes. He could not be discerned in the throng, perhaps; or, to put it more positively, he cannot be pinned down.

There are no more paintings by Fabritius, at least none that survive, if he painted any at all, until after his move to Delft.

My father, who kept a careful record of what he saw on our Dutch trip, makes a note about the portrait of the silk merchant in the Rijksmuseum. It was dark enough in those days, before cleaning, and yet he wonders at it, just as I do, every time I see it. 'Fabritius – Abraham Potter. Modern Eyes.'

TWO

My father was almost forty when I was born. He had all this life of which I knew nothing. And it seems to me that this remarkable span, this first great mystery – what our parents' lives were like before we came into existence – is still almost unknown to me. I knew him, touched his face, held his hand, loved him, rejoiced in his zany humour and his silky black hair, which he used to parody seventies hairspray ads to coruscating effect, all of my ideas of life and art come originally from our conversations. He died in my arms, and yet how can it be that I know so little of his first years?

He was born in 1922 in Dunfermline, in the East Neuk of Fife, as that windy corner of the Scottish coast is known. His father was superintendent of the local swimming baths, his mother a factory worker who went on to have three children over the space of seven years, the youngest born in such traumatic circumstances that he was given the full name of the doctor, John Murray Black, in gratitude for saving both mother and child.

James Cumming was their firstborn, my beloved father Jimmy. He swam a hundred lengths in those baths every morning before High School. Were his discipline not evident from his meticulously beautiful paintings, or his lifelong craving for knowledge – from science and philosophy to art and anatomy – it would be apparent from my bookshelves even now. There are his prizes for Latin and medieval poetry, for geometry, piano and painting, all bearing the High School bookplate. I have the parrot that won him the national competition at the age of eight and the watercolour of the Dunfermline wall, every brick given the attention of a Dutch painting. When he applied to

Edinburgh College of Art at the age of sixteen, his parents took a train across the Forth railway bridge to ask the college principal if this was not a ruinously precarious future, especially if one did not have sufficient talent? He never mentioned this (my mother told me about it half a century later, appalled). He revered them.

No sooner had he started at Edinburgh than war was declared. Like all those boys who lied about their age, he tried to sign up for pilot training straight away. It was two years before he was accepted. His mother was so anxious about his safety, he wrote regularly even when his letters could not be sent from their classified locations; and he kept exquisitely detailed photograph albums for his return home on leave, so that they would see this life out there in the world. They are as immaculate as everything he made, annotated in white ink on black paper; and they are entirely censored. There is no hint of the rape of Burma or the poverty he saw in Calcutta, of bombs tearing through civilian buildings or planes torched before their crew could eject, of the pilots who never came back. He kept it all inside him, with the silent gallantry of the serviceman. I remember only one story, when he turned away with disgust from the sight of our cat in the garden mauling a sparrow. His crew had been sent to shoot a Bengal tiger terrorising a village near their camp. They searched for three days before coming upon the scattered limbs of a baby.

There is a fading photograph of him with his navigator in Terrell: two flyboys, Jimmy on the right, earning their wings over the immense flatlands of Texas.

In America he had a week's leave in New York. 'Museum of Modern Art – Picasso, Matisse, Van Gogh. Ella Fitzgerald at Carnegie Hall. Dutch art at Frick Collection.' He must have seen Ruisdael, Ter Borch and Vermeer, stood before Rembrandt's magisterial self-portrait with those great hammer hands, in

golden tunic, sash and furs. The king of painters, he seems, until you look beneath the velvet hat and see the eyes, watchful, wary, sceptical, keeping up appearances against all kinds of doubt and turmoil. It is 1658. He is verging on bankruptcy, his studio disbanded and his great house about to be sold.

At Terrell, they trained my father and his fellow pilots how to tow gliders full of troops for secret missions. This is how the Allies brought airborne forces into Holland, where the polders were sometimes too marshy and the roads obscured by long avenues of poplars, during Operation Market Garden in 1944. Many Dutch cities were liberated, but the human cost was terrible. My father would one day go with Frans Winkler to visit the receding avenues of British war graves at Arnhem.

His mind was so often up in the air, dreaming, imagining, cogitating, to use a word he loved; watching the planes overhead, waiting for Apollo to land on the moon, for the undreamed-of wonders of the space age. And he would find them later on,

too, beneath the electron microscope, where what is present in the material world, and in our lives on this planet, becomes visible in an airy weightless nowhere beneath the circular lens, a universe made visible through millions of magnifications to the power of our eyes.

After the war, my father went back home to live with his parents, crossing that same bridge from Dunfermline every day. Like other demobbed servicemen, in those grey post-war days when clothes and food were still rationed, and money out of reach, he wore his wartime uniform to paint at the easel. He won a travelling scholarship in the late 1940s. This was a time when other students yearned for the Mediterranean, for the Matisse Chapel in Vence, Picasso's Barcelona, Giotto in Padua. His closest friends went to the South of France. But not my father: he asked for time instead of distance, and went no further than the Outer Hebrides. There he found a croft at the northern end of the Isle of Lewis, where the rain gathered in pools beneath his iron bed and he caught seventeen mice in one record fortnight. The money for two or three months of European art was eked out for twelve, and then for another whole year by teaching art at the village school. The children began to win prizes too, in fact they won a national award and his pride in their achievement was lifelong. There were no galleries on Lewis and barely any images in the kirks. Underpopulation drew the islanders close around the traces of past cultures, which were to be found outdoors in the barren landscape.

He once spoke about it to a Scottish journalist:

I went to an island I'd never seen and a people I'd never known. It seemed to offer unending material and a challenge to translate into paint the character of the Lewis islanders living and working in a land of gneiss rock, flat, wind-exposed, desolate. Seaweed and white sands, pipelines, boats, lochs and inlets,

peat bogs and peat cutters and rolled-up trousers and white sand shoes; herdsmen and animals. I saw pie-hatted musicians in odd clothes playing tin whistles; burnt-out machinery beside a black house; crofters of the Grazings Committee making irrevocable decisions amid wintry laughter. I had visions of curtains opened at 4.30 to let in the cold early-morning sunlight, the gun and last night's bouquet of field flowers lying on a kitchen table.

Callanish was where he lived and painted. It was barely more than a few crofts and a post office, its circular stamp nonetheless so punctiliously impressed upon the correspondence he addressed in pencil, by oil lamp, that the envelopes still look as if they have only just been posted despite the passage of more than seventy years. The village gives its name to the towering figures known in these parts as The Men: the Stones of Callanish, high slabs of ancient gneiss that have watched over the landscape for five millennia, older than Stonehenge and standing in a cruciform arrangement. In his descriptions, they are watchers on the shores of Loch Roag or formidable dark verticals in the gloaming. The present was to him coterminous with the ancient ways of living.

Winter brought extreme isolation and claustrophobia. Towards the end of 1949, he wrote a letter to his friends in France that came to worry them. 'I've hardly stopped working since I came here and all the flesh I had on me when you saw me has disappeared. I've had one cough after another – the island is rotten with damp cold this time of year and there's no exercise, how can one with pouring rain and gales every other day. I suppose I managed to keep fit through the work, and oh my god how I like it.' His friends want him to come straight to France so that they can look after him. His reply holds a self-portrait of the father I knew. 'There's something here and it must be worked

out. I can find no instinct better than this one. And I know of no happier agony than that of creating your mind's picture – it's so slow and you're screaming all the time inside and frustrations pile up. But I will never be able to stop painting now.'

After two years of extreme thrift, the money finally ran to its end and he bought a seat on a Dakota – the very plane he flew in the war – and returned home to Dunfermline again.

The paintings my father made from his time in Lewis continued for almost eighteen years, all the way through meeting and marrying my mother and the arrival of us two children. He was sustained entirely by the memory. Callanish became one of many Lewis names indelibly commemorated in his art to Lowland audiences. I remember the hamlet of Garry-na-Hine – he cycled there once, at two o'clock in the morning, to see if there was any truth in the sightings of spectres at a crossroads (he saw nothing). I remember Breasclete, where the Grazing Committee used to gather between two crofts; and a painting called *The Charred Trolley, Mangersta*. I only have a slide of it now, but its presence holds me: a monochrome of bone-whites and dark greys with a single orange flash as if the trolley were still alight. Mangersta might have been as far away as Iceland or Asia to me, growing up with these paintings, and the hearsay about these places. My father talked about the way the cold and dark reached into his bones, the island atmosphere filling his imagination with premonitory visions. The past was present everywhere and to everyone; and to some people, so were events in the future. He encountered many islanders with the foretelling gift known on Lewis as second sight. They included the minister who wished to be rid of what he regarded as its curse, the carpenter who bleakly knew the dimensions of each coffin before a death had even occurred, the woman with second sight who brought milk to Callanish in an iron urn. There is a painting of her, showing a

vast female head, pale-faced, tormented by her visions, defensive as a hermit crab; and another, titled *Seated Lewis Woman*, where the crofter's feet are deep in the sea, and one far-sighted eye, a planetary circle, rhymes with the all-seeing moon.

My father believed what they said about their strange gift, which defied explanation or logic. It was, to him, simply a very pure form of intuition and he held the islanders in utmost respect. And who is to gainsay the prophetic instincts of others in any case? Ignore them at your risk. I think of the woman in seventeenth-century Delft whose warnings about the lethal gunpowder lying in wait below the streets were disregarded. Women like that are Cassandras, their prophesies fatally unheeded.

Nobody is more associated with second sight in the isles than the so-called Brahan Seer, also known in Gaelic as Coinneach Odhar, or Grey Kenneth. Born in the early seventeenth century near the village of Callanish, his visions foretold the future sometimes whole centuries in advance. There are those who say he never existed; but others claim direct descent from a real man, whose nickname comes from Brahan Castle on the Black Isle, where he worked for the Earl of Seaforth as a labourer. He is said to have had visions of the earl's behaviour abroad in the Netherlands, and later France, where he worked as a spy for the future Charles II. Grey Kenneth is supposed to have met a dark death as a punishment for 'seeing' his employer having an adulterous affair in Paris, for which the Countess of Seaforth had him violently murdered.

There is a myth of origin. According to this legend, the Seer's mother helped a spirit who was lost on earth, like Orpheus, back through his grave in a Lewis cemetery to the safety of the underworld or afterlife. In return, this spirit gave the woman a special gift: foresight for her young son. This part of the story may seem implausible; but those who do not believe in the Brahan Seer have against them his immense body of predictions, which

were passed down the generations for centuries after his death and published as a book in the nineteenth century.

He sees: a black metal horse belching fire and steam through the glens. He sees: the Battle of Culloden, with its terrible harvest of lopped heads. He sees: a vision of a Scottish parliament, come again only when men can walk from England to France. He predicts the Highland Clearances, the building of the Caledonian Canal and quite possibly the discovery of North Sea oil. 'A black rain will bring riches to Aberdeen.' Some of this is a matter of interpretation, and yet his visions are not hard to parse. The metal horse is of course a train.

All of these prophecies take the form of visions – specifically, pictures. The Seer has need of these because he lives in a place without much writing, at a time when very few people can read; pictures will lodge best in memory. And they are unforgettable, as readily imagined as parables – the prodigal son, for instance, or the miracle of Jesus walking on water. There is a great beauty to the Seer's pictures, of skies and glens and rowanberries, of seas and lochs, of crofters tilling the land and trawling their nets through the water. And eventually, when he is somewhere between historic figure and deathless legend, the Brahan Seer becomes a picture himself.

People have to imagine him, for there is no portrait from the life. No matter how various the faces given to him, the hair, the colouring or even the age, the Seer always carries his special attribute – a blue adder stone, a stone with a hole through the centre through which he looks to see his prophesies. He holds it up to his eye, like another eye, and through its circular window the pictures appear. And of all the pictures of the Brahan Seer himself, there is one in which the stone becomes the eye, and it is a vision by my father.

The Brahan Seer wears the stone in my father's eponymous painting, which is more than half the size of life. All the visions he has had and will have in his mysterious existence are held in the polished blue of this eye. The great body moves to the left, yet the head turns, and the eyes look to the right as if he saw something in the past or was noticing something in the future. The clear light in the eye, the flash of white moustache and the silver bonnet seem reflected in a shining metal gorget. He is of the landscape, one with it, made of the island itself.

Of all the Hebrideans my father painted, the Brahan Seer made the greatest demand on his originality and imagination. To be credible in paint, the prophet of Lewis required an iconography, and one far removed from the costume drama that commonly illustrates his legend. He was after all a real person to the islanders; his prophesies are still widely believed.

My father, on Lewis, heard these visions passed down the generations. Black metal seals would show their backs in the waters of the Clyde. Nuclear submarines. Black lightning would destroy European cities. I think of Dresden and Delft. And on the day that Picasso died, I remember my father running down the stairs astonished. The birth and death of the most famous of all modern painters were given, he said, in one of the predictions.

The painting glows, the figure shines, as if surrounded by St Elmo's fire, the great boots grow from the rocky shore. And if one looked at him, eye to eye, through the mist of the Lewis hills, would it turn out that he was really looking at us – seeing all of us far away in the distant future, according to his gift? Who knows. I only have a slide. The painting itself has vanished.

I have tried to find it. I thought it might be in the Netherlands, or America, or somewhere in Scotland. It was last seen at a show in the 1960s. Perhaps it is hanging here in London, where I live, on someone else's walls. I once glimpsed a picture by my

father framed in the upper window of a house as I passed by on a bus, and it suddenly seemed to be leading a separate life of its own, nothing to do with me. Some days this is how he seems to me too, apparently dead for over thirty years but still thinking hard somewhere else. His paintings bring me close, every time I look. I see his mind all around me.

An eye is an orb, filled with light and images. It holds the pictures of our lives. It is the agent of beauty and it is a beautiful thing itself, pointlessly, inexplicably, unnecessarily coloured in billions of variations, nobody knows why. The beautiful eye sees the beautiful eyes.

The eye is even able to see its own intricacies, its own performance, its own white blood cells. Yet we could see so much more if it were differently designed. Even lowly birds can see the ultraviolet in a butterfly's wings as we humans cannot. We have blind spots, although paradoxically we can actually perceive them.

The eye is an extruded part of the brain, drawing whatever it can of the outer world in through the retina to be transformed into neural images. Nowadays, some specialists consider it a part of the mind itself, its freight of information modified by individual cognition, and even in Charles Darwin's day its curious status was sufficiently understood for him to have written that 'the thought of the eye makes me cold all over'. The connection between mind and eye is always there: I see, we say, in acknowledgment of a truth, a fact or an explanation. To see is to know. We see the mind in the eye.

The eye in all its radial beauty is also a picture; a picture in the face. Once there was even a fashion for painting a single eye to stand as a whole portrait, a keepsake of the beloved to hold close about the person. I would give anything for a painting that would let me see even one of my father's eyes again. Photographs can never give me the exact brindling of greens and greys in his irises; the digital camera is too volatile and contingent and cannot resist noting the play of light more than the fixity of hue.

I have to keep the sight of his eyes alive, as we do, through the labours of memory.

He was as extravagantly irritated by opticians' theories of art as I am – that the elongations in an El Greco reflected an astigmatism supposedly visible in the wall-eyes in a painting thought to be a self-portrait. He hated all talk of Monet painting his waterlilies with diaphanous airiness as a consequence of his cataracts, or of the distant blurs in a Renoir as the side effects of myopia. Naturally his great fear was blindness: losing the vital faculty that allowed him to draw and paint, and thus to understand the world. He began to teach himself Braille in his forties, in case such a thing might occur, so that he would at least be able to read.

My father revered Milton, not just for his poetry but because of his endurance of the obliterating darkness that abruptly descended in mid-life. He taught me the passage on blindness from *Samson Agonistes*.

> The Sun to me is dark
> And silent as the Moon,
> When she deserts the night,
> Hid in her vacant interlunar cave.
> Since light so necessary is to life,
> And almost life itself, if it be true
> That light is in the soul,
> She all in every part, why was the sight
> To such a tender ball as the eye confined,
> So obvious and so easy to be quenched,
> And not, as feeling, through all parts diffused,
> That she might look at will through every pore?

For light read sight, almost life itself.

The tender ball was a matter of considerable care. My father

wore a green cellophane visor when he painted at night, to mitigate the yellowness of the electric light. And night was when he mostly painted. He worked all day at the art college to feed his family, came home, took off his work clothes, slept for four hours and then went at it through the small hours. He used to come down from his studio and make breakfast for us children before returning up the Mound to the college.

In the Louvre, once, I was stunned to come across a self-portrait by Chardin, wearing exactly such a visor in the eighteenth century. Chardin, great still-life poet of the ripe cherry and the soft, dead hare, had eyesight so poor he had to use two lenses hooked over his eyes to paint, even from an early age. Yet he was already there with a primitive technology unsurpassed in the twentieth century.

My Dunfermline grandparents had a book called *Better Sight Without Glasses* by a New York scientist named Harry Benjamin. It set forth a system of exercises for every kind of vision defect and my father used to practise them: palming and rolling and massaging the lids and temples, shifting between darkness and light. My sense is that it appealed to his self-discipline, and the notion that he might be in charge of his own destiny. He had long sight and I remember him standing far back from the substrate, as he called the surface of the canvas, staring at it with such attentiveness he did not always notice that I had slipped into the studio. I once saw him hide a cigarette behind his back long after he had supposedly given up, the smoke rising above him in a cartoon question mark.

He used to do something that could not be interrupted which was known to us as laying a glaze. This involved a slow and meticulous wash of acrylic paint, which he somewhat pioneered in post-war Scotland, laid across the substrate with various tools including brushes, rags and a Gillette blade, removed from its

wafer-thin paper package, for razoring off the excess. The glaze would itself be so fine as to be translucent, its colour glowing through the next layer and the next, all underpinned by pivotal details such as stars, nuclei or pinpricks of reflected light. Each had to be perfect, and perfectly dry before he could continue. If anyone rang for him he would sigh so hard the caller could no doubt hear it downstairs on the receiver in our hall. He can't come to the phone just now because he is laying a glaze. It delights me to think of his fulfilling absorption.

The Lewis paintings were loved and praised and everywhere collected. And then, quite suddenly, my father changed course so completely people wondered if the new works were even by the same painter. This change was partly to do with our Dutch trip and the Apollo mission that brought the surface of the moon directly into the sight of the watching world on black and white televisions, its grey dust perceptible beneath a human foot; and it was partly to do with our Edinburgh neighbour, a surgeon at the Royal Infirmary. This man had access to the revelations of the new electron microscope and my father was now able to see infinity in close-up, the macroverse in stupendous miniature, the golden mean that ran through universal laws, vast and small, the atomic particle, the vacuole and the chromosome. His sketchbooks had always been full of connections, the movements of the solar system repeated in the spirals of a fir cone, and so on, but now he could literally see the world in a grain of sand. A microscope extended his vision as well as his sight.

His glazes built up into the most luminous paintings when contemplating what could be seen through the microscope – transparent gold protoplasm, the germinating nuclei of a silver fir seed, fluttering like a bird on blue air, the alphabetical shapes of chromosomes. Organisms scintillate on the surface of his paintings exactly like cells on a slide, or stars glimmering in the night

sky. Gathering and dividing, they breed new forms, and these bio-morphs are all given an energetic character of their own.

In 1970, he painted by far his largest and most jubilant work and I remember it being brought out of the studio like a burst of sunlight: the glowing yellow *Chromosomes II*. Arrays of vital symbols dance on translucent glazes of lemon, chrome and cadmium yellow. And each little figure has larger affinities – moons, animals, faces, the dancing K-shape in the middle, which is both hieroglyph and letter, right at the heart of it all. It is a work of exaltation, in praise of what science had lately revealed: that the universal calligraphy turns out to be present even in the code of human life itself.

I have kept his paints all these decades in their buckled tubes, the gunmetal grey of old shell casings, labels parched but still legible with the names of colours of such redolence to me. Cerulean for the start of the summer holidays, cadmium green for the seventies, orange laque for the Netherlands. They sing of themselves, and of our lives together, even as they mean something quite else in his paintings, uniting in soaring performance.

In later years my father began to paint aerial abstractions of the places he had seen from high above in his Dakota: Indian highways, the gridded fields of the Netherlands, Texas where he had trained as a pilot. Dallas is a joyful circus of geometric arcs and crescents, scarlet and crimson balanced with ochre. Blanched pathways evoke the city's arterial flyovers, and the long sweep of Dealey Plaza. Chromatically, its reverberating colours are tuned to the jazz he heard there during the war. Memory is a picture.

And hanging in my house now is his radiant painting of Laredo, on the Mexican border, as if seen from the skies. The sun seems to be directly above the town, bleaching out all but the street plan. The plaza and its surrounding blocks are a pale lemon, deserted, yet there is also a sense of indoor life and shaded parks in the geometry of darker yellows. The painting is a perfect metaphor for the place – I have been there to see – strips and avenues and baking squares, leading to the bridge that crosses the border.

Elating, uprising, luminous: the colour of light and hope. I used to wonder why there were no remaining yellows among his old paint tubes and it occurs to me now, of course, that they had dwindled to nothing with use.

Chroma: colour. Soma: body. My father's art is a body of colour drawn through the mind and eye. I see him now, removing his glasses to renew his sight with his palms after the long studio night, leaving on the canvas a glory of cobalt, cerulean, gold, all the way to black and white and every yellow.

Seeing is everything. Looking is everything. It was for him, it is for me. If I had no more speech, hearing or movement, I would still have the active life of looking; and the luxury of its replay in my dreams at night. The insatiable longing is constantly and miraculously fulfilled; pure joy, total gratitude. And art increases this looking, gives you other eyes to see with, other ways of seeing, other visions of existence. Art and artists enlarge our world.

One Saturday my daughter is watching me dice butternut squash. What colour is that, she asks? I think she is referring to the evergreen fascination of words for colour, what they define, whether they determine what we see, what they tell us about the people of the past. Ancient Greek has no word for blue (didn't they notice, didn't they care?). Latin comes closer, with the etymology of our cerulean blue, the colour of a high-summer sky to me, though the relationship between hue and word is precarious. Certain Celtic languages make no verbal distinction between green and blue, and the Himba people of Namibia apparently do not perceive any difference at all. We have been discussing this of late. At least the squash isn't blue, I laugh, so much as stark staring orange. Ah, she says sadly, I can only see pink.

A hand of bananas on the table is suddenly pink. A lemon is pink. An ochre mug is a dark pinkish-mauve. Casting about for some kind of immediate reassurance for her eyes and mind, I lay hands on every definitively pink thing I can find. They all range quite securely between baby pink and wine-dark magenta in her perception; even red seems to be safely itself in every variation from scarlet to vermilion. We feel hope. But then her eyes wander to the window and the grass is no longer green. The sky is turquoise, so are the leaves on the trees and even a navy towel. We go on like this for hours, praying for something to change, for some reversion to normality, appalled by the transformation of her entire field of vision. Naturally we end up consulting the internet.

As a child, I was fascinated by some old machines in the museum in Edinburgh's Chamber Street where successive discs

of coloured dots would flap up, like targets in a shooting gallery, to test your vision. The colours were signs of the seventies, as it seemed to me: spew-brown, wilting orange, the avocado of bathroom suites, with spatters of arsenical green. The tests were presented like exhibits inside a glass case and activated via a white Bakelite button. The viewer stared through something like binoculars concealed inside a dark hood, with the instruction to make out a number within this buzzing array of dots. Easy, tantalising – but what if you couldn't distinguish the green from the orange and brown? What if you couldn't see the number 33? Then you were *blind*; or at least blind to colour.

Now even small children can spot the paradox here. Why is it so very important if you see red where others see green? Who says which is which? And where do words enter into it? You were born to see the world this way, *your* way. You could argue over the terminology – you say blue, I say green, or something to that effect, with more or less radical differences. But who determined which colours were which in the first place, as if there were some sort of objective truth? And did it actually matter?

It did to my friend Francis. He did not discover his colour blindness through the fascinating tests devised by Ishihara in 1917, but during his first week at senior school. When the science teacher sent him to the lab to get his green notebook, Francis came back with the wrong one more than once and the teacher hit him with the book. Francis wanted to study science, but the teacher never lost the prejudice that he was some kind of smart alec and wouldn't let him take science A-Levels. He became a writer instead. I am of course deeply glad that he did. But he felt that his responses to colour were never worth mentioning. Another friend who did eventually become a scientist had to take the Ishihara test to become an apprentice engineer, whereupon he was discovered to have red-green colour blindness. He

wonders what the world looks like for other people, and what it would be like if his brain had a dialogue with the world in which colour featured as a significant factor. Visioned people, as he calls them, drive him crazy when they cannot agree about what colour they are seeing. He imagines a kind of twelve-tone system, in which one note on a keyboard does not have a hint of another.

That two people might see or appreciate colours differently seems a truth too obvious to mention. What's your favourite colour is a kindergarten perennial that palls with age. But still our bias remains. A painter friend once declared, disdainfully, that pink was not a colour and I feel the rainbow spectrum of Richard of York Gave Battle in Vain places undue emphasis upon indigo, a colour whose character nobody can agree upon or even readily identify. For a moment, at the outset, I thought it was a trick of the light that cast orange as pink for my daughter, especially since she had paid such scant attention to butternut squash that she really did not know what colour it was supposed to be, and did not favour orange in any case. But the well-remembered colours of familiar objects made us see, so to speak, that she had developed sudden-onset colour blindness.

A traffic light is now red, pink, turquoise instead of red, amber, green. She stares hard at a yellow bag, trying to make it stay yellow in the mind's eye but feeling the abrupt tug to magenta. Every blue or green is turquoise, every orange or yellow is pink. It has a name, this sudden world-shifting phenomenon that has taken hold of her vision. She has a particular kind of blue-yellow colour blindness, so rare they had never come across it at the hospital. It is called tritanopia.

At first the doctors could find nothing to cause this weird condition. They could discover no damage to the optic nerve, no neurological dysfunction. They wondered if her retinas were somehow lacking in dopamine; as if the neurotransmitters were

failing to get the right colour messages across between her eyes and brain. But Thea had her own idea.

She was fifteen at the time, a skygazer, fascinated by comets and stars and the shifting theatre of clouds. She photographs dawn and dusk with spellbound amazement every day and never asks for the beauty to have a meaning beyond itself. All of these records, accumulating by the year, take the form of pictures in the treasury of her mobile phone.

At King's College Hospital, London, they scanned her eyes in improbably vast degree using the sonar specifics of the radar system. Every time she moved her eyes, the radar picked up a million detailed traces. She was to blink, and swivel, and stare. The scans were blown up to the size of a computer screen. And when they examined the images at length they found a tiny black dot on the back of each eye; dots that appeared in exactly the same spot respectively. The surface of the central cones of her eyes had been burned right through, from looking at a very bright light. That very light, of course, was the sun at which she had been staring hard to take a photograph on the day her sight went awry.

Thea even has the photographs that show the moment. The first has a cloud backlit by brilliant rays. A millisecond later, the cloud shifts and the sun beams straight into the magnifying lens of the phone. It becomes exactly what it is, not just the source and sustenance of all life but a stupendously focused laser. She was colour-blinded by the sun.

This solar scorching is called a scotoma. The sun's rays are not only dangerous on bright summer days; it was the light of an overcast March day that permanently burned her retinas. From now on she will confuse the colours of life and some lights will flare too hard. She sees the wrong colours when looking straight on. However, peripheral vision gives a tantalising glimpse of

the past in a very narrow band of undistorted colours ringing the edge of her sight. When she looks at *Chromosomes II*, traces of all my father's brilliant yellows are just there, scintillating at the edge of her vision as she moves her eyes, which she does as a kind of homage. Once, in a dream, the picture reappeared to her in its true colours. Perhaps what we once saw hovers forever in memory. This is what Thea hopes, in her heroic way.

The sun changed her sight in a thunderclap.

Dr Johnson wrote a medical dictionary even before his celebrated dictionary of English, given to me by my father when I left home. The one speaks to the other, and with such a particular feeling for the eye.

> *Sight*: perception by the eye, the sense of seeing.
> 'Oh, loss of sight, of thee I most complain!
> Blind among enemies, O worse than chains,
> Dungeon or beggary, or decrepit age!'

> *Cataract*: a suffusion of the eye, when little clouds, motes and flies seem to float about in the air; when confirmed, the pupil of the eye is either wholly, or in part, covered and shut up with a little thin skin so that the light has no admittance.

Johnson suffered terrible sight almost from birth. Perhaps it was the effect of infant tuberculosis. His left eye was always the weaker. 'The dog', he wrote, 'was never good for much.' None of his friends, not even his own biographer James Boswell, seems to have realised what he endured and Johnson never complained. He was eventually forced to read with the words held very close to his face, just as he is tactlessly portrayed by the painter Sir Joshua Reynolds: peering at a book held scarcely inches from his eyes. Johnson hated the portrait, protesting that 'he would not be known by posterity for his defects . . . I will not be blinking Sam.'

A blinkard: 'One that has bad eyes'.

Johnson refused to wear spectacles most of his life and his landlord observed that the good Doctor's wigs were all scorched around the face from reading too close to candles.

His house in Gough Square in London was famously crammed with visitors who arrived and sometimes remained. Among the semi-permanent guests was a Welsh poet called Anna Williams, who came for tea one afternoon and was still there decades later. She had cataracts in both eyes for which she was treated by the wincingly named Samuel Sharp, a surgeon at Guy's Hospital who had helped the composer Handel. But Sharp did not succeed with Williams. 'The crystalline humor was not sufficiently inspissated,' Johnson wrote, lamenting her fate, which he himself so feared. For Miss Williams became blind and was Johnson's responsibility until her death.

My father and I went to Gough Square in 1990 to see where the great dictionaries were written. We had no inkling that his sight would also fail and that these were the last months of his life. Johnson's epigram remains with me from that day, for it stands for them both.

'It matters not how a man dies, but how he lives.'

Sir Joshua Reynolds, President of the Royal Academy, goes in pomp to Holland. He looks at Dutch art and tries to find something to admire. In Amsterdam, he comes across some paintings by Gerard ter Borch. 'Two fine pictures of Ter-burgh: the white sattin remarkebly [*sic*] well painted.' But Ter Borch does it too often. 'He seldom omitted to introduce a piece of white sattin in his pictures . . .' Worse still are 'dead swans by Weenieux, as fine as possible, I suppose,' he sighs, 'but we did not see less than twenty pictures of dead swans by this painter.' Poor Reynolds, casting fruitlessly about for Dutch paintings to praise. 'As their merit often consists in the truth of representation alone, whatever praise they deserve, whatever pleasure they give when under the eye, they make but a poor figure in description. It is to the eye only that the works of this school are addressed.'

This has been the general bias of foreign commentators pretty much since the seventeenth century, when the French art writer Roger de Piles excoriated the diet of vegetables, fish and dairy which he believed made the Dutch phlegmatic, sneering at these artists who 'would toil with infinite patience on one, usually small, work at a time, generally depicting a base subject'.

His contemporary, the English diplomat Sir William Temple, believed it was the dank and frigid air that made the Dutch more earthbound, their art unambitious and inclined only to imita-tion. Criticism of Dutch painting was so often bizarrely based on climate: low weather, low art. But I have heard curators dispar-age it even now as a brown art of cattle, cartwheels and mud, of peasants and platters, too many flowers and wide skies.

Too many for them, perhaps, but not for me; I cannot get

enough of Dutch art. You can turn to this other world – and it is a picture world as no other, a whole society visualised through time and place, seasons and generations, moment by moment – and live inside it in your thoughts. There is always more of it, and then inexhaustibly more. Every time I think I have seen my last Dutch painting another comes into view, in some old museum or faraway city. I once saw, in a hotel in Algiers, a Dutch still life of redcurrants glinting on a silver dish and was momentarily transported to a long-ago Delft day. Paintings can take you anywhere, but they are also a land in themselves, a society, a place to be.

I specially feel this whenever I see a painting by Gerard ter Borch, whose satin seems the very least of his acute psychological gifts. His art, painting by small painting, is distributed in galleries all over the world and yet it always feels like coming

home. Partly that is because of the recurring cast of models, so recognisable over time as to seem like a family; as indeed they are, the chief protagonist in almost every scene being Gerard's vivid sister Gesina.

Here she is as a young woman sitting at a mirror just as a maid arrives with startling news that may affect whatever she does next. Her expression is exactly on the cusp between self-absorption and realisation, as revealed in the looking glass held up by the servant (played by Moses, youngest of the Ter Borch siblings). Her turning head, her reflected expression: this was such an innovation, front and back views of Gesina all at once, via the mirror, as never before. And now here she is again, distractedly fiddling with a ring, an anxious expression flickering across her face; and again, sitting with a letter in one hand that clearly contains such bewildering news she has become oblivious to the world around her. Without the intimate scenes of Ter Borch, known to him personally as both man and painter, there would have been no Vermeer.

Gesina, in cream and gold, appears in *A Woman Playing a Lute to Two Men*: lively, humorous, keenly performing her role as musician, one foot jauntily parked on a warming box. On the wall behind the two men, one still in his cloak, the other about to sing, is a painting in a gilded frame that strongly resembles this one. On the floor lies a playing card, the Ace of Spades, ominous as the black spot in *Treasure Island*. Take nothing for granted. Is this a music party, or is the man at the table trying to conduct something other than music? However suggestive the scenario, its atmosphere is altogether altered by the vitality of Gesina, with her plucky expression and unflattering hairdo. It is always the same style, and it never suits her: the hair scraped back in a topknot too foolish for her intelligent face, with its slight double chin and pale complexion. She is the most attractively radical

heroine in Dutch art, her blithe spirit nearly undermining Ter Borch's fictions with a complicity you feel they both relished.

Gesina is known to us as few other women of this era partly because she is so present in his art – playing every girl with lute or letter, and sometimes the maidservants too – but also because she was a painter herself. Her own self-portrait is a pearl of a picture: a faint cast in one eye, the weak chin, the upturned nose and the liveliest of looks. If she wasn't concentrating so hard in the mirror, you feel, she would surely be bursting into laughter. She awards herself an expensive Chinese fan, a suave silk dress and a fetching view of trees behind a swagged satin curtain. Accompanied by a witty poem, the watercolour is small and breezy, just brushed on to paper, it seems, in a glance.

Gesina lived in the same house in the same small town of Zwolle all her life. She avoided marriage but is said to have had a long and secret romance. She loves her fellow men and women and always draws them affectionately, as curious creatures passing through the pages of her family albums like figures observed in the street. All of the Ter Borchs are represented in these albums, for this was a family of artists, from the father who taught them right down to the last child, Moses. In the Rijksmuseum hangs a portrait of Moses like no other, painted by Gerard and Gesina together. It shows him very young, head held high, blond hair cascading nearly to his waist, dressed in cloth of golden yellow. By his feet lies the armour Moses had so lately worn in the battle in which he died, aged twenty-two, fighting for the Dutch against the English. This is a posthumous likeness. Moses left several sketches of himself that corroborate the long hair and telltale snub nose in this two-painter memorial, where he remains forever young and alive. (Gesina produced another image of art's triumph over death featuring a woman

working hard at her easel as a skeleton tries, but entirely fails, to get up off the floor.)

All three artists noticed what contemporaries in other countries overlook – moments of unmediated reality, odd side-scenes and casual poses. You see this especially in Gerard's paintings. The way a woman sprawls on the floor with her head in a young man's lap, as if they were watching late-night television, the difficulty of getting the dregs out of a long, narrow glass without banging your nose on the rim, the yank of a child's neck as its mother combs out the hair. And what an amazing painting that is: the child's eye has lost its moorings somewhat, as eyes sometimes do when the hair is pulled right back. He has an apple to hold, to keep his hands and mind busy.

Their art makes me want to be part of the family. The Ter Borchs do everything together. Their painter father is famous for his kindness – for helping and teaching his children, for the loving letter he sends to Gerard when the boy is in England working with his engraver uncle for Charles I. Ter Borch senior ships handkerchiefs, shoes and even his own jointed wooden mannequin over the water from Zwolle. 'Dear child,' he writes, 'I am sending you the mannequin. Use [it] and do not let it stand idle, as it has done here, but draw a lot: large dynamic compositions.' Ter Borch would become one of the most international of Dutch Golden Age painters, working for William of Orange and Cosimo de' Medici, even in the court of Philip IV of Spain, alongside Velázquez. And yet he always comes home.

His originality is strangely overlooked, it seems to me, even though it is everywhere apparent; most particularly in a

tremendous self-portrait of 1668. The rectangle of the picture has become a proscenium frame for the actor, who appears front of stage in a pool of limelight. Standing back from this glow, but with one foot forwards, is the painter, face slightly averted, body entirely concealed in an obliterating black cloak. Everything depends upon that foot, in its black-satin shoe, like a dancer poised to begin, or waiting for applause, static but signalling imminent motion. The foot acts as a pictorial fuse leading the eye all the way up the leg to the riddle of the artist's face. No hands, no arms, no gestures, lips sealed and only this one pointed toe: what a *coup de théâtre*.

I am following in the path of Joshua Reynolds across Holland in a car. Bright dykes criss-cross the low-lying plains, acres of cloud lie motionless above. Other cars passing down parallel avenues of poplars seem to be going much faster than me, like some experiment in relativity, until we suddenly converge. Reynolds hates this terrain. 'Too many strait lines,' he complains, 'bad country for a Landskip painter.'

In Delft he finds very little to detain him. On the journey to Rotterdam he is bewildered by the sight of ships in the meadows – 'you wonder how the devil they got there'. In Amsterdam he is sharply disappointed by Rembrandt's *Night Watch* but concedes that *The Anatomy Lesson* corpse looks properly dead. Out he goes by carriage to the north of the city, struck by the blue and green of certain Beemster houses. Those houses are long gone, but April tulips are showing their timeless colours in yellow, white and scarlet stripes like some great flag spread out across the fields. I realise I am driving, now, along the very motorway taken by the chauffeur in my childhood.

The land approaching the village is a great flat meadow divided into chequerboard squares by roads so narrow that you cannot turn the car. Heron, swan and coot rule the water-filled ditches on either side. The Dutch exported this exemplary grid to the New World in the seventeenth century and it has even been claimed that the Beemster polder is the model for the mighty street plan of New York. Its Mondrian beauty is perhaps only visible to perfection from a plane overhead. I think of my father.

Down below, mist unfurls over the village and its waterways,

so that everything in the landscape appears to consist of moisture. Middenbeemster church rises steeply over the featureless meadows, the spire exactly as Fabritius's father painted it, but softened by the spectral light. Jan Leeghwater's bust remains steadfast and stout on the main street and there are buildings still standing from the earliest days of Middenbeemster, when Pieter Carelsz arrived here to start his new life. But the schoolhouse is long gone and there is not a whisper of Fabritius or his bird.

It seems to me, on this cold spring day, that his life is as scattered as his art. I keep trying to organise the fragments into some kind of shape but nothing is yet coming into view. There is no hint of him in Middenbeemster and the return drive to Amsterdam offers no trace, except for the route. Runstraat is still there, but no archive can yield up the answer to my question about where the sign of the Dutch Garden was in those days. All those people who thought Carel was a carpenter, confused him with Barent, or thought his paintings were by so many other Dutch artists were perhaps not so ridiculous. They were trying to see him through a cloud of unknowing far denser than mist.

And it is not so different in modern times. Fabritius was only ever presented to me as a satellite to Rembrandt: a slide in a Rembrandt art class, an understudy in a Rembrandt exhibition, just another Rembrandt assistant; as a voice only ever heard once in Rembrandt's studio or as the proverbial missing link between Rembrandt and Vermeer, a theory to tidy up art history. And I have a painful memory, all of a sudden, of a night in the National Gallery in London with a camera crew filming after hours for a television programme on self-portraits. We were looking at Rembrandt's painting of himself at thirty-four, magnificent in velvet and furs, one elbow on a ledge, taking his pose from what he had seen of Titian and Dürer. Again and again we homed in on every nuance and brushstroke. But in the darkened gallery behind

us was the self-portrait of Carel Fabritius, outdoors against the sky. We did not think to film him; the other man in the room next door.

What was he to Rembrandt, exactly: assistant, apprentice? According to the old theory, Fabritius just turns up with his new bride to study at Rembrandt's knee and becomes a star pretty much overnight. I cannot see how this can be true. That first picture of Lazarus stirring in the grave, the size of an altarpiece and bearing his signature, was possibly painted as early as the following year. He has already looked so long and hard at the art of Rembrandt that he must have been in that studio much earlier. Surely this is where Fabritius learned to paint; he must have been one of Rembrandt's boy pupils.

The route between Middenbeemster and Amsterdam suggests something more. The distance is only about eighteen miles. He may have married Aeltje in Middenbeemster, but he might have got to know her in Amsterdam, through the connections between the various silk merchants. Her sister lived there, her older brother lived there; it seems to me that Fabritius must have stayed there on and off too.

Almost nothing is known of those final years in Middenbeemster in his late twenties. This would not be unusual, given the lapses in our knowledge of the lives of most Dutch Golden Age painters, but in Fabritius's case the silence always seems strange. There is the portrait of Abraham de Potter in 1649 and the payment for the missing Deutz portrait the following summer, but he scarcely seems to have painted anything else.

Then, all of a sudden, he reappears in Pieter Carelsz's church register in 1650. August 14: Carel Fabritius, widower of Middenbeemster, is betrothed to Agatha van Pruyssen, widow of Amsterdam. Fabritius is marrying again at the age of twenty-eight.

The banns are recorded in her hometown of Delft as well, in

the Oude Kerk register, where Agatha is described as the widow of one Volckerus Vosch. The betrothed are apparently already living there, on the canal-side street known as Oude Delft, which runs straight through the centre of Delft. Nonetheless the marriage takes place, three weeks later, back home in the village church in Middenbeemster.

I can find no trace of Volckerus Vosch, who he was or what he did. But Agatha came from a family of artists. Her father Lambert van Pruyssen was an ivory carver, and his father before him; and when Lambert died in 1653, his inventory contained some further news. Agatha, described in the document as a married woman, has a sister named Maria, unmarried and aged twenty-five. Thirteen paintings by Maria are listed among Lambert's possessions; Maria too is an artist. Or at least she was, and might have been again, for all I can discover, if there was any more evidence of her entirely forgotten existence. The inventory records the dire fact that Maria is 'leggende crancksinnich in St Joris Gasthuis': confined sick in mind in St Joris Hospital in Delft.

Agatha van Pruyssen, widow of Amsterdam; presumably this is where she met Carel, which speaks to the idea that he moved between city and village. It is no stretch to imagine that his future father-in-law had customers in Amsterdam, and that social as well as professional connections came through art. But Delft too was a thriving community for painters. Out of this city came the luminous interiors of Pieter de Hooch, the churches of Emanuel de Witte, the flower paintings of Maria van Oosterwijck and very soon the art of Vermeer. Perhaps Delft would be a new beginning for Fabritius, although it was also financially expedient, since the couple moved in with her father at first. Perhaps if they had stayed there, in Oude Delft on the other side of town, Fabritius would not have died in the explosion.

Art proliferated in the new Dutch Republic as nowhere else and as never before. Somewhere between 1.3 and 1.4 million paintings were produced by between 600 and 700 painters in not quite two decades at the mid-century, according to scholarly calculations; though other estimates run as high as 8 million. And against all the paintings that have survived, by these staggeringly prolific artists, untold others have perished – burned, junked or drowned, like the treasury of Golden Age art lost off Finland in 1771 on its way to Catherine the Great in Russia. Still other paintings are known only through descriptions, wills or etchings and presumably many more have disappeared without any kind of documentation. Given the hundreds of thousands lost, and the millions saved, this is a nation of paintings – a painted nation. I don't know where there is a parallel.

People of all incomes bought art at lotteries, studios and auctions. The English diarist John Evelyn was astonished to see paintings for sale outdoors at the Rotterdam fair. I have seen a sketch of an Amsterdam shop selling books, pictures and what look like rolls of ready canvas, around 1650, by one of the De Bray brothers, an artist family of five. It irresistibly invites a caption. Two gentlemen in cloaks accompanied by their obedient greyhounds stand before a jammed array: which size to hide the cellar damp spot?

For we know, now, that the Dutch hung pictures everywhere. Documents patiently mined by historians in the past only gave hints of the domestic whereabouts of art. But a recent study of Golden Age Leiden goes right inside actual rooms of the houses. A printer has seventy paintings all over his home, from the cellar

to the kitchen and on up to the attic. The physician and scientist Francois de le Boë, otherwise known as Franciscus Sylvius, owns 172 works of art. Among them, and displayed in his best room, is Gerrit Dou's *The Quack Doctor*, which says something about Sylvius's sense of humour. Two vicars and a churchwarden have seventy-five pictures between them; the proprietress of the Target pub sells fifty-two to the local pharmacist; while the innkeeper Aermout Eelbrecht has 102, including eleven by Fabritius; no first name or initial. Alas, they are all now attributed to Barent.

Best of all, because so wonderfully detailed, is the inventory of a wealthy brewer called Hendrick Bugge van Ring, who had a house on the grand canal in Leiden and was an avid collector of Van Goyen. His is the largest collection of all: 237 paintings. In one room alone there were sixty-four, plus twelve chairs, six bookcases, two writing desks, a cabinet and what is described as a prodigiously large table. The pictures must have been frame-to-frame all around the bookcases and up to the ceiling, like those crowded picture galleries amassed by European monarchs at that time. No doubt Bugge van Ring had himself portrayed by some prestigious painter, although I can find no surviving likeness. In my mind's eye he is the colossal brewer in Frans Hals's mighty portrait in the Met: a man of outsize prowess, satin doublet

straining to contain his girth, looking back at us with a shrewd and capable vigour. His hat is so large it has its own planetary halo; the white lace collar could practically cover a table. It is not hard to imagine the awful strength of his grip. From the affable yet undeceived eyes to the reddening jowls, the shaggy hair to the elbow jutting right out of the frame, everything is painted with an apt and equivalent force. The portrait rises to meet the man at every turn.

Dutch art, so treasured at home, soon began to disappear abroad. By the century's end, whole collections had vanished overseas, seascapes washing up in Scandinavia, breakfast pieces disappearing into Britain and Belgium. There are said to be more Dutch pictures in Germany today than in the Netherlands. And more foreigners have seen the country through its art than have ever actually been there; a Dutch landscape means a picture to most people now before it means a real poldered meadow.

The flower piece, the tavern scene, the estuary, with or without skiff, the lady reading a letter, with or without maid: we all know, as with few other cultures, what we are talking about when we speak of Dutch art. Perhaps in part because there is so much of it, the question never ceases to be asked why exactly the Dutch painted what they did. The first mystery in the museum, for some, is why did they paint this lobster, this lemon, or yet another towering vase of blooms; instead of the question why is it *like* this – why is this lobster bizarrely oversized and slithering off the platter, why is this lemon peel unfurling over the side of the table, or this vase standing in a window with a view across the blue-remembered peaks of a fantasy landscape? We might assume that these are specialities, or diversifications devised for the market, or that somebody specifically wanted an exorbitantly

large lobster. Tulip mania is reflected in tulip painting; priceless bulbs in costly pictures; labour-intensive horticulture in painstaking art. The value of a painting is often said to derive from the value of its subject, as if Dutch art were all about commodities. But artists make paintings for all kinds of reasons far beyond the initial commission. Writing of a Dutch still life by Willem Kalf that included a Ming bowl, a Persian rug and a rare nautilus shell incorporated into a golden goblet, Goethe declared: 'One must see this picture in order to understand in what sense art is superior to nature and *what the spirit of man* imparts to objects.' He would choose the picture over the actual gold any day.

The spirit of women, it seems to me, transformed flower painting in seventeenth-century Holland. Take a woodland scene by the marvellously zestful Rachel Ruysch. Spring tulips,

summer lilies, overblown peony roses: none of these flowers would be in bloom at exactly the same time, so that is the first fiction. And what are they all doing growing out here in the woods, with toadstools and red admirals and a distant evening twilight? A cumbersome stag beetle tries to clamber up a rock towards them, but they're not scared. Most comical are the two striped snails on the muddy ground below, ignoring the flowers altogether. One is sulking in its shell, the other exiting stage left as if they've had a row. Imagine adding that to your standard bouquet.

Rachel Ruysch, of the alliterative name and the perfect rhythm: her flower paintings are shot through with humour. She was apprenticed at fifteen and began signing her own work within a year. At twenty-eight, comparatively late, she married a fellow artist and they had ten children together. Ruysch never stopped painting and eventually became court artist to the Elector Palatine, though she was allowed to work from home in The Hague. Her marriage lasted more than fifty years and she was well on her way to a prodigious ninety when she died. We know this, because Ruysch often included her own age, superbly, alongside her signature.

Consider how we commemorate a bouquet nowadays, with not much more than a poxy phone shot which does nothing but store the image on a chip, never to be looked at again. It is absurd to characterise Dutch still life as merely photographic. Maria van Oosterwijck, the most successful woman flower painter of the Netherlands before Ruysch, brought all kinds of props and narratives into her scenarios. She is also the queen of hot colour, her paintings a fiery carnival of orange, scarlet, gold and crimson. The parrot tulips, striped carnations, chrysanthemums and poppies in a magnificent painting in the Mauritshuis burst like flames out of darkness. They are all gathered together in a jug decorated with cherubs foolishly trying to restrain a wild goat. The lid of this jug, removed and placed on the table alongside, takes the form of a statue of Venus, crouching down with one hand slapped to her forehead as she stares upwards in amazement, knocked out by all those flowers.

Oosterwijck was the daughter of a Dutch Reformed clergyman in Delft, so we are generally taught to interpret her works as solemn Christian pronouncements. But this goes against their palpable joie de vivre and wit. She worked for a while with the still-life painter Willem van Aelst, who tried hard to make

her marry him. She refused, and instead raised a child – her orphaned nephew – with the help of a young woman (supposedly a servant, but one wonders) whom she taught to paint and to whom she lovingly left all her worldly goods.

Samuel van Hoogstraten writes that only artists of the lowest category paint flower pieces, and that they are just foot soldiers in the story of art. I notice that he never includes a flower in his scenes; he couldn't hold a posy to Ruysch or Oosterwijck.

Not many people feel the need to ask why Chardin painted peaches or soft dead hares; why Manet painted white lilac or glowing oranges; why Morandi painted congregations of humble bottles and jugs. It sometimes seems to me that a revolution took place with Golden Age Dutch painting so that nobody ever needed to ask such questions of future artists again. But still there is the supposition that all these hundreds of thousands of still lifes were commissioned or bought by the Dutch out of an intense attachment to material possessions. That might be true of tulips, so perishable, so insanely expensive, so hard to recall in all their ephemeral glory, but what about cheap cheese or bread?

I think of a marvellous painting of these trivial comestibles by Clara Peeters: a breakfast roll newly torn from the morning batch, some hunks of Dutch cheese piled upon each other and topped with a dish of butter, the knife laid ready on the bare surface of the wooden table; exactly what we ate in our Dutch boarding house on that first holiday. Isn't this the very definition of unnecessary art – a quick meal, rapidly eaten, a bore to clear away; why would anyone bother to paint breakfast? But the elements are so simple and joyous, the scene so modest yet exhilarating in its knowledge of the salty smoothness of the butter and the crisp crust of the roll, the relish of slicing that knife

down through the ready cheese; a vision of common pleasures enduring through time. Peeters makes philosophy out of a poor man's banquet.

And for me the greatest of these Dutch still-life painters was the one who painted the smallest of portions, and pictures, a humble visionary whose work I came upon entirely by chance as a student.

I had gone to hear the French philosopher Derrida speak at the Modern Languages Faculty. What I remember is not the substance, alas, so much as the experience of perching on a high windowsill, the last spot in a hall jammed with devotees receiving an impeccably difficult lecture from this famous thinker. He was speaking in French, which I had only studied to Higher level in Edinburgh, so my aim in attending must have been more to do with witnessing the historic occasion than advancing my understanding of deconstruction. But it led to a more significant encounter. Ashamed of my poor French, I afterwards slunk straight into the museum next door for the relief of its old art and ancient butterflies. And it was there that I saw a small painting glowing in a gallery dim with shadows.

It showed a bunch of asparagus lying on a shelf, perhaps a dozen spears, running from white to silvery-green at the tips. This humble sheaf, tied up with string, is positioned at a curious tilt. But what strikes first and last is the black and white thunderclap – the obliterating darkness from which these stalks stand out in a light so bright it appears to come from within as well as without. Young asparagus has that pale metallic sheen, as if it had stored up some internal power from growing up out of darkness. But this light was almost supernaturally bright, darting along the edge of the stone shelf like a laser, igniting the nubs and tips and woody root where the blade has sliced right through – such modest vegetables held in such glory.

I cannot recall where the picture hung in those days, except that the asparagus shining out of the seventeenth-century darkness seemed an exact equivalent of the painting's own light in

the gloomy gallery. How it must have lit up some wintry Dutch house. You were not meant to walk on by, but to stop and stare at its radiant presence, the here and now of this asparagus laid out to astound.

Adriaen Coorte: the vowels wouldn't stay in my head. But an after-image remained, a graphic flash in the mind. Had I not been so youthfully scornful of guidebooks, I might have learned that Coorte painted other pictures of vegetables, fruit, occasionally shells, although nobody knew how many, for even so late in the twentieth century his star had yet to rise.

Coorte is somewhere between a shadow and a passing ghost. Even after the tireless searching of scholars, his identity is still scarcely known. Nobody can say for certain when he was born, where he lived or died, though Middelburg in the spit of Zeeland that juts out into the North Sea is the usual assumption. His paintings were made between 1683 and 1707 – the dates are often inscribed on the edge of the stone shelf – with a strange five-year silence that remains unexplained.

Until quite recently the one fixed fact came from that tireless bureaucracy, the local Guild of St Luke's. Coorte was fined for selling paintings in Middelburg market without being a paid-up member. Perhaps he was ignorant of the rules or just trying to dodge them; maybe he did not live there. In the Guild records for 1695, his last name is spelt Coorde and his first name not given, as if perhaps they did not know it (or him). The transgression concerns four oil paintings not much bigger than the palm of your hand. Pure things, still life further distilled to the scale of a small page – which is exactly what Coorte was using.

Paper: so easily scattered and lost, and with it whatever was drawn or painted. One of Coorte's works turned up as recently as 1982 in the archives of a French museum, a slip of paper simply shuffled among the documents. It showed a trio of plums spotlit

on the ledge. The weight of oil paint, a substance that needs a place to seep, to be absorbed, had nothing here but the fragile page, so easily torn or rubbed to a hole. Somebody – not the artist – had glued the paper to a bit of cardboard for strength; tiny creases were visible, which this anonymous person had tried to smooth out with nineteenth-century paste. Another picture of a butterfly, pausing in a beam of light as if suddenly noticing two peaches on the ledge below, was painted on a page torn from the accounts book of a long-dead merchant trading in Gdansk. It was only discovered this century. Used paper changed hands for decent money in those days, though it was still cheaper than canvas. Perhaps it was all Adriaen Coorte could afford; or all he could come by.

Two peaches, three plums, a parade of seashells; his objects are carefully numbered, the relationships between them dramatic and strange. All are staged on this same stone shelf, of which only a section is ever visible, sometimes ending abruptly in mid-air. You never see the rest of the room, never know what lies beyond or below the ledge.

An apricot lingers unnervingly close to the edge. Blackcurrants roll towards it in a darkening tide. Copper-coloured medlars dangle like Christmas decorations from a branch suspended above by some unseen hand, while a dragonfly looks up, startled. Coorte's art is a high-wire performance of tension and magic. And all the elements are presented in such exceptional close-up you feel the artist's presence – his seeing eye – drawn up to the ledge. The stone is often cracked, with a surprising fissure that angles across the surface or drops in a vertical split that rhymes with the frame. Coorte's signature scrolls slowly along the side, a ghost of a name in the encroaching darkness. Something is being expressed here about the poetry and composition of still life.

These paintings are so refined that it is hard to conceive of

Coorte as a Sunday amateur who didn't know the rules. How they are lit is a riddle in itself. Some adjustments of windows and shutters must have been required to send the light of dawn or dusk across the ledge; unless he simply conjured all these effects. His paintings have the character of revelations, of light striking out of darkness.

Coorte himself arrives like a comet from the past; hidden and then emerging from obscurity after a quarter of a millennium. Nobody seems to have known much about him until a one-room show held in Leiden in 1958. His paintings seem to have stayed where they were made, circulating within a narrow radius of Middelburg, passed down through generations of local families until there were no more descendants. Only in the late nineteenth century did any of his works appear on the open market, whereupon a Dutch collector with the melancholy name of Arnoldus des Tombe bought a bundle of asparagus for his home in The Hague. It hung in his drawing room, next to another of his purchases, Vermeer's *Girl with a Pearl Earring*. Des Tombe bequeathed both to the Mauritshuis in 1902. And an architect

who spent more than three decades restoring Middelburg Abbey gave the museum a stupendous painting of five apricots, each an almost incandescent orange, processing bravely towards the cliff-hanger of an edge. One leads out front, the others follow behind, with a single apricot propping up a stem of foliage above, like US marines raising the flag on Iwo Jima.

For me the most startling mobilisation involves a group of shells arranged along the ledge like a corps de ballet in the foot-lights. They are all on tenterhooks. A long spiny shell poised on tiptoe stretches an arm out towards a dainty little red one, as if longing to touch her, or to invite a *pas de deux*. Its spines tick-tack along the stone, like Prufrock's claws at the bottom of

the sea. A pearly conch sounds out its rising music. The eye sees, and it *hears*.

Around a hundred paintings have been found so far; many more than Vermeer, far more than Fabritius. Despite their size they are not miniatures; although Coorte has a miniaturist's eye. Sharp sight, close scrutiny, intense proximity: there is some irreducible connection between them in his work. He does not move far from the edge of the ledge, from these close companions in his small society.

Two local scholars, searching for knowledge in 2015, discovered the coat of arms of a family named Coorde in a seaside village church in Zeeland. Among the documents were three successive Adriaens, including one presumed to be the painter's father. Coorte is recorded as living with his parents in this village until his mother moved to Middelburg on her husband's death. She owned shares in a polder, until it was destroyed in a flood. There is no trace of any gainful employment for Coorte, no documents of tax, inheritance or wealth. He lived a sheltered life, it is clear, and seems to have become a recluse after his mother's death. An older brother, overseas in the navy, sends money home to him. The scholars wonder, with tender insight, whether Coorte might have been limited in his movements, quite possibly in some way disabled.

Perhaps someone helped him reach Middelburg market that day. And it is here that Coorte displays for sale a dazzling painting of two peaches side-lit in deep darkness like two phases of the moon in outer space. The forms are almost abstract in their spherical beauty; a spectacular appreciation of the dip and cleft and firm roundness of fresh peaches, but also of their planetary strangeness. Coorte notes every wen and lagoon – tiny things in life, here made vast by the artist's extremely close scrutiny. They are lunar fruit, marked like the seas and mountains of the moon.

And this is the only true glimpse I can get of Coorte, a man selling the most refined and original paintings, of glowing objects set against pitch-darkness, outdoors in the strong spring light of Middelburg market. Perhaps the paintings are carefully laid out on a table, or he has them in a folder. He stands on the cobbles, beneath the soaring Gothic town hall with its shutters and turrets and statues of the counts and countesses of Zeeland, red and blue in their painted costumes, crowned in gold before the gilding wore off with time's weather, but still shining on that day.

Two hundred and fifty years later, the Luftwaffe bombed the building. Deafening explosions went off all night. Centuries of documents and old paintings were destroyed in May 1940, along with details of the artists who once thrived in Middelburg. If Coorte ever worked there, what he did, when he lived or died, who he was – the paper proof of it was all lost, ash on the wind that night.

There was no postcard of the asparagus to buy at the shop when I was a student. This was a blessing in retrospect, since I was in such a hurtle through life I might have pinned it up and accepted the substitute. Instead I kept going back to the

museum, knowing that Coorte's painting would always be there to unleash its surprise. It never ceases to transfix. His still lifes offer a vision so intense they seem to require no further context, no justification as religious or moral works. Coorte steps free of all this. He does not speak through these humble objects; he paints their pure uniqueness, their free and concentrated presence in this world.

The professor who wrote my report that year took a determined detour from my studies to warn me against always crossing bridges before I reached them, in my haste, especially bridges that did not yet exist. I have remembered her words with gratitude, but alas without much effect. I am still rushing to get it all done before the clock strikes, cannot bear to waste a second of the unknown span of a lifetime, always wondering what is over the horizon, how to solve the future dilemma, never able to separate this moment from the next.

I did not know how to be still, and I hardly do now, except perhaps in front of art. So my gratitude to artists is unending. And to me these paintings by Coorte are life stilled, dense with the time taken to paint them, and the appreciation of what is painted. They are not peaceful so much as pointed, not sedative, but poised in wonderment and awe. They slow my eyes and my thought, and they help with that hardest of all questions – how to live in the here and now.

Still life, where nothing moves and apparently nothing is happening at all. There is no inner life, as with a portrait; no outer narrative, such as a parable or domestic drama. To read the period literature, you would think it the lowest rent of all art forms, right at the bottom after landscapes and animals; just depictions of trivial stuff, nothing even as majestically unchanging as a mountain.

This relegation of still life hits hardest at seventeenth-century Dutch art, not least because there is so much of it. The subject matter of these paintings is always too lowly for critics like Reynolds, who had been on the Grand Tour and witnessed the soaring saints and goddesses of Italian painting. Where was the rhetorical uplift in Dutch art, by comparison, where was the moral or spiritual grandeur? For him, there is no story, no legend, no public exhortation, effectively *no subject* at all. There were just the objects, views and people Dutch painters saw and depicted; and the viewer in turn simply saw (and admired) their depictions; and that was that.

But Dutch still life contains multitudes to anyone with eyes to see it. The snail in its sulk, the ringing sound of the seashell, the bud on the brink of bursting into fireworks, the liveliness of a cricket dancing defiantly close to a skull in a Van Aelst. There are tables laid with a crust and a herring that know what it is to dine alone, or to be grateful for food; and others where the scarlet spirals on a shell or the upward blush of a lily exist almost on the border between art and nature, as if created by God the Painter. There are still lifes that feel like sacraments, or hymns to everyday existence.

Reynolds dismisses Dutch art as addressed only to the eye, not to the mind, heart or spirit. What he finds to praise is the accuracy of illusion, no matter how low-down the content to him. He notices the white satin in the paintings of Gerard ter Borch because it is so expertly depicted as to appeal to our supposed appetite for resemblance. But he does not sense the mood in these scenes, the ambivalence of Gesina playing the part of a lover dreading the opening of a letter, or forced to take part in a musical duet with the overbearing, not to say menacing man in a painting of that name, which we know Reynolds saw in the house of an Amsterdam collector. His remarks about Ter Borch make me think, in protest, of an astounding image made by the Dutch painter when he was young. It shows a man slumped over his horse, possibly even dead in the saddle, seen from behind as they trudge towards a no man's land that might be the edge of this life, or even the next, so apocalyptic is the painter's vision of war.

This painting is not about the way the light sparks off a soldier's armour, or the way a horse's hoof looks from behind, any more than Fabritius's *A View of Delft* is about how many buildings you can see from this spot. It is addressed to our sense of tragedy and the horrors of war.

Even for its admirers, the relationship between art and life in Dutch painting seems bafflingly controversial. It is believed by some to be an almost complete association of reality depicted with reality lived. The art of Coorte alone tells you that this is not true. There are more factual proofs, of course: Ruisdael never went to Sweden. Vermeer shifts the buildings in his *View of Delft*. The tulips in the Delft vase cannot be in bloom at the same time as the roses, at least not in those days before refrigerated lorries. Painters can do what they like and make it all up.

But for the novelist Henry James there is insufficient fiction. Traversing Europe in a series of uncomfortable nineteenth-century

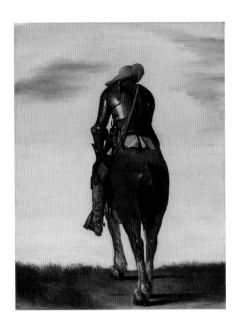

carriages, he eventually reached Holland, where he defines Dutch art to a fault. 'When you are looking at the originals, you seem to be looking at copies; and when you are looking at copies, you seem to be looking at the originals . . . The maidservants in the streets seem to have stepped out of the frame . . . and appear equally well adapted for stepping back in again.' Dutch art is like a reflection in a Dutch canal. It has barely passed through the filter of the imagination.

Yet the maid pouring milk in that sweet session of silent thought, the lunar peaches against outer space, the goldfinch on its perch: each has its transcendent charisma. Nobody who sets eyes on these images believes they are just looking at fruit or birds. The world, in this depiction, is infinitely stranger and greater. But in justice to Henry James, and to Joshua Reynolds, they had not seen any of these works.

So many Dutch painters were unknown outside the Netherlands for centuries after their death. Vermeer, Fabritius,

Hals – some of the greatest of painters – were only rediscovered or revived abroad in the nineteenth and even the twentieth century. This was the golden age of reclamation and Reynolds did not live to see it. He never heard of Fabritius, let alone Coorte, never saw Hals's *Laughing Cavalier* turning his eyes upon us, with their captivating sidelong innuendo, the embroidery on his sleeve an amazing salad of strokes, twisting and twinkling against the copper-coloured cuffs, the lace splintering like ice, and perhaps fragments of that ice in his eyes, for it did not reach Britain until 1865. He never saw Vermeer's *View of Delft*. I imagine him obsessed with the glinting pinpricks all over its surface.

Reynolds was notorious for buying up old masters and stripping back the paint to discover the secrets of how they were made. He owned many works by Rembrandt and even interfered with one of them to drastic effect. To the canvas of Rembrandt's *Susanna and the Elders* he actually added paint, as well as removing it. Large areas of the picture were wiped away using solvents, to be 'updated' with lighter shades that he thought more contemporary. Reynolds also collected the landscapes of Ruisdael, which changed hands all over Europe in the eighteenth century, so that his remarks about the humdrum fidelity of Dutch art (and the straightness of Dutch geography) appear especially hypocritical. But so much depends on what he was able to see. He had no knowledge, for instance, of the dizzying masterpiece by Ruisdael's only pupil that still startles everyone who sees it: *The Avenue at Middelharnis*, by Meindert Hobbema. For this painting stayed where it was made, in the little islanded village of its title, all the way from 1689 until the nineteenth century. Somehow it turned up for auction in Edinburgh in the 1820s and was eventually bought by Sir Robert Peel, twice prime minister of Great Britain.

What an astonishing scene it is: two lines of high alders zooming away to a vanishing point almost of their own creation, a lightning strike of geometry, symmetry and sheer verticality. Effulgent clouds, silver-lined towards the right (is it ever a completely clear day in Dutch art?) drift above the stupendous towering heads of the trees on their slender stems, like gigantic flowers grown up to the full height of the sky. The birds soaring just above are like an extra measurement of their spectacular height; up where the air is clear, up through the stratosphere, so the avenue flies.

Far away in the distance is a sequence of tiny uprights – masts and windmills fringing the horizon; puny verticals compared to the trees. But they indicate shore and sea. And by the sides of the long avenue, dregs of grey water occasionally send up a dull gleam from the ditches. The avenue's dry, rutted clay is familiar from a million summer paths; pale from the seasonal drought. On the right, a gardener cultivates baby trees, infant versions of the grand masters flashing down Hobbema's avenue. This man, blade in mouth, is fixing a stripling, showing you how to lop off the lower stems to get this kind of growth. You can do it with quite ordinary roses, even now, turning them into rose trees; a small but instructive horticultural detail. Hobbema's figures appear properly busy, walking the dog, pausing to talk, planting, working, getting on: inspirational.

Avenues of high poplars and alders measure the land and fringe the skies all over the Netherlands, sending the eye out across the flat planes and far horizons. They are what obscured the terrain in the Second World War and made it vital for the Allies to land troops using gliders. But Hobbema's trees go beyond nature to become a blazing parallax sensation. His blanched-white avenue runs like a landing strip between two stretches of water from which it has been ingeniously recovered. It is the ancestor of all

those reclaimed motorways criss-crossing the Netherlands, of the very road we drove with the chauffeur that day.

No perspective quite like *The Avenue at Middelharnis* had been seen before in Dutch art, and Hobbema never created anything like it again. He gave up painting not very long afterwards, for the more reliable job of tax collecting.

Even in the twentieth century, the idea that Dutch art 'only' represents reality was the crux of a long-running international row. One side argued that Dutch painting is essentially descriptive – as opposed, say, to the narrative art of Italy at that time. It belonged to a visual culture, and it appealed to that culture; to that time and place where instruments for seeing were being invented. This is necessarily a *reductio ad absurdum*. This side opposed (and offended) the committed iconologists, who saw symbols everywhere, and believed that Dutch paintings carried historical meanings, both moral and spiritual, and were not addressed only to the eye.

Certainly this was a visual culture like no other – what proliferation, what permeation, what love of images. Which other nation wanted to portray all of itself in this way, its food and drink and physical conditions, its lovers, its doctors, housewives and drunks? Here is a cashiered soldier trying to keep awake and a housemaid fast asleep. Here is a spider inching up the wall beside a plate of shelled walnuts, a mother carefully combing her child's hair for foreign bodies, a tailor snipping linen, the daily sluicing of a courtyard.

But if these images are never merely descriptive, nor are they made to be read like proverbs. They are paintings, not texts. Yet the iconologists often saw them as a form of utterance through symbol, Protestant exhortations to do better, moralising through cats and dogs and sloppy housework, intimations of our sinful mortality.

Dutch art is always proposing that you get ready to meet your maker, meet your fate, prepare for the grave – or so it is argued. Here is a skull, a guttering candle, a dying carnation; it is all about to end. And yet there is such an opposing vitality to this art. For real death you want Grünewald or Caravaggio or Goya – the drowning dog, the devil, the skeleton pointing to the single word '*Nada*'; not some mouldy cheese or a fading blossom.

Their sense of order and beauty is death-defying, to me; their energy resurgent. Dutch art is a buoyant ship, a rising wave, a soaring tree, dazzling blue ice; an unexpected conversation in a parlour, the echo of light around a whitewashed church, the luminous apricot and the departing soldier, the complexity and strangeness of the world. It is Rembrandt in the night and Fabritius in the shadows. Dutch art: so familiar and yet so unfathomable.

We now are able to see so much of it, so infinitely more than the people of the past. Not just in every kind of reproduction from postcard to phone shot, but even in the comparatively novel advance of the retrospective that reunites all the paintings the artist never once saw in the same building together, allowing us to witness the evolution of a whole career in a morning. This was more or less impossible with Golden Age Dutch artists until the twentieth century, and even later in the case of Fabritius: the first survey didn't take place until 2005. Paintings were brought from as far afield as Los Angeles and Montreal to surround *The Goldfinch* in the Mauritshuis, and such rows ensued that two scholars came almost to blows. All of the known and contested masterpieces (the source of the fury) were together at once, numbering a meagre thirteen. And still Fabritius felt as if he was somewhere else in the forest.

That he was rediscovered at all is mainly due to the efforts of one man, the French journalist and art critic Théophile Thoré-Bürger.

Thoré-Bürger was a supporter of the Socialist Republic who took an active part in the 1830 Revolution. One of his more restrained essays on democracy cost him a year in prison. In 1848 he founded a political journal with the novelist Georges Sand, titled *The True Republic*, which ran for only two editions before it was banned. Thoré-Bürger was condemned to deportation in absentia; for he had already escaped.

This photograph, taken by Nadar sometime in the 1860s, shows the emaciated writer on his return home after nine punishing years of exile. All through this time he had managed to publish articles on politics and painting, mainly under the pseudonym William Bürger – Bürger for citizen, William after Shakespeare. The image carries a charge of the phenomenal energy he holds about himself in those braced arms, and in that powerful head. His eyes are alive to something other than the rival lens of Nadar's camera, still searching through this visible world.

Thoré-Bürger spent his exile roaming through the Low Countries in pursuit of paintings. His exemplary achievement was the revival of Vermeer. It is true that others had been there before him and that he overestimated Vermeer's output, occasionally

confusing him with another painter who happened to be called Jan van der Meer, for which he was criticised back home. Charles Blanc, founder of the *Gazette des Beaux-Arts*, sneered that 'Nowadays, Mr Burger sees Delft just about everywhere.'

But he identified, praised and catalogued more than half of Vermeer's paintings. The rediscovery of Fabritius, however, turned out to be a much harder task. 'The paintings of Fabritius are still more difficult to find than those of Vermeer,' Thoré-Bürger lamented in 1859. 'I do not think the name . . . is mentioned in the catalogue of any museum or collection in Europe.' His fascination began with the chance sighting of a small bird in the collection of a Belgian nobleman in Brussels. Thoré-Bürger never forgot the painting, always wanted to own it and by the most indirect means would eventually manage to acquire it. But *The Goldfinch* was not quite the first Fabritius to be rediscovered. That was a painting still scarcely seen outside its home in the former East Germany; it too required the scrutiny of French eyes.

Around the turn of the millennium, headlines promised an epochal show of Delft painting travelling from New York to London. Naturally it would centre on the 'Sphinx of Delft', in Thoré-Bürger's unshiftable phrase; and naturally that is what we were supposed to be going for. But the exhibition turned out to imitate, somewhat, the circularity of the city itself, a central ring with spreading side streets and alleys peopled by many other painters. And it was in such a backwater that I saw my next Fabritius, hanging on a solitary wall. It was so unlike all the others as to come as a shock; I thought I must have misread the label. But the picture was signed C Fabritius and dated 1654. It showed a lone figure in a corner by a city gate: a soldier slumped on a low wooden bench, one leg sprawled out, boots at half-mast, back to the wall. A musket lies across his lap; perhaps he has been attending to it, perhaps not. A soldier, a sentry, a man supposedly on duty but visibly off-guard; neither awake nor asleep but in some kind of dwalm. Beside him waits an anxious black dog – the opposite of his owner, to whom the animal has now become sentry.

The picture was conspicuously unlike all the other Dutch art around it. It seemed from another world altogether. The man was not obviously Dutch, the city stones around him could have been anywhere, along with the slack boots and the highly polished helmet. The painting of the wall behind the soldier so perfectly imitated the very thing it described – the creaminess of plaster, the fading stains of old whitewash – that it made me think of Fabritius's Spanish contemporary, Velázquez (whose work I do not believe he could ever have seen). Above all, with

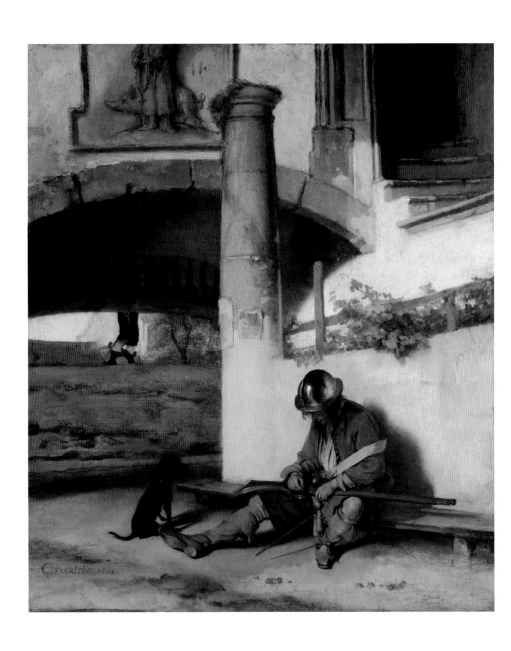

its odd editings and croppings, the painting appears to zoom in quite deliberately on the man, dreaming, turned inwards, almost losing consciousness. He looked like a figure from a future century, from Romantic art; out of his head, and this world.

All around man and dog is the strangest stone labyrinth: a classical pillar crowned with dusty weeds that has clearly lost whatever function it once had; an arch bearing a bizarre cut-off relief of some clerical figure carrying a string of rosary beads, accompanied by a pig with a curly tail. A series of steps above the sentry's head leads to and from nobody knows where. It is a flight of fantasy that seems to prefigure the fantastical masonry of Piranesi.

The Sentry is the most enigmatic of Fabritius's scant few works, especially to anyone hell-bent on comforting symbolic explanations. There is no moral to it; no guffawing or pointing a finger – the guard who drifted off on the watch, while his pet dog does the job. This is not some comical Dutch proverb, or a scene of merry slackers by Jan Steen. It is a different order of Dutch art altogether: atmospheric, existential. But that has not dammed the flood of theories in the slightest, as if it were a riddle and not a painting.

The man in the relief has been identified as St Anthony Abbot, an Egyptian hermit often accompanied by a pet pig, alternately the embodiment of the Devil or a creature he had once healed. But why, then, is his head chopped off? It is speculated that Fabritius, son of the strict Reformed Church, might have had something against Catholic saints. Unless St Anthony is there to draw a sanctimonious contrast between the saint who stayed up all night praying for humanity, and the idler who couldn't keep awake in the day. Then again, if he is a soldier with a gun perhaps he is an emblem of the ever-ready Dutch Republic, newly free from Spanish tyranny; except that he is clearly the very opposite

of alert. And what is he supposed to be guarding, given that the town stretches well beyond this gate? And where is this gate, with the pig and the saint? People have driven all over the Netherlands seeking out every possible Sint Antoniuspoorten, but none fit the bill, and architectural veracity is hardly the point.

None of these interpretations or identifications even begins to explain, let alone acknowledge, the startling mood of *The Sentry*. Fabritius's painting is not just outside time, but ahead of its era. And it turns out to be the work that first made his name, not in seventeenth-century Delft, when Fabritius was alive and it might have helped, but much later in nineteenth-century Paris.

Nobody knows what happened to *The Sentry* after Fabritius signed it, or exactly when that signature disappeared. A hundred years pass before it reappears in the possession of an Amsterdam collector who is selling it, unthinkably, as a Rembrandt. The dealer who buys it makes an even worse guess. He thinks it is by one of Rembrandt's more mediocre pupils, Gerbrand van den Eeckhout, who was in the studio around the same time as Fabritius and who will turn up later selling drawings of Delft blown apart by the Thunderclap.

The first time the picture is seen anywhere in public is in Schwerin in north-eastern Germany in 1755. Duke Christian Ludwig II adds it to the growing collection of Dutch art in his canal-ringed castle. The duke, who employs a court comedian and is so fond of theatre he founds Germany's first acting school, already owns paintings by Avercamp, Hals and Van Goyen, along with a celebrated portrait of Clara the Rhinoceros, who toured Europe for seventeen years. Fortunately, the duke will be long dead by the time Napoleon's troops besiege Schwerin in 1805, storming the city and his castle.

The Sentry was looted, along with so many other masterpieces of European art hauled back to France on carts, often protected

by nothing more than tarpaulin. Restorers in Paris, cleaning the painting for exhibition at the Musée Napoleon, as the Louvre was in those days obsequiously named, made a sudden discovery. Beneath the grime and the over-painting emerged the date, alongside the signature of Carel Fabritius. The painting mesmerised French audiences when it first went on show before the public and the art market responded by reflex. Fabritius's name began to appear in sales catalogues almost immediately, attached to many paintings that were certainly not by him. The French art historian Gault de St Germain remembered the first sighting in a book in 1818. 'Fabritius . . . great painter . . . his rare talents and his fame, which began among us in 1806 . . . with a hunter resting at the foot of an architectural ruin; a picture of striking veracity.'

To see *The Sentry* now you must go to the beautiful yellow-gold museum in Schwerin where the returned picture hangs in a corner, just as it should, away from the black-clad burghers and Dutch horizons. He has a narrow wall to himself, beside an archway into the next space. The arrangement perfectly repeats the central compositional point of the picture: a man alone, cornered, the architecture zooming in on his head-down solitude.

It would all be so different if you could see his eyes, if the scimitar rim of the helmet didn't conceal them by a bare millimetre so that you could deduce their expression. Or would it? Every time I see this painting, I am reminded of another Fabritius – cousin in spirit to this sentry, and to the artist himself, as it seems to me now – a man whose eyes are not concealed: the music man in *A View of Delft*.

Perhaps *The Sentry* was a commission; after all, there are so many pictures of Dutch soldiers idling in inns or readying themselves for the fray as to be nearly a genre in itself. But none are anything like this. And as a commission, it surely far exceeds its

function as a representation of a Dutch sentry at a city gate during the long resistance to the Spanish, over by 1654. Like Gerard ter Borch's soldier riding into the empty distance, slumped over the saddle, exhausted, wounded, a cowboy in a Western, Fabritius's sentry is outside his time, and his task. These gates no longer need to be guarded. That pillar rises to nothing, a billboard for fraying old posters.

People of the past, not knowing who painted the picture, ascribed it to 'The artist AS', interpreting the tiny grey square at the top left of the main poster as a cryptic signature. Even the Paris restorer's catalogue put him down as Karle Fabritius.

Despite the period clothes and the antique weapon, the painting speaks immediately into our present. The man appears stalled, with his downcast face. And the painting puts you on the spot, down there with this withdrawn soul, his exact feelings withheld. Against the depiction of the scene itself – Fabritius's paint a perfect imitation of plaster and masonry, and of warm shadows and energy in soft abeyance – the sentry is so distinct and radical, breeches rucked up to expose one dirty knee, hand poised yet idle, eyes hidden, doing nothing he is paid to do, turning in on himself, a dark figure against a sunlit wall. This is a public painting of inward emotion; a civic guard with a private mind, a man who exists, as we all do, in relation to the world, both within and without. He might be deserter, outsider or anti-hero. Fabritius withholds his story, almost to the point of abstraction.

THREE

Samuel Pepys goes to Delft half a dozen years later, so impatient he 'was with child to see any strange thing'. The young English diarist visits the old church, as he calls it, to see the marble tomb of the war hero Admiral Tromp and then crosses the market square to the new church, passing Vermeer's front door, to visit the tomb of William the Silent. This monument to the nation's assassinated leader, its John F. Kennedy, is a landmark so significant that people travel from all over the country to set eyes on it. Some even commission patriotic pictures of themselves standing beside it. But Pepys pays no attention to the dead William, apparently asleep in nightgown and slippers, or the dog dozing at his feet with half an eye open as if still watching out for his master. The naval administrator in him is more interested in the tomb of Tromp, captured by pirates, enslaved by Corsairs, fearless hero of the Dutch fleet. 'A sea-fight the best cut in marble' is what really catches his eye, 'with the smoake the best expressed that ever I saw in my life.'

Somewhere in Delft that day, perhaps, *The Sentry* is hanging upon somebody's wall. Certainly there are three paintings by Fabritius in Vermeer's house as Pepys passes. But the English diarist never sees or hears of the radical art of Fabritius, or Vermeer. He himself is depicted by old-fashioned London painters, generally sporting a brown three-quarter wig, heavy as his jowls, in antique portraits as lifeless as the wig.

Pepys describes Delft as a 'most sweet town, with bridges and a river in every street'. He is struck by the fact that every pub has a poor-man's box for pennies, to pay whenever drinkers settle a deal. On the way back to his lodgings in The Hague he tries to

chat up a girl on the horse-towed barge: 'Back by water, where a pretty sober Dutch lass sat reading all the way, and I could not fasten any discourse upon her.' The barge service ran twice an hour between The Hague and Delft, taking an hour to arrive. Nowadays you hop on a tram that arrives in minutes outside the walls of Delft, like the pony express in a Western.

What was it like inside a barge? Here's an image.

The old church, the new church, the marketplace and each bridge: it sometimes seems to me that every brick and cobble of Delft appears somewhere in Dutch art. The washed doorstep, the gleaming flagstone, all those strange ascending steps of the Dutch gable roofs that look like stairways to heaven: the paintings praise every inch.

And they home in, closer and closer, picture by picture, starting with the outer city walls in Vermeer's magnificent *View of Delft*. Even as Pepys is crossing the market square, this painting is very possibly in some state of progress. It shows the tower of the new church, where William lies with his marble dog, entirely without bells after the Thunderclap, narrowing the time scale to

around 1660. Some barges are drawn up on the quayside, ready for passengers to alight or disembark. Pepys can take one back to The Hague.

Which is where Vermeer's painting now hangs, in the Maurits-huis, an electrifying presage of the Delft to come for the visitor about to take that journey. Its view of the city is both impossible, because you can never step back into a past where figures in long clothes gather on the sands in all this morning glory, and yet continuously alive, in the present moment, with its vision of a Delft that reverberates forever.

Vermeer's great panorama shines like a dream of paradise across the water. No reproduction, certainly not the postcard of my childhood, can prepare you for the scale of its grandeur, four feet wide. Standing before this sparkling expanse of clouds and canal banks, diamond-pane windows and slate-blue tiles, of steeples, courtyards and alleys, one sees that the whole surface is jewelled with pinpricks of luminous paint that crackle and glow; *pointillés* that rise from the canvas to catch even more light. The sky slows; the shadowy water below lies perfectly still to carry the reflection of its beauty, so astonishingly – so conspicuously – made of pure paint.

To achieve his view, Vermeer had to leave his house in the middle of all those buildings, roughly where the sun strikes down, cross the River Schie and turn to look back across the water from the second or third floor of a building on the opposite bank. There is his Delft, his lifelong city, spread out before him, doubled in the water and witnessed by these surrogate figures beneath a firmament that fills half of the canvas. They make me think of those early astronauts, their feet upon the moon.

This was the masterpiece that drew Marcel Proust out of his cork-lined room in Paris for the last time. He had seen it once

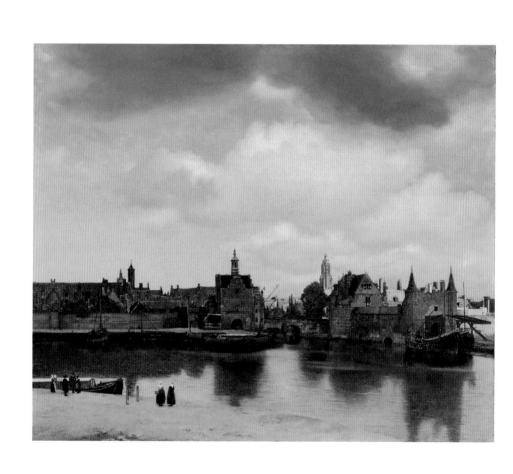

before, on a visit to The Hague in 1902. It was to him 'the most beautiful painting in the world'. Almost twenty years later, suffering from lung disease, he made a shorter but more arduous pilgrimage from his apartment in boulevard Malesherbes, near the Madeleine, across four streets to the Jeu de Paume, where it was appearing on its travels in 1921. A photograph exists in which he holds himself elegant and erect outside the gallery, hoping, he confided to his friends, that he would not ruin the exhibition by expiring inside. This is the last photograph of Proust alive.

In *À la recherche du temps perdu*, Proust puts the novelist Bergotte in exactly the same position; except that Bergotte will actually die, right in front of the *View of Delft*. He experiences a final epiphany as he stares at the '*petit pan de mur jaune*' – the little patch of yellow wall that seems to him to be so transcendently beautiful it makes his own life's work seem dry and diminished. 'I ought to have made my language precious in itself,' he laments, 'like this little patch of yellow wall.' And thus his life ends.

What exactly was Bergotte looking at in these last few seconds of consciousness? For a long time there were disputed candidates for the little patch, some of them not walls, others not obviously yellow; pedantry set in. Yet I believe everyone truly knows. My daughter Thea, on seeing the painting, immediately sensed that it was the brilliant oblong of roof that comes alive in the sunshine, its radiance mysteriously conjured out of salmon and bluish grey as well as yellow, even despite her colour blindness. She can see that several colours are working together, secretly, to make this precious patch of roof, its substance as magically precious as it was to Bergotte. The art matters more than the colour.

Vermeer's *View of Delft* was painted perhaps six years after the Thunderclap. It shows the other side of town, literally and

metaphorically; undamaged and with its Sunday morning stillness, the bright obverse to the disaster. Does it seem so terrible that Bergotte should die with his eyes full of such beauty, silence and calm? This painting, this picture of life, feels like a miracle.

Dutch art enters into Delft through those very archways, wandering among those walls, through those streets, into courtyards and through windows, right into those rooms filled with shifting light, echo chambers of the passing day. It homes in on pitchers of milk, copper bowls, the bird on its perch, the tile, the smallest seed in a loaf. This compact city of bricks, balmy air, twinkling light, peace in the city of William the Silent: it becomes one picture and then another, and another. Delft is a painted city to me.

Arriving by tram, visitors walk straight through the open gates of the Prinsenhof, where William was assassinated, across the courtyard and under the arch that opens into Delft. And within those walls, every window seems to frame a smaller picture. The curtains are drawn back so that you can see each tableau on its ledge. Painted eggs at Easter, summer flowers in blue and white vases, tiers of ochre and orange cheeses, ranged up in towering shop-front ladders, an abstract of pure form and colour. At Christmas the journey to Bethlehem, the nativity, shepherds and wise men bearing gifts are all played out in figurines, scene by scene, candlelit on an icy Dutch night. These windows are exhibitions for the passer-by; sightseeing all year round.

All windows make pictures for the eye, framing views of the world, turning outside and inside into landscape or interior. The appeal is impossible to resist. Growing up, my brother and I used to wait for the moment when the presenters of the television programme *Play School* would pause before three windows and invite us to guess – with the illusion of choosing – which one we would pass through today. Square, arched and round, each was

the Platonic ideal of a window, set in a freestanding screen and perfectly lit to cast its shadow in latticed negative on the wall. White and wafer-thin, they were so captivating that generations of children felt an irreducible joy when their favourite window was chosen. A camera, possibly hand-held, then approached the window, getting ever closer, until it seemed to cross the threshold into another world. What lay beyond was entirely invisible until, by some editorial intervention, a film or illustrated story gradually materialised. Whatever we saw, however, was made more magical by this visual device: so simple, and so imaginative, touching on our human affinity for windows. It seems inevitable to me, now, that my favourite shape was round.

Our instinct for windows is pure and universal. Who hasn't stood before a window looking out, fascinated by the configuration of life it presents, as if it were the chosen view of some discriminating eye? Open a door and the mind immediately seeks the window in the room: what will it reveal, and how much? I remember a schoolteacher telling us about the Scottish poet William Soutar, confined to bed from his twenties with an incurable illness. His father took a hammer and enlarged the window of the bedroom in their stone cottage so that he could see more of the ever-changing world. Soutar was still writing poetry until his early death in 1943. *Diaries of a Dying Man* is the name of his book.

To walk through the streets of Delft is to feel this pleasure redoubled: here is the world, and then smaller views of it, framed, as you look through arches into inner courtyards, through doorways into cobbled passages, into the windows of houses. Perhaps this is why I so much cherished the postcard given to me in childhood by our family doctor: Pieter de Hooch's strange indoor-outdoor courtyard which turned the city into secret rooms.

All of De Hooch's art turns upon the human urge to look through apertures into the world beyond; to see what the window

reveals, glance over a threshold into another room, look through a doorway into a garden, hall or courtyard: to see more of life pictured. The instinct is there from our earliest days and De Hooch understands it so profoundly, this desire to see what is through *there*, in part the subject of *The Courtyard of a House in Delft*.

First there is the amazing verisimilitude: the brickwork lying in its separate courses, the paint exactly imitating mortar; the dusty blue of the weeds and ivy, the clear light of the street; then the wonderful set of rhyming shapes – the scarlet shutter on one side, its wooden counterpart on the other; the oval window in the stonework and its glass twin in the hallway, the recession of arch inside arch inside arch that takes the eye right through the corridor and out into the streets of Delft.

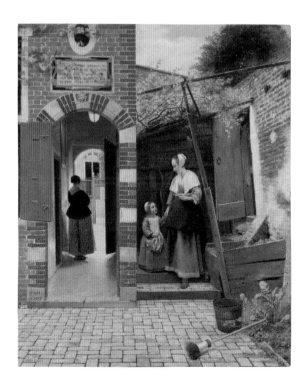

Everything is shipshape, everything fits together, so that you think of the making of the house and the making of the painting simultaneously. What is beautiful to look at must have been beautiful to paint. All those angles on the right – beam, shutter, box and broom, all running in exact parallels. Even if you only wanted to see behind the façade of a house in Delft there would be all this and more. Such a tender relationship between woman and child, eyes joined, hand in hand; such a vision of blue sky and scudding cloud so neatly partitioned; the immaculate sweeping of the courtyard, corridor and street, and of the light cleansing the scene just as the women have cleaned their surroundings. And these two women are like the figures in a weather house, opposed and yet connected, each within an arch facing outwards – one into the courtyard and its confines, the other into Delft and its light.

De Hooch was born in Rotterdam (his father, perfectly, a bricklayer). He came to Delft in 1652 at the age of around twenty-three and more or less pioneered the ideal home, so to speak, as a new subject for Dutch art. Women are the stars of his pictures, no matter that their domesticity may seem invidious to modern eyes. For they create all this order, they preserve the perfect peace and cleanliness; and the beneficent light in De Hooch's art illuminates all their herculean labours. Light polishes the flagons they have washed, twinkles in the water sluicing from their courtyard pails, sweeps across newly wiped tiles, the flawless glass in the windows, the sheen of a waxed wooden table.

A wonderful scene in the Wallace Collection shows a mother with an apple performing the all-in-one peeling trick that everyone loves, including her watching child: a tiny everyday miracle to compare with the celestial light that streams through the immaculate (and perfectly painted) window. The word *schoon* means both clean and beautiful in Dutch.

His rooms are sometimes conceived like Chinese boxes; you look from foreground shadows into a middle room where sunshine ricochets in patches of brilliant light around the walls, and then out into the dazzling blue yonder through a half-open door. And all these doors, floors and windows have a geometrical abstraction to prefigure his compatriot Mondrian. His paintings are like a secret refuge, offering the possibility of calm, of ideal forms and beauty, of a perfectible world.

De Hooch is younger than Fabritius and older than Vermeer so is invariably slotted in between the two, by scholars, because they all overlap for a time in Delft. He is supposed to have learned from Fabritius for no more substantial reason than that they arrived in town the same year. And he is supposed to have taught Vermeer, who certainly looked hard at his art. He is often dunned by comparison. It is true that his figures can be clumsy, occasionally oversized. A sweet-faced woman recurs in his paintings, always slightly too large for her surroundings. Perhaps the model was close to him, in all respects, conceivably his own wife.

But De Hooch doesn't just show you the perfect home and its inner workings. He turns the inside out. People sit in doorways talking to passers-by. Courtyards become outdoor rooms. Families drink and dine in gardens; do their laundry and even their cooking in backyards. The alley running up the side of a house has no door to conceal it. It is as if we have passed through a wall or a window; what is usually hidden is revealed.

And it is possible to come round a corner and find Delft opening out as in the art of no other painter. Men suddenly appear at the end of long streets, children play in side alleys, women bleach linen on grass patches between the houses. There is even a painting that leaves town altogether. *Maid with a Bucket and Broom in a Courtyard* is all grace and symmetry. The distant blue spires, framed in a doorway leading out of the courtyard,

are possibly the new and the old churches of Delft. But who knows, for it all seems like a dream. The gentle dappling of the brushwork has nothing to do with the supposed exactitude of Dutch art; it seems entirely of itself, and experimental, a kind of advance Impressionism.

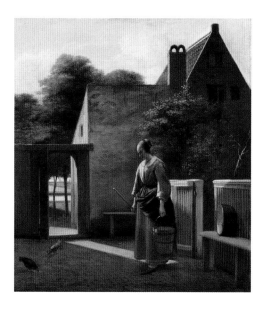

The maid's pail is blessed by the sunlight filtering through the open door. A copper bowl stands propped on its side, its shining interior turned like an eye to the light, taking the sun into itself, but also watching the view. Isn't that exactly what eyes do? A faint seam of light glows enticingly through the gap between the door and its frame. The courtyard is immaculately clean. (Foreigners used to say that the Dutch even sponged their cows.) And then consider how much of the painting is wall: a beautiful piece of plastering, here and there coming away in patches that seem like tiny clouds, rhyming with those above in the sky. Paradise is here and now, on earth.

Of De Hooch, it was always recorded that he died in a madhouse. And people claimed they could see it, could detect the insanity in these beautiful, lucid, unpressurised paintings. But in the twenty-first century, historians realised that it was not the artist who had died deranged but his son of the same name. A sad document was discovered recording the boy's tragic committal by his parents, who are unable to understand his mind or see how to help him any more. As for Pieter the painter, his wife died not long afterwards and he raised their remaining six children on his own. He is known to have left Delft for Amsterdam at some point, where he lodged well outside the city walls. Either he painted less and less, from his mid-forties onwards, or his pictures have disappeared. Nobody knows what became of this gentle mind. De Hooch's name just fades away.

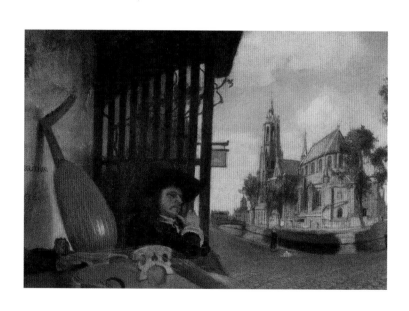

Fabritius in Delft is a bird of a feather. There are artists in almost every street. Just over the bridge from his first home on Oude Delft is Jan Steen's brewery, The Snake, and further along the street live two famous flower painters, three still-life painters and the *vanitas* master Harmen Steenwyck, who paints bizarrely jaunty skulls. The bookseller who would later write Fabritius's one brief obituary lived at number 93 on that canal-side street, and just behind number 143 is the newly arrived Pieter de Hooch. Fabritius only has to leave the house, turn right and walk past a dozen front doors to reach the home of the prominent surgeon Dr Theodorus Vallensis, upon whose ceiling he will one day paint a mural.

He crosses the market square to get to the new church, passing the inn owned by Vermeer's father, where the teenage painter is learning his craft. He can get to the old church for evensong along the canal in moments. The centre of Delft is so small, step by step, over the cobbles and narrow bridges, that it is impossible to believe that all of these painters – so many of them, crammed into these modest brick houses – could have been strangers to one another.

To picture Fabritius in Delft you only have to think of his music man seated at the junction of three ways, the new church rising up above the little bridge that spans the canal before him. If the artist did not arrive from Middenbeemster by road – still unpaved, often impassable, certainly more expensive – then he too reached his new life on a succession of waterways and just such a crowded barge from The Hague as Pepys. A little stretch of water glimmers in the picture, holding reflections of the banks

around it. But Fabritius's view looks nothing like any other painting of Delft. You know where you are, to be sure; the landmarks are all there, the same spires visible in so many Golden Age pictures, the church containing the tomb of William the Silent right at the centre, but a sense of Fabritius's way of thinking enters into everything. He cannot paint even so much as a side street in Delft without making it appear transfixingly strange.

His scene arrives on the canvas like a vision in the instrument seller's head, somewhere he might one day go in a dream. Behind him ten dark planks form a vertical screen, hemming him in. What's beyond them is almost impossible to make out, except for the jutting sign of the inn with its drifting swan. The lute leans against a wall, like the wall in *The Sentry*, like the wall in the first self-portrait. And there again, meticulously painted on that cold surface, is the same set of capital letters, C FABRITIUS, and below it the date, 1652, two years before this cityscape will be torn apart by the Thunderclap.

A View in Delft, A View of Delft, A Delft Street: the title of this picture has wandered. It is strange that titles are such a recent tradition, when you consider their potential for significantly altering the view, as it were. But since it began changing hands in the nineteenth century, nobody has much cared about the title so long as it identifies the location as Delft. The painting has only very recently acquired a subtitle – 'with a Musical Instrument Seller's Stall' – still alluding to place over person, and oddly sure of the man's profession. For it seems to me now, so many years after I first saw it, and all the paintings by Fabritius since, that the instrument seller is a man of mind and refinement. He has surely made these instruments himself, just as Fabritius made this painting. The affinity feels apparent and profound.

But none of this is the point to scholars of art. What the painting was *for* seems more important than what it shows.

A View of Delft is significant to them as an example of that rare object, the seventeenth-century perspective box. Fabritius paints his scene, mounts it on copper, bends it into a bowed semicircle and fixes it inside a triangular box. The viewer puts one eye to a hole, looks inside and encounters a miniature Delft. The church, streets, table, musical instruments and all would have fallen into perspective, every distortion resolved. Or perhaps not.

This optical experience is still possible with another work in the National Gallery. Samuel van Hoogstraten's peepshow presents the illusion of a Dutch interior inside a large wooden cabinet. What you see through the hole is strangely unsatisfactory, however, irresistibly inviting criticism of the strength of the illusion from the start. Is this a persuasive three-dimensional vision of a woman lying asleep in bed while another woman sits reading across a chequerboard hallway? The image is no longer a work of art so much as a fairground attraction, a thrill that never quite hits.

Hoogstraten's cabinet can be taken apart, and of course that is a primary urge, like wanting to break into a kaleidoscope to

find out what the coloured fragments actually look like in the palm of your hand. What you see in this case is a sequence of painted flats, like the elements of a stage set, angled to create the appearance of rooms opening out of each other. Hoogstraten deliberately left one side open, in any case, to reveal his calculated achievements; he was always something of a show-off.

Only six Dutch perspective boxes have survived. What happened to all the others: knocked to the floor, dented, junked? A curious child prizes the box apart to see how it's done and the pictures are lost with the magic. These boxes are of their time; John Evelyn records the rush to Rotterdam to see one in 1656. But the fashion fades, especially when artful juxtapositions of organ pipes and chequerboard floors no longer appeal. Once you have appreciated the illusion, the optics, the manipulation of perspective, they're over.

Fabritius's *A View of Delft* is art of another order altogether. Art historians have argued for years about its method, shape and function; what it would have looked like, how it would have worked in a box. The conservator who cleaned it in the 1990s dreamed of gently curving it back into shape and fitting it inside a replica contraption, with a paper roof to diffuse the light. Enclosed on all sides, inside its own little microclimate, the painting would have been entirely invisible except when museum visitors queued in line to put one eye to the peephole.

But what difference would it make if the *View* were part of a peepshow? There is certain evidence that it was. Minute traces of copper were found on the back and there is a slight vertical crease in the centre as if it had been bent. The paint would have been very young when this was done, lightly creasing rather than cracking: just what the conservator saw and expected. Perhaps the base of the box might even have been painted with a continuation of the vendor's table for extra effect, the form turning a

physical corner but remaining continuous to the eye. If all these theories are true, this would have been the most ingenious peepshow ever made, since the others generally involve anamorphic distortions on a flat plane, never a curved surface. And monocular too – involving only one eye, technically all the more sophisticated. How cunningly conceived, how artfully executed, what skill: its cleverness would have received the first (and possibly the last) praise. But to see it out in the open, entirely visible, is fully to enter into its spell.

All of these theories can be modelled on computers; and even using far less sophisticated methods. Photocopy *A View of Delft*, curve the paper to the right degree of concavity and you have some sense of the way it resolves. The difference is negligible in my experience. I have walked round and round the junction of these little streets in Delft to find the exact point where the man is sitting; and to find the spot where Fabritius might be standing to paint this view. It is all still there. Nothing has changed, except that there are now shops selling sports shoes and sushi. The façades are otherwise the same and the great church rises, just as it once did, now holding in its vaults not just William the Silent but all the dead kings and queens of the Netherlands ever since. It is possible to see everything just as he paints it, with scarcely any distortion, except for the evanescent atmosphere of a dream.

Fabritius is praised for his ingeniously curved and calculated perspective, the way the painting must have forced the eye to rove from left to right in its socket. But this is the case with or without a box; our sight sweeps all around the scene, back and forth between the shadows and the sunny side of the street, between the loner and the prospect. And this has nothing to do with optical experiments, with the eye as a compliant puppet, the painter its master, tugging the nerves. We see with so much more than our sight.

Whoever freed the painting from its box also released it, mercifully, from its limiting function as a trick. For the spell of *A View of Delft* has far more to do with the man in the shadows. Nobody writes about him, so still and dark, on the wrong side of this brightly beautiful city; and yet he could stand as our surrogate, pensive before the scene. Fabritius puts us on his side of life, a human being contained in thought, a world in himself. No apparatus can change that. Whatever its supposed function, the image goes far beyond it.

The painting is small, oblique, easily missed among the galleries of Dutch art. It has moved around over the years, but it never shifts in my head. It is like a seer's dream, a vision materialising as if through an adder stone, floating in mind and memory.

Fabritius has married again and is deeper in debt. There are further loans to come, more money to repay, yet he does not seem to make any discernible living. He doesn't join the local Guild of St Luke for two years, so he cannot easily be selling art in the city. There are traces of praise, here and there, for 'perspective' paintings by him; and more than one mural is mentioned after his death. Agatha would declare in writing that her husband once worked for the House of Orange: a royal commission, according to her notarised document acknowledging a debt of 1,200 guilders to her sister Maria, presumably now released from hospital. So perhaps Fabritius was out of town, making paintings for the walls or ceilings of these grand manor houses in the countryside outside Delft. But there is no mention of him in any of the meticulous lists of payments to painters. If Fabritius ever worked for such famous patrons, all trace of whatever he made has gone from the face of the earth. But two years after his removal to the city, and whatever else he did or did not do in between, Fabritius was painting *A View of Delft*.

The names of Delft premises are forever associated with Delft painters. Willem van Aelst lived in The Savoy Arms, Leonaert Bramer in The Danzig Arms, a painter called Willem Delff in The Longbow. The Blue Dog, the Golden Head, The Claw and Gilded Crowbar all at one time accommodated seventeenth-century Dutch artists, some of whom set scenes of drinking, singing and card-playing in these hospitable interiors. Bills for bed and board might occasionally be repaid with paintings.

And it is, alas, through such debts that Fabritius surfaces again. There is no way of knowing exactly what he painted, or

when, during his last four years; and there is no record of any children being born to the new marriage. But there are odd scraps of paper, bar bills, legal contracts and witness statements that indicate where he went and the kind of company he kept. Fabritius appears as a living presence in Delft, however fleetingly, as he never did back home in Middenbeemster.

In May 1651, he is appointed guardian to two small children orphaned by the death of their father, a pub landlord in the centre of town. His co-guardian is a fellow painter. The novelist Brigid Brophy once published the generous suggestion that Fabritius might have painted *The Goldfinch* to amuse these poor children. The following October, a businessman loans him 200 guilders. Two months later, the widow of a deceased vintner declares him to be still in debt to the tune of 5 guilders and 3 stivers for French wine. In the spring of 1653, the loan made by Jasper de Potter has accrued so much interest that another document is drawn up in which Fabritius promises to pay it all off, or at least a part of it, through the sale of 'a large painting at present hanging in Delft town hall'. Except that his right to sell that work is in dispute. The painting is a seascape, upon which three different artists have worked, including Fabritius, who is supposed to have conceived the original composition, laying in the under-drawing himself. That argument will continue long after his death.

A touching deposition records a conversation that took place in the fish market in Delft in the summer of 1666 between the two remaining artists and the youngest of Abraham de Potter's sons who believes that he has actually purchased three-quarters of this painting, bearing the hand of Fabritius, on behalf of his family. Here the paper trail ceases, along with the seascape, which has almost inevitably disappeared.

At some unknown date between 1651 and 1653, Fabritius and

his wife moved out of the family home on Oude Delft and into a more modest area of the city named after the Doel, or shooting gallery, where target practice took place for the local militia among others. Fabritius took a house on Doelenstraat, where the dwellings were small enough to be described in the town archives as cottages. One of his neighbours there was the painter Egbert van der Poel, who specialised in what can only be described as disaster art – fatal fires and terrible storms, generally raging by night. Their street was narrow and convivial; it still is, the front doors open even in winter, chairs permanently fixed to the pavement outside. The two painters were certainly acquainted, and perhaps even friends. For in the summer of 1653, Fabritius acts as witness to yet another of those classic IOU notes in which artists promise to pay up for food and drink. Van der Poel solemnly declares that he will honour his bar bill at The Golden Fleece within four months, in part by painting pictures for the innkeeper.

About the Guild of St Luke, delays in joining were hardly uncommon. Plenty of artists couldn't stump up the membership fees, and could not sell their work to make that money as a consequence, a Catch-22 sometimes solved by part payments. Pieter de Hooch, for instance, did not register on arrival in Delft for another fifteen months and only paid half the fees. Vermeer never paid the second tranche. But the Guild rules were strict and it is not easy to imagine exactly how Fabritius managed to keep going for two years without becoming a member. Perhaps the Van Pruyssens had money; or perhaps he had some himself, at least for a while. He painted *The Sentry* and *A View of Delft*; there is mention of a double portrait of a fellow painter and his wife, so perhaps he painted others. We know he left at least two murals.

Fabritius associated with quite humble painters in Delft: Egbert van der Poel, the local church painter Pieter Leendertsz van der Vin, Daniel Vosmaer, who worked on the seascape. All

were jobbing painters, turning out work to pay their way. Art history, with its perpetual war on uniqueness – the idea that any artist could ever be a true one-off; the conviction that all artists must be connected, one to the next, in a constant chain of influence – believes in more elevated connections for Fabritius. He is described as 'the missing link' between Rembrandt and Vermeer. It is true that he studied with the former, and that his works would one day be owned by the latter. But there is no evidence that Fabritius taught Vermeer, who was his junior by a decade and of a higher social echelon. And it seems to me that Fabritius shucks off the influence of Rembrandt very early in his career.

Eventually, Fabritius would pay half of his Guild dues: the sum of 12 guilders. It is a figure of ironic significance. For the only other record of a civic payment comes two years later, in July 1654, and involves exactly the same sum. He is recorded as receiving a payment from the burgomasters' coffers for 'one large and several small town arms': in short, basic town signage. A meagre commission for such a great painter, and for this drudgery Fabritius was paid exactly the 12 guilders he had once owed. In all the ledgers of payments made by the city of Delft to its painters in the decades between 1640 and 1660, this is easily, and agonisingly, the smallest.

The last time his name appears in writing is in late September 1654. Fabritius owes 110 guilders for food and drink to Dirck Jansz Colijn at his local inn, the Doel. Picture the sign of the target above the door. A schoolmaster called Steyn stands as witness to the note. Fabritius is going to pay it all back, he promises, within three weeks. But he never will.

My parents had no money when they married in 1953. Who does? Penury among artists is normal. My father taught art at public evening classes; their friends worked as life models or providing occupational therapy in hospitals. One returned home to mind the cows on her parents' farm. My mother taught art to a handful of rich girls hidden behind the long walls of Oxenfoord Castle School, a long bus ride outside Edinburgh, until she managed to get a job inside the city at John Watson's School. The room where she taught – and was sacked for accidentally breaking the plaster cast of a Michelangelo hand – is now the director's office of the Scottish National Gallery of Modern Art.

When she had children, and stopped working, in the custom of the times, my father's income as a part-time lecturer was all they had and it was never quite enough. My mother's diaries run across more than fifty years, and until quite late in the evening of her life money was a constant fear. There are entries that perfectly coincide with my own memory, specifically of her attending Red Cross classes for what seemed to be season upon season, with a view to some kind of paid work. Learning to bandage, learning to splint, learning to apply pressure to a wound, which is exactly what was needed when the man who came to lop branches from our sycamore tree had an accident with the chainsaw. My mother had to hold his thumb back on, while staunching the blood until the ambulance arrived. We waited so anxiously to hear if he got his thumb back, and with it his livelihood. We never knew.

And then one day – as the entries are growing more financially anxious, and my mother is going over and over the white

account book they kept with so much precision that I still have it for its immaculate beauty, all the colours and the asterisks, all my father's ink numbers and underlinings, so Dutch in its record of every single thing, the taxes paid, the alarming fragility of the old car, the first jersey she buys him that isn't black or navy (with his white collar and dark jersey, he was always Dutch) – I come across this stark entry. 'Go through the books with J. There is no money. But at least I am now able to apply for the job of auxiliary nurse at the Royal Infirmary.'

She fails to get the job. But two days later, the news comes that an American for some reason passing through Edinburgh has bought two of my father's paintings, and the mercury instantly runs the other way; until the next time.

And still it is the same for painters. Nothing in the absurd world of blue-chip galleries, super-collectors and millionaire artists can possibly alter everyday living for most artists. Still now there is the painful calculation, where the price of the painting is only just above the cost of the materials. Artists give away their art; it used to cause me seizures of anguish to see my father doing this all the time. Here, have this, in gratitude to you for helping with something, for being gracious, or – worst of all – for buying an earlier painting. My parents carried themselves with so much humility. I wanted, as progeny do, for them to leap above this economy of kindness, for collectors to treasure everything they ever made.

Canvas was always expensive. The history of art is full of images hidden beneath other images in order to recycle a stretch of this precious fabric. Paintings made on pieces of wood, reused, remade; paintings on trays and bits of old lino. This so-called Golden Age of Dutch art is marked by punishing thrift and financial catastrophe. Hercules Seghers, who could not sell his deeply enigmatic etchings, hacked the metal plates to pieces in

despair, prophesying that the time would come when collectors would pay four times what he had asked for the whole plate just for one print. Which is precisely what happened, predictably too late for him. Seghers began to drown his sorrows, or so the old story goes, and returning from the inn one night fell down the stairs to his death.

Dutch painters are always in debt, verging on destitution: Van Goyen, De Hooch, Fabritius, Vermeer, Rembrandt above all. They aren't generally born into poverty. It was too expensive to pay an artist to train your child, so most painters came from domestic stability. But it is easy to see how it all goes off track. Bad weather, the passing seasons, low daylight in the long winter months, unending war. Vermeer's widow, in her petition, says her husband 'during the recent war with the King of France, a few years ago now, had been able to earn very little or hardly anything at all, but also because the works that he had bought and with which he was trading had to be sold at a great loss in order to feed his aforementioned eleven children'. His patron, Pieter van Ruijven, who had lent Vermeer money to pay for everything from slow time to priceless ultramarine, and who probably bought the majority of his paintings, had himself died unexpectedly the previous year.

The still-life painter Evert van Aelst, once so successful that his pictures were collected everywhere, was renting rooms from a tailor when he died. He left little more than a bed, some clothes, his brushes and an easel. His better-known nephew Willem, who once lived four doors from Fabritius and was always trying to get Maria van Oosterwijck to marry him, thought it not worth the cost of travelling from Amsterdam to collect these poor items. He simply repudiated the will instead. Frans Hals endured the humiliation of having his possessions bailiffed from out of his own house because of an unpaid baker's bill. A decade

later, in his eighties, he was granted a pathetic one-off payment of 50 guilders from the burgomasters of Haarlem, plus an annual pension of 150 guilders: so small it was less than the baker's bill.

In those days – though when has this ever changed – artists needed another string to their bow. Gerrit Lundens tried to run a bar in Amsterdam, and failed. Pietro de Potter invested in a gilt-leather factory, and failed. Pieter de Hooch was employed as a '*dienaar*', or servant, by the linen merchant Justus de la Grange in Delft. Jan Victors, a religious painter, ended up with a job as 'comforter of the sick' aboard a ship bound for the Dutch East Indies, where he simply disappears; a Red Cross job.

Most tragic of all is Emanuel de Witte, who was living on the very street where the music man sits when Fabritius first arrived in Delft. De Witte had a long career in the city that began to go awry with the death of his first wife. He remarried, disastrously, and moved to Amsterdam, where he wandered from one address to another. His stepdaughter was arrested for theft, and his second wife banished for co-conspiracy. The terrible fate of this great painter, in old age, is directly related to poverty and debt.

Sunday in Delft and light fills the clerestory, washing the bare walls of the church. Sun streams across the nave, projecting glowing window shapes on the opposite walls. In this box of pure whiteness, the black squares and diamonds of old coats of arms hang from the pillars like Russian icons, or abstract paintings. Men in cloaks stand like chess pieces, listening in silence; children crouch over toys; dogs come and go. Occasionally someone prays, or bends over a Bible. But mainly there is the amazingly beautiful performance of sunlight, shifting, filtering, dappling, or fixed in a golden burst that you know will subside or disappear in an instant, behind a pillar, or outside behind Dutch clouds. No artist gets that transience – that cinema flicker – into the scene like Emanuel de Witte.

He painted the great churches of Delft for ten years, then Amsterdam for another twenty and more. He stared at these canyons of light and dark, with their high windows and tall pulpits and bare flagons, among which people wander like dazed tourists, or to which they repair for sermons as if they were at social gatherings. It seems a compulsion to vie with Monet among his lilies or Cézanne constantly returning to the great baked rock of Mont St-Victoire. De Witte had some church commissions, it is true, and possibly a few civic patrons, but nothing quite explains the long sequence of these interiors, so full of the redemptive grace of sunlight, so attentive to the little human beings far below the soaring windows, with their hazy prospects of another world beyond, so attentive to the atmosphere and air between them.

De Witte painted actual tourists – those who came to visit the Nieuwe Kerk in Delft to stand before the shrine of William

the Silent, heroic father of the nation, the man who had with-stood the Spanish, who had led the Dutch against the cruelty of the Inquisition only to be murdered in his own residence on his way downstairs after a genial dinner with Rembrandt's father-in-law. The bullet holes are still there in a wall of the Prinsenhof. You could put your finger into them, in the past, feel the force of the blast in the pocked plaster, imagine the death of William of Orange, *pater patria*, as he was known, the first leader in history to be killed with a handgun.

His body was buried in Delft because it could not be taken to Breda, like all the leaders before him; Spain was still in control there. The tomb was at first a modest construction, apt for this taciturn man; but it grew a lot grander when Hendrick de Keyser designed a vast mausoleum to surround it. Dutch monarchs have been buried there ever since. People still take phone shots of their families standing by the tomb: we're here. The shrine is a destination.

And this is exactly what De Witte shows in his *View of the Tomb of William the Silent*. Here is a tourist in a red cloak making an extravagant gesture with his outstretched hand, showing off history to his heedless young wife who turns her attention, instead, to an urchin pleading for money. And here is a faithful greyhound, taken to visit the dead hero, behaving with perfect obedience. The black squares, in all that puritan whiteness, are like covered faces.

The windows are so clear you can see the exact shape of the buildings outside. A gentleman in a turban leans over the guard-rail, listening, as the whole story is told to him too. Gold sparkles here and there. The light is as bright as a spring day.

In the Metropolitan Museum, De Witte's children are drawing on the church walls; a dog urinates, another scarpers across the aisle. All appears secular except for the incredibly beautiful

scarlet-stained light: the soft tinge of ecclesiastical evening. In the Thyssen Museum in Madrid, they are digging a grave directly out of the stone flagons. I suppose you are to think of death, but the morning sun, igniting a man's white collar in the foreground, a column in the middle distance and the faraway pillars behind the choir stalls, leads the eye away like a song trailing through the picture.

The paintings glide round and round these interiors, up through the arches, in and out of the aisles, and from every angle. Preachers are seen from the front, the side, even behind, dark silhouettes against the white walls. Congregations circulate. There are curious nooks where people sit, and once or twice the old woman reading the Bible from Rembrandt appears, in miniature, deep in the good book, with its reflective glow, contained in the parameters of her bonnet. The man in the red cloak reappears like Everyman staring up at the altar, the rib vaults and Gothic arches, at peace and in wonder.

Sunshine moves through these churches, leaving its fluttering imprint on the floor and walls, shimmering through the aisles, passing among the pillars through the sessions of twilight. Some of these paintings – shrivelled in reproduction, glorious in actuality – have the feel of massive solid forms almost melting in translucent air. You could live there forever in that slow stopped time, the light gradually shifting through all of its seasons and hours. The church is a faraway land of light.

De Witte was born in the small city of Alkmaar, a few miles from Middenbeemster, around 1616. His first teacher was his father, a schoolmaster like Pieter Carelsz Fabritius. He was also a pupil of poor Evert van Aelst, who died in such poverty in Delft. De Witte painted myths, parables and eventually the churches for which he is best known, but he also painted contemporary

reality as if it was happening right now. A painting of a busy fish market shows the morning's catch laid out in all its scaly wetness, gills agape, still possibly half-alive. A woman asks the price of that fish there, the stallholder tries to sell her everything else. Behind them, a ship is just setting off from the quay; more bream and seabass to come.

It could be a thriving Victorian port, down to its fishy details, breezy tarpaulins and voluminous skirts. The buyer is a red-cheeked, gingery Dutch woman in a slightly tarnished velvet jacket and sure enough, in all its force of personality, this is a commissioned portrait. It shows Mrs Joris de Wijs, wife of De Witte's landlord, circa 1662. Later, De Witte will move out of their house in a fury – or so it is said – and into the house of another patron, Hendrick van Streeck, who wanted to be taught how to paint churches, thus eating up the artist's time. De Witte's life was filled with trouble.

You can buy a reproduction of *The New Fish Market in Amsterdam* from a press agency these days, with a stock caption. 'Women vendors in a Dutch fish stall sell an abundant variety of types and sizes.' It is as if this were a reportage shot. And to some extent, that was De Witte's other forte: from scenes of the Amsterdam stock exchange to the market stalls of Delft, bringing you the news of the day.

He was a restless shifter between cities. He moved from Alkmaar to Rotterdam to Delft, met a woman, had a baby, got married one year later. Not long afterwards he was widowed. In Amsterdam he married again, to a young woman who already had a daughter. Both women received heavy punishments in 1659 for stealing from the neighbours. His stepdaughter was incarcerated in the notorious Spinhuis reformatory, her mother banished from Amsterdam for six years. De Witte never lived with them again.

At this point he moved in with Joris de Wijs, lawyer and collector, and was given free bed and board plus 800 guilders a year to surrender everything he could paint. When he finally managed to get out of this arrangement, nothing more than indentured servitude, De Witte spirited four paintings away with him, including the fish market portrait. Mrs de Wijs sued, successfully, but the artist is said to have duped her by returning a copy and not the original. A tall story, given the time and money required to turn out a facsimile, but perhaps it is true. Period anecdotes certainly depict De Witte as a man harassed, sharp-tongued, depressive, put-upon and openly annoyed by innocent interruptions in the churches where he worked.

De Witte never had a fixed abode again. The time with his pupil, Hendrick van Streek, was unhappy and insecure and only the existence of forty and more paintings of the Oude Kerk in Amsterdam, steadily succeeding each other, year after year, show that the artist was consistently living in the city. In the perishing January of 1692, when his latest landlord insisted on rent the artist could not pay, the two men argued. De Witte went out into the night and through the darkness to the Korsjespoort Bridge, where he tried to hang himself. The rope snapped, and he plunged into the canal below. Somewhere between the moment of his drowning in the black waters and the deepening and darkening of night, ice set in so hard that his body was trapped beneath the surface.

Such detailed records were kept of the weather during the Little Ice Age that scientists have been able to corroborate the truth of this horrifying fate. There was no letup until the end of February, when rain brought a thaw. De Witte's body was discovered at a canal lock, suddenly visible through the melting ice.

*

There is a painting in Cleveland that seems to exceed all others in its balance of grace and austerity. It is late De Witte, and it is also late in the day. So calm, so pristine, everything takes the eye upwards so beautifully through the church, white on white, in the gentle evening light. Dogs rest, contentedly. There is no more strife.

It is not quite a real church, but a half-imagined place. The Gothic architecture is no longer to the fore, and almost bypassed, as you look directly across the church to the great rose window. As if it was at last time for De Witte to give himself up completely to the one sustained beauty – light, filtering through the windows, arriving with slow grace on the walls in these radiant screens that you know are about to vanish.

There is no congregation, no gathering, no hint of a sermon. Two men are quietly talking. Very small figures are observed on a bench far away beneath the soaring window: a picture of light, transparency and grace. And then there is the passage of light through another window streaming across to meet the light from this one. And most wonderful of all, the dappled form outside: a tree, or something like the impression of a tree, as a kind of celestial nature – hazy, spectral and remote. The colours are so beautifully laid there, faint evening warmth, the world slowing down, the silence deepening. Barely any colour beyond variegated greys, here and there a faint golden line indicating a shining chandelier or the glow held inside the panels of the choir stalls upstairs. I want to be there, in that place where late-afternoon rays steal across the floor and the world outside is as soft as a dream. De Witte has become Prospero. His labours now are ended.

How can it be that a man so rootless and unhappy, so remote from the pristine calm of this place, could have created such a lucid and exalted vision; and that he does so time and again? I suppose this is the miracle of art, and the nobility of those who make it: the transcending of all private suffering.

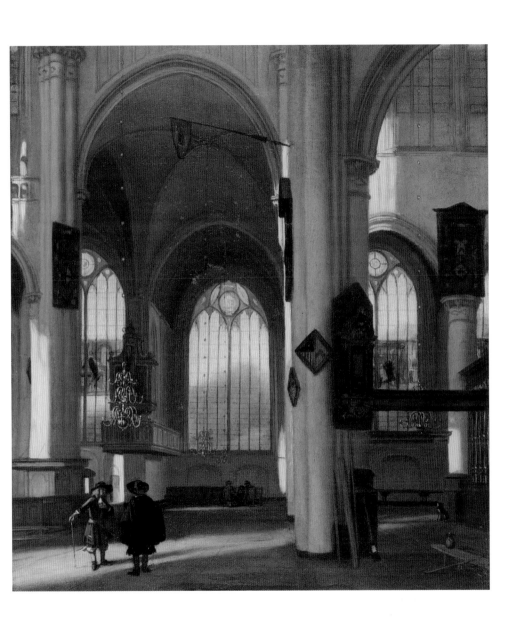

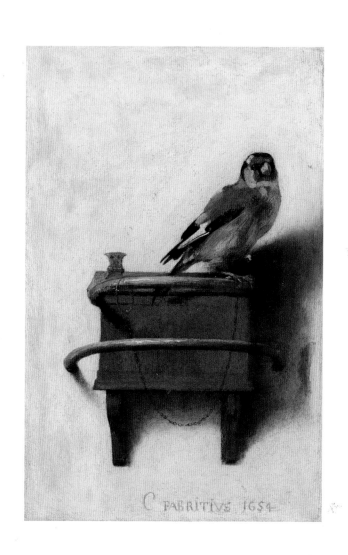

The first sight of *The Goldfinch* is abrupt and austere. The little bird appears on its perch, so quick and alert, dark against the wall that receives its hovering shadow. One eye glistens as it turns its head out of profile towards you. You must not disturb the millisecond in which this winged creature looks straight at you, eye to eye, and yet of course it can never fly away. It takes a moment to notice the chain around its leg. So delicate as to be almost imperceptible, this chain is viciously cruel, tethering the bird to the spot. The beauty of the painting is in equal tension with its almost unbearable poignancy: the captive bird so enigmatic, a mortal being made apparent to us for all time yet forever imprisoned by the chain (and the picture frame). There is not another painting like it.

Fabritius's goldfinch is an adult male with a soft reddish-brown head, a glittering eye and a lightning flash of yellow on its wing. It has gone as far as it can towards the right edge of the ledge, and the picture. There it turns back to look at you in a frisson of noticing, and being noticed. This is no generalised bird of the sort in those days kept for pets, and then depicted in supposedly amusing paintings in which they perform the trick of drawing water from their own little well with a tiny cup on a chain. This bird has a specific force of personality, an air of solitude and sorrow, a living being looking out at another living being from its prison against the wall. This painting is a portrait.

The contraption on which it sits is like an opera box with brass balcony railings; except that the bird is the spectacle and not the spectator. And there is no performance. The goldfinch is not singing, fiddling with its chain or trying to get away. It is

shackled there for the rest of time. The painting alludes to some offstage tyrant who has jailed the bird for pleasure. It reminds me of the starling in Laurence Sterne's *A Sentimental Journey* which cries out the same song, continuously, from its cage: 'I can't get out, I can't get out.' The narrator, Reverend Yorick, tries to open the cage door, the bird pressing its breast against the bars all the while, but he fails. Yorick knows that he is witnessing slavery.

Anyone who has ever seen goldfinches fluttering and chattering and alighting on seedheads in meadows, or watched them bumbling through the thistledown they love, will know why the word charm was chosen for their collective noun. A charm of goldfinches soars at dusk, swoops at dawn, sings upliftingly in summer trees. In flight, the yellow stripe spreads into a golden cape. They startle and captivate, and their quick intelligence seems to have a parallel in that flash. Chrome, cadmium, daffodil, aureolin, the last sometimes known as cobalt yellow and used to paint an angel's halo: everyone has a different name for the colour they perceive. In the gallery, where the bird's shadow flitters against the white wall, the yellow stripe glows at a distance. It is painted with a long-lost colour called lead-tin-yellow, made using an oxide that produced an opaque and saturated brilliance. But lead-tin-yellow, so often used in Delft for the peel of a lemon or a woman's velvet jacket, was potentially poisonous if ingested. Nobody makes it now. It has disappeared from art and from memory.

In the Mauritshuis, where it hangs, the goldfinch is alone and unfree in Fabritius's profoundly tender painting, a small miracle issuing from his modest house in Doelenstraat. His signature appears with the date at the bottom: C Fabritius, 1654, painted with characteristic delicacy. Directly below, a brass plaque nailed to the heavy frame repeats that same date. 1654: the year of the painting, the death of its maker.

The Goldfinch is painted on a wooden panel, recycled, to which Fabritius made various adjustments involving dowels and nails. They are all given in the art-historical record. Scholars have speculated that the panel was meant to be attached to a cupboard door, a window jamb or, even more dispiritingly, the back of a birdcage. The idea that Fabritius might have painted this tragic captive only to imprison it yet further in an actual cage runs directly against the spirit of the painting. But scholarly concern is once again with function, and location. A person entering a room and seeing the picture set into a cupboard door might experience a double-take; likewise a passer-by looking up at a front window. The Dutch invented the *spionnetje*, or 'little spy', a mirror attached to a window frame that could allow them to see who was coming and going in the street outside. They also set up perches for their goldfinches, so that if the painting was an illusion of reality it would make a person on the street look twice, glimpsing a finch; literally a miniature exhibition for a Dutch window.

All these theories turn upon the supposed *trompe l'oeil* of the picture; the way that the painted wall, with all its patches and shadows, might have appeared continuous with a real wall, say, so there would be no breach of illusion. The bird's shadow, blurring off towards the edge, would make it seem very close to that wall; an illusion enhanced by the feeding box that appears to project sharply forwards only a couple of inches. This is certainly a standard *trompe l'oeil* technique. And much has been made of the vantage point – we are supposed to be looking up at the bird, so perhaps the painting was meant to be hung high, like a real pet finch. X-rays have shown that Fabritius altered the image, adding a second railing, shifting the bird's position, repainting the wall, possibly to make it look more like whitewashed plaster. This is all supposed to be testimony to his eye-deceiving ambitions.

A picture is an image within limits. Even a vignette qualifies, bounded by the edge of canvas or paper, or floating like cherry blossom on a Japanese scroll. A stamp is a picture, even when it contains nothing much more than a number against colour. *The Goldfinch* became a Dutch stamp as well as a postcard.

But postcards and stamps, so precisely cut off at the edges, go against the whole conceit of a *trompe l'oeil* goldfinch, as much as the black frame in which the painting appears in the Maurits-huis. All the possibilities of seeing the bird's background blur, as it were, with the reality of an old plastered wall are lost because the frame removes it from its context. So the trick is thwarted.

But *The Goldfinch* is not a trick. The picture departs entirely from the optical illusion that is conventionally cited as its great achievement. With *trompe l'oeil*, you should not be able to see – in the same instant that you come across it – that the goldfinch is quite clearly made of paint. Yet this is what Fabritius's master-piece immediately and openly declares. The bird is conspicuously created out of pigment and brushstrokes and you can even count them: one for each feather on the wings, one for the patch by the beak, the amazing flash of yellow through which Fabritius has scored the end of his brush.

These strokes are all visible, not too much strenuous colour, not too much ornithological detail: as gentle as the bird itself. The wall is a feat of shadow play; the bars of the perch, the bird's claws, the individual links of the gold chain are all painted in the finest threads of light pigment. That brush-end, dragged through the lead-tin-yellow, somehow establishes a shadow inside the wet paint of the wing. It is both a magnificent feat of persuasive depiction and at the same time its exact opposite; the signature conspicuously lettered on the flat surface of a painting. Fabritius sets up an illusion and undermines it all at once: the goldfinch to the life, but as a spirit of paint.

The Frenchman who rediscovered Fabritius wrote in praise of its perfect simplicity, stunned by the sight of it in the Brussels collection in 1859. Admiration turned to longing and Thoré-Bürger made many attempts to buy it. 'Don't forget,' he wrote to a mutual friend, as its owner lay dying, 'I must have his goldfinch at any price.' Six years later, an heir gave it to him for nothing as a gift for services rendered.

'The charming bird sang a lot for him . . . but one knows how everything comes to an end.' So wrote a friend in the foreword to the catalogue of Thoré-Bürger's own art collection, up for sale in Paris after his death. *The Goldfinch* was at its heart. The painting had been hanging on the wall of the critic's apartment in the Quartier Latin for years. It was before him in the hour of his death; his first Fabritius and his last.

Memories float like the bird or the cherry blossom, vignettes in the mind's eye, surrounded by nothing but space if we are lucky. The buzzing narrative of the present is always threatening to dispel them. Early memories of what we see sometimes seem to me the strongest because they are so unaffected by knowledge of what came before or after, who was with us, where we were, how we got there. I took the bus up the Mound every day to school with a view of Edinburgh Castle, but I remember it – or at least am able to keep it in mind – only as a single photograph taken from a plane in 1920, where it appears like a sceptred Camelot ringed with bright clouds. There is no day-to-day; no time, no tale, no incident on the bus, no history lesson in my head, no tattoo or bagpipes or one o'clock gun. It remains perfectly clear and isolated.

My father's sketchbooks are all vignettes; every tiny motif is like a memory held in white space. And, in the act of drawing, he becomes one to me. I see him with one ankle crooked over the other knee in an orange chair next to a circular table; on his lap a tall black sketchbook in which he is perpetually drawing with a Staedtler pencil or a fountain pen filled with Quink ink. He never looks up, which is how I am able to watch some daring *Plays for Today* on television as a teenager. It is a strange fact that he made documentaries about painters, long before we had a television. I was ten before the black box was brought into the house and my mother went upstairs to read, every night, pretty much forever. But for him its intermittent hiss and glow and constancy of transmission were a perfect ambience for his

infinite dictionary of drawings. Nothing from the screen ever entered the black sketchbooks. I have searched.

His hair was long, until he occasionally cut it with a Gillette blade. He used to tease it, absently spiralling it round one finger as he listened attentively to what was being said. The curlicues stood out from his head. There is a strangely bright brown suit, one he had made up from cloth bought in Calcutta during the war from a tailor's shop too dark to see the colour. He is standing back from the easel, smoking and looking; he is sitting on the edge of the sofa, knees splayed, arms down, holding a drink somewhere low between his ankles: an exact oval. I never once saw him asleep.

He paints our stairwell, balanced on scaffolding, over and again. This yellow is too orange, too blue, too green. Scale of colour, he remarks, pointing out how loud or mute the yellows seem. Above is a window shedding Edinburgh's silvery light down upon the yellows until one morning he hits on the right one with a cry of jubilation to my mother. Cobalt yellow: the radiance of aureolin.

Where do you live, asked a small child at a party. I live in a sugar cube, he replied, to the child's delight. How is the painting going, I eagerly ask; slowly, he always replies. I used to wish I could bring him back through his particular words – pandrop, substrate, glaikit, zany – all run into some sort of stream of consciousness modelled on *Ulysses*, a novel he loved. But a narrative, at least for me, would undermine the distinctiveness of each vignette.

He loved what I love: painting's magnificent availability. It is surely the most open and immediate of all art forms, always there, always waiting, ready. Its offer is so full and instantaneous and it relates to both art and life all at once. He was far more interested in the lives of others than his own, and never makes an

appearance anywhere in his own work, except once as a thumb-nail self-portrait on a page with cell structures, pine cones and camels, just another tiny element in the universe.

But he appears for me, at least by other means, in the person of *The Brahan Seer*, always looking and seeing.

Where are all the paintings Fabritius did not make? People who write about his art sometimes do so with unquestioning acquiescence, as if there were not something astounding about just how little of it there is. Other painters of that time and place produced hundreds of paintings; Van Goyen left more than 1,000 and perhaps as many again that are now lost. Even Vermeer painted thirty-six works that we can still see. With Fabritius we have barely a dozen.

The standard explanation is that everything else must have been lost in the explosion. But that hardly makes sense. For one thing, four masterpieces exist from the preceding weeks of 1654 and we know that he was working on another, the portrait of Simon Decker, on the day of his death. They are all still with us, the goldfinch, the sentry, the view and the final self-portrait; this was hardly a fallow year.

But if Fabritius was far more prolific than he seems, which is the usual assumption, then where are all the pictures from his life before Delft? It is surpassingly strange, to me, that if so much was lost in the Thunderclap then so little has been discovered anywhere else. When a man could paint a portrait of such depth and subtlety and high originality as the likeness of Abraham de Potter, silk merchant of Amsterdam, Beemster landowner, then you might have expected the wealthy middle classes all over the Netherlands to commission portraits from Fabritius. Yet there are none.

Carel is nothing like his brother Barent, who goes out there and paints in different cities across the Netherlands and has his solid patrons, particularly in reliable Leiden, and who is quite clearly more successful. It always feels as if there is some kind

of parable here, perhaps the tortoise and the hare, or the more dignified version that my father often quoted from the English philosopher Francis Bacon: 'The lame in the path outstrip the swift who wander from it.' Carel outstrips Barent at every turn. And then again, I think of my father's extraordinary diligence, night after night, very slowly solving problems, as he modestly called it, yet producing hundreds of paintings, against the weird paralysis of Fabritius, limping along and producing so little.

Ghostly traces of a few other paintings from the Delft years linger in documents. A Leiden inventory from 1669 mentions 'a perspective of the Court of Holland, made by the late Fabritius'. A will from the same decade mentions 'the small piece by Fabritius, being a little case'. Perhaps *A View of Delft*. There is the painting on the ceiling of Dr Vallensis's home on Oude Delft. Hoogstraten mentions it. He also deplores the fact that no paintings were ever made by Fabritius for a church or some state or royal building, where they might have been freely visible to the public and better preserved.

The most tantalising lost work, perhaps, is mentioned in a special petition drawn up by one Maria Duijnevelt, widow of the owner of a Delft brewery called The World Turned Upside Down. This deed, from 1660, asks that if the brewery is sold 'she will be allowed to keep the painting by Carel Fabritius, and, notwithstanding that the same is a fixture, she be allowed to break it out and remove it'.

It sounds as if it might have been a fresco – 'fixed fast' or 'a fixture' are the translations of the phrase – but it might equally be a painting on canvas or wood. The Odeon nightclub in Amsterdam still has seventeenth-century ceiling paintings made on wooden planks that were glued to the plaster. And Rembrandt's enormous work *The Conspiracy of the Batavians under Claudius Civilis* – bigger even than *The Night Watch* – was painted on

canvas to be fixed to the walls of the town hall in Amsterdam. A shadow play of warriors ranged along a table that resembles a giant light beam, painted in bursts of impasto that glimmer strangely in the ambiguous light, the canvas was taken down almost immediately by the dissatisfied burghers, who clearly did not like it. Rembrandt was never paid.

Alas there is no hint of Fabritius's vision for The World Turned Upside Down, but the widow's desire to keep hold of the painting while giving up the brewery is significant. So is the 1690 inventory of the museum in Denmark that believes its 'large optical piece standing on a pedestal is made by the renowned master Fabritius of Delft'. It is not by him, but it shows how far and wide his name had apparently travelled.

Of course, there are supposed works by Fabritius all over the place. There is a portrait of a little boy, for instance, in a stately home in Surrey, a sad-eyed lad of perhaps eleven or twelve with a broad nose and full lips, who looks as if he might have been a member of the Fabritius family. At least the resemblance is there for those who wished to see it. Behind him is a pale view of land and sky, and he wears a white stock painted in thick, bright streaks that also appear, coagulated, on his nose. But his hat is not quite attached to his head, and the painting is wilfully inept. Poor Mrs Greville, who once entertained majesties and maharajahs in her famous golden salon at Polesden Lacey, and boasted of owning a rare Fabritius in the 1930s, doesn't have one any more. The painting was long ago downgraded.

Two portraits of a genial Amsterdam couple, belonging to the Duke of Westminster, may be by Fabritius; if so, he is invisible behind the style of young Rembrandt. He is said to have painted a double portrait of a fellow painter and his wife but this remains a figment. I can only come up with perhaps ten more paintings in a career of at least fourteen years. The old theory that there

are so few paintings because so many were lost in the blast presupposes that there were many to lose, all of them apparently unsold in his house, despite his extraordinary gifts and the raging appetite for Dutch art. It is possible that someone may yet find a Fabritius underneath a coat of whitewash or behind a layer of plaster somewhere on a Dutch wall, but it will not be for want of yearning or searching, and now seems vanishingly unlikely.

Rembrandt never mentions him. Neither does Govert Flinck or Nicolaes Maes or Jan Lievens, or any of the famous pupils. Nobody reports meeting him, or talking to him, except for a couple of words from Hoogstraten. According to a passage in his book on art, Fabritius once asked Hoogstraten how he could tell whether a young painter was likely to succeed. How implausible this sounds – the senior artist consulting the junior – and Hoogstraten puts a pious and characteristically verbose answer into his own mouth, recollecting the occasion many years later.

If Fabritius had painted so much more, wouldn't we expect to hear something of it? Wouldn't we expect more paintings from his early life to survive? It sometimes seems as if he too often paints what others ask of him – the studio works for Rembrandt, the wretched coat of arms for Delft that might contribute to his bar bills – and it sometimes seems as if he is just completely unable to finish a picture. How is it going? Always too slowly.

Paintings disappear all the time. Clearly I have lost one myself, even so recently, though I still believe that *The Brahan Seer* is out there somewhere. So it may be with Fabritius. A portrait of Aeltje, perhaps, or of Agatha may still be hovering somewhere in the world, waiting to be seen and observed, waiting to have its signature revealed like *The Sentry*. But I don't really believe it and I still can't get it to stand up as an explanation for his deep silence.

Fabritius is sunk in mystery still. Or he is sunk in sorrow, as seems so possible. His paintings speak of isolation and withdrawal. The solitary bird, the lone instrument seller, the inward sentry: privacy of mind might almost be an abiding characteristic. It does not seem so strange in the end that Fabritius should put his own signature on patches of shattered or flaking plaster, given that his subjects are locked in thought against a wall. I go round and round this tiny tale, this life circling out from the village of Middenbeemster, ringed with mystery. It is a man's whole life. Yet I can get no more of him, except perhaps through his art. He is like a suicide who takes his secrets away with him.

I remember a midsummer morning many years ago. My older daughter Hilla was three. She had just woken up in such excitement that I wrote down what she told me.

H: I dreamed about a little boy who wanted to come and play and have me as his friend. And so I said, 'Yes, come, come!'
M: And did he come?
H: I think so.
Me: You're not sure? Who do you think he was?
Hilla: I don't know. There weren't any pictures for that part in the dream. Where do they come from, all the pictures?

Perhaps they are in her eyes; this is her childhood guess. How else would we see what we see? Our eyes are shut when sleeping, and yet we still see pictures as if we were awake with our eyes wide open. So this might be where they live, these images stored up in the treasure house of our eyes. Where else would they be?

I suppose that they are somewhere else, behind the eyes, but perhaps this is only because the connection between pupil, retina, optical nerve and brain has been so investigated in my lifetime as to make me realise that the eye itself is nothing without its loyal team of colleagues. My daughter will later learn at school the staggering fact that what we see arrives the wrong way up on the retina and is righted by the ingenious brain; and that this happens continuously, forever and ever, all of the time, instantaneously; in less than the blink of an eye.

But if behind the eyes, then where exactly are all these pictures? Of course I don't say that they have the same character, quality or source. Dream pictures may be nothing like the

pictures thrown up by memory, or conjured by the imagination; and none of them may be anything like the involuntary images produced by trauma or drugs or sudden flashbacks. I have a vision that always comes with a rising temperature: a scimitar blade swinging low from one corner of the room to the other, cutting the air in a frightening diagonal. I had it first at the age of seven, in bed with mumps, and it always arrives unbidden at anything from 38 degrees upwards. But give me melatonin, and I see the most beautiful black and white animation of twilight falling in different glades of a forest. Like so many other dreamers, worried about whether the alarm clock will go off, I see a brown-leather suitcase with white stitching round its handle, standing upright on the platform by a train that is about to depart. Successive whistles blow. I have to retrieve this weirdly old-fashioned object in time. My dream is a cliché of imminent departures, lost property, forgotten items, never-ending urgency, unresolved swithering between luggage and train. But all of this has its insistent definition in an *image*.

And where do these pictures live the rest of the time? Are they in some cupboard in a chamber of the mind, brought out for special occasions like mounting fever or travel anxiety? Scimitar, glade, brown-leather suitcase: they are all there, for certain, hanging about like the paintings in some permanent collection. I cannot believe that they are somewhere other than in my head, even if what occasions their sudden appearance is a purely bodily sensation elsewhere – a dead arm, say, or a case of the mumps. But if they are in my head, then where precisely: certainly not behind the nasal cavity, around the mouth or at the base of the skull. Somehow these hovering, glimmering, fluctuating visions seem to be adjacent to my eyes.

People talk of ghostly projections, as if upon some kind of screen; of a distinct viewing theatre in which memories or dreams

appear, small as a pixel or vast as a movie house in their estimation. Somewhere there is a visual shimmer that flashes up, as it seems, in two dimensions. The parallel is exactly that, for me, between the pictures in one's head and the image on a canvas. They are both visions perceived: one incorporated in the material world, the other among the irreducible mysteries of the mind.

Hilla has a strange experience of going blind in her dreams. By which she means that she might be crossing a street when her ability to see suddenly fades out. The sound of the street is still there, but she cannot see the scene or her place within it. She loses the faculty of sight while still involved in the dream. This may be her mind withdrawing from unconsciousness but still holding on to the state of illusion, I imagine, a distinct phase that is known as hypnagogia. But Hilla has found a way of willing her sight to return, in fact, in order to bring the dream back into visibility. When the edges of her vision are growing dark, the spot of light at the centre gradually dwindling like the end of a movie, she concentrates hard to reverse the effect. The bright ring, shrinking, now starts to expand.

When I think of *A View of Delft* it seems to me to be holding its vision before me in just the same way, by an act of will.

The slide I have inherited of *The Brahan Seer* is small and bright as the thing it most resembles, a single cinematic frame of a celluloid strip. Held up to the light, it turns into something brighter than a photograph and yet immaterial, ephemeral, fluctuating with the sunshine. The vision is there, but only momentarily; something like a memory or a dream. And that seems inherent to the painting itself: even its static reproduction on the page seems to hover.

The Dutch painting, and the Scottish painting: pictures of seeing through the mind's eye.

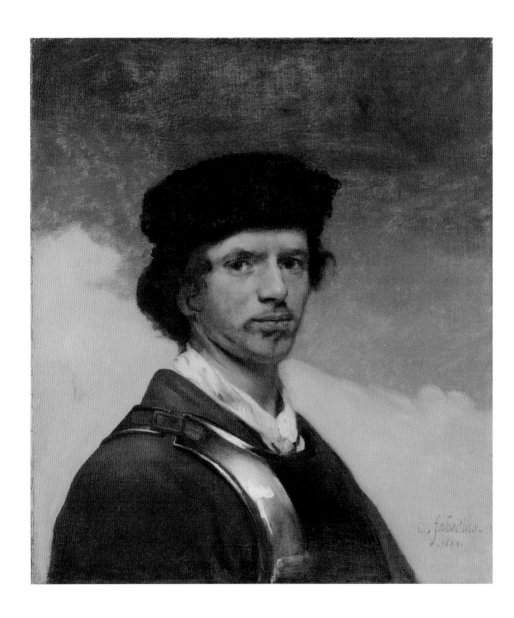

Out of that small house in Doelenstraat came the second and final self-portrait. It can appear commanding at a distance across the room in the National Gallery in London because it shows the artist very slightly larger than life. He is dressed in a metal gorget and fur hat, possibly astrakhan, like props from the trunk in the Rembrandt workshop. Perhaps they are meant as some kind of signal to future patrons, a reminder of where he started out; or a measure of how far he has gone, which is right outside into the daylight, the clouds and the air. Fabritius stands against the sky.

But the paint, in this image, is now so thin and fine, only a couple of glistening impasto shines on the metal breastplate. The mouth is still full, but the lower lip droops slightly and the moustache is growing scant. Fabritius looks in the mirror and there is a trace of the optical act in the painting, his eyes shifting to and fro, looking at themselves, first at one and then the other. But the focus is not ostentatious; Fabritius is not intent upon the particularities of eyelid, iris and pupil. Time has passed and the painting shows it. He is not quite frowning, since that would involve some kind of deliberate or conspicuous performance from which, one feels, he recoils. His gaze is getting further away.

The declaration of himself is qualified and retiring. Perhaps Fabritius painted his own portrait for somebody else; like Rembrandt, whose self-portraits so often have patrons in mind. And of course this painting appears to be the more Rembrandtian of the surviving pair because of the cap and the gorget. But Fabritius is out of the darkness. The paint is pale, the light around him brighter, almost to the point of photosynthesis.

All around him is this curious atmosphere, a drift of cloud below, a curious darkening above, like gathering pressure. It is almost impossible to look at this painting without seeing some kind of portent in the sky, in that hint of taupe haar, expanding, circumambient, perhaps weather, perhaps clouds, atmospheric, adrift; a premonition of the smoke to come. Fabritius keeps everything in the air.

Some people think Fabritius had more to say, that the painting is unfinished. It seems so nebulous, after all, as if he were already receding into the smoke. But his critics are surely wrong. For the painting is very clearly signed C Fabritius and dated 1654.

Fabritius is thirty-two, and I was the same age when I first wrote about his self-portrait. He and I remain the same age whenever we meet. He is dead, I am still alive, so the existential maths is now absurd. But a person in a portrait does not age, even if the painting does. The picture removes the person from time's harm and fixes them in the moment; and so it does for me. I never go to a gallery and think that these people are dead and gone, no matter how long ago they were depicted. The painting fuses the person in the moment and that moment somehow includes me, and you, and everyone to come. Here he is now, Carel Fabritius, and so he will remain; the artist appearing in and as his own painting.

Long ago, after a trauma, I thought to go as far away as I could and try to be of some kind of use to somebody else. I flew to Algeria to write about the Saharawi people whose land had been annexed by Morocco and who were now living in the desert in refugee camps. In the city of Algiers, I slept in a room the size of a royal court, with flaking walls and an elderly fan casting stuttering shadows on the pale plaster. The following morning I was met by a Saharawi fighter from the Polisario Front, who drove me to an airstrip where a primitive plane with no seats flew us out across the desert to the Western Sahara. A shepherd in long robes tried to keep order among a quartet of disorientated goats. The cabin blinds were firmly closed for the last few minutes, so that we would not see the lie of the land at Tindouf, where there were military installations.

The camps were mostly tents, white against the cloudless blue sky. War on Want had installed artesian wells so that water could be gotten, somehow, from deep below the miles and miles of barren sand. They grew beetroot and carrots out of the desert. The goats lived on the carrot tops; the Saharawi lived on the vegetables and the goats. I remember the ceremony of the women poets who came, in flowing blue robes, to recite oral verse to the people.

The Polisario kept up their war against Morocco, and vice versa. The focus was a thirty-mile wall of sand built by Moroccan workers as a kind of futile Iron Curtain of the desert. The legend was that the Moroccans would lay land mines on the Saharawi side of the wall; and then the Polisario would delicately disinter them and put them back on the other side. I was taken in a jeep to see this great wall.

A young soldier in camouflage moved gingerly across the sand some way from the jeep, his feet performing a terrifying ballet. We watched in awe. He did not find a mine. He did not step on one. He began to tiptoe back towards us. But then there was a sudden nameless sound, followed by an unrecognisable bang. Sand shot into the air behind him – then seemed to hang there, motionless, before descending in a strange pale rain. It was so slow as to appear like an image at this distance; or a sequence from an old film that you could rewind; as if you could heal the land that had so violently exploded, as if you could turn time backwards. The soldier ran.

An autumn day in Delft, and barges glide along the canals, bearing passengers and parcels, perhaps even paintings, back and forth to The Hague. Grocers wheel barrows of cheese over narrow bridges, carpenters turn their lathes and the city's potters and painters are quietly at work. The morning is cool, with mounting grey cumulus. It is 12 October. A government clerk called Cornelis Soetens, all too new to the job, is sent to check a sample of the gunpowder stocks held below ground in a disused convent a few streets from the market square in the area known as the Doel. It is somewhere between 10 and 10.30 a.m. He goes down some steps into the darkness, presumably carrying a lantern, turns a key in a lock and the moment's silence is followed by an explosion so powerful people hear it seventy miles away.

Trees are torn from their roots, bodies lifted into the air in a torrential up-rush. It takes a while for the living to rise up from the ground, stunned and terrified of another blast. Which comes, as 90,000 pounds of black gunpowder stored in barrels in the vault detonate in a rapid bombing pattern of explosions that rip through Delft, exactly as happened in the present century when the port of Beirut exploded, the sound heard as far away as Cyprus. Some citizens are tormented by tinnitus for weeks. Others are permanently deafened.

The sound of an explosion travels quicker through the ground than the air. People in the streets would have seen a huge flash, felt and possibly even heard a rumbling through the ground and then heard the devastating crash of the shock wave. This

is exactly what the Lebanese experienced in Beirut: a flash, a rumble, the deafening bangs.

The Thunderclap flattened all the buildings in the small streets around it in an instant. The lessons learned by scientists studying Beirut tell us that. The first blast would have given houses nearby and even several hundred metres away such a structural shock they could no longer support their own roofs and would have collapsed straight to the earth. A crater developed on the site, filling with filthy black water thickened by the gunpowder residue. This appears in pictures made at the time. Doctors hurried to the wounded, soldiers tried for hours, and then days, to rescue people trapped under masonry and timber. Numberless citizens died.

Thousands of pounds of gunpowder ignited by not much more than a spark, perhaps, caused by metal on metal as Soetens turns his key in a rusty lock, or is careless laying down his lantern. He is of course never seen again. So intense was the explosion that some people believed it was the end of the world, the gates of hell opening and God's wrath raining down upon Delft.

The city was, and remains, beguilingly small. Its population was only about 25,000 in those days, so you might think it possible to have some idea of a death toll. But nobody was ever able to determine the figure. Some people simply disappeared, their bodies entirely dematerialised as in the tragedy of 9/11. But after the explosion came seething smoke, and then fires, in which other people died, and a lengthening list of the missing among the fallen roofs and timbers.

There and not there: a split second between life and death. The stained-glass windows of the Oude Kerk were all blown out, but the figures on the tomb of William the Silent in the Nieuwe Kerk merely trembled. People about to enter their houses lived, while those inside died. There is remarkable first-hand testimony

224

of this horrifying near-death experience from a man who told his story to the unlikeliest of sources. Living in The Hague at that time was Elizabeth Stuart, sister of Charles I of England and widow of Frederick V of Bohemia. Curious, energetic and always alive to the moment, Elizabeth visited Delft by carriage as soon as she could after the blast. She walked through the ruins, talking to everyone she met, one of whom was none other than the innkeeper of the Doel. This is the account she gives in a letter to her son Charles Louis, Elector Palatine:

> I am sure you hear of the blowing up of the magazine of Delft, this day seven-night. I went upon Thursday to see it, you cannot imagine how the towne is ruined, all the streets neare where it was are quite downe, not one stone upon another. The host of the Doel there was standing upon the thresholde of his doore, when the blowe was. It stunned him a little, and after he turned himself to goe into his house, he found none there . . .

This was the man to whom Fabritius owed his very last debt. His house had fallen on the spot. The world turned upside down.

The innkeeper could not believe his eyes; though eyes themselves can conjure this disaster. This happens when the brain can no longer invert the images that project upon the retina. It is a possibility so appalling one might imagine that it could never occur, and yet it has. There is a Brazilian woman who can only see everything upside down, so that when she walks it is apparently on air and not ground; and when she looks in the mirror her chin is uppermost and her hair at the bottom like a beard; the way we see our faces in teaspoons. The monstrosity of this is so great that she might prefer to be blind.

And this is what happens during the Thunderclap: the roof is on the ground, light pours in, the body falls and sees the world now in a wildly different way. Houses tumble inwards,

windows shatter outwards. The chaos that might be in our minds at all times, and is certainly so commonly represented in disaster movies as a result of vivid, calculated editing, is truly perceived, actually experienced, as the world tips over.

And imagine it now: a pristine De Hooch with the roof blown off and every rafter criss-crossing the ruins. All these peaceful sanctuaries with their immaculate interiors, their plaster walls and gleaming windows, their milk jugs and brooms and blue and white tiles, all now blasted apart.

The windows of the Oude Kerk were gone, wind whistling through the missing panes. They were eventually replaced with the small squares of clear glass, sometimes pink or tinged with a faint blue or green, that are visible in Emanuel de Witte's paintings in the following decades. Not for another 300 years, until after the Second World War, was brilliantly coloured stained glass restored to that great church and the last of the damage finally repaired.

An explosion could only be depicted as an act of memory until the age of photography. What you saw had to be recorded after the event. Everything we now so readily visualise when an explosion occurs – the mushroom cloud, the fainting buildings, the rain of grey dust – is seen for us through the eye of a camera. Catastrophe was first slowed to a fraction of a second with Harold Edgerton's deathless shot of the milk drop exploding in its fabulous corona in 1937. Otherwise known as 'the man who made time stand still', Edgerton developed a flash quicker than any before, and even allowed us to see what we can never see, milliseconds indiscernible to the human eye. And he chose explosions as his great subject; the moment a bullet exits an apple, or the hammer shatters the glass.

In Beirut, in 2020, some 2,755 tons of ammonium nitrate carelessly stored in the ancient port suddenly exploded. The blast, one

of the worst in world history, released a fireball miles into the sky. People spoke of being lifted into the air like feathers, of sudden deafness and hot blood in their eyes. Some buildings stood, unaccountably, while others right next to them collapsed in an instant. The explosion had the magnitude of a small nuclear bomb. In the briefest of moments before the whiteout, it was possible to see silver sparks flying – fireworks, lethally contained in the same depot – through the apocalypse caught on mobile phones.

What was it like, the Delft Thunderclap? There are images. Some derive from drawings actually made on the spot in the aftermath. At least one claims to record the very moment itself. It shows a massive airborne chaos with people shooting upwards in their chairs like ejector seats bursting from an airplane. Figures fling their arms to the heavens, for rhetorical purposes. Bodies heap up in the foreground, a single decapitated head rolling towards us. It is what we might imagine, and sure enough the image is imaginary. The speed of the explosion would have made such a spectacle impossible to witness, let alone draw. Many different moments are incorporated into one fictional account. The blast is occurring in a white ray at the back, yet some people are already dead and still others are begging God for mercy. It is pure Disney. The artist, Jan Luyken, made the image half a century later. He was never there.

There is a contemporary drawing by Gerbrand van den Eeckhout, formerly assistant to Rembrandt and once thought to be the genius of *The Sentry*. I resent him for this, unreasonably; but all the more so given that he travels in perfect safety to Delft to get the topographical details down only days after the event. There is a ringing in the cold, bright air of his image, it is true, and a powerful sense of toppling masonry. But it also shows what people wanted to see: namely the fabled baby who is supposed to have been found still upright in its high chair the next

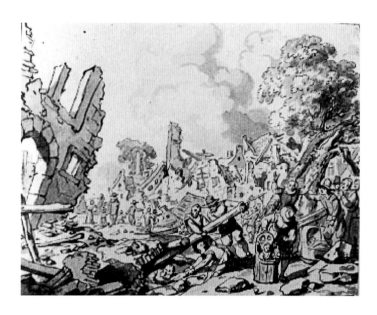

day, clutching a wholly implausible apple. I don't believe in his drawing, which was used to illustrate a hasty historical pamphlet.

The most accurate report is by far the largest – a huge panorama drawn across two sheets of paper by a painter named Herman Saftleven, whose testimony corresponds with our expert knowledge of explosions today. Saftleven is the classic, almost parodic, Golden Age artist. His father is a still-life painter in Rotterdam, his brother paints genre scenes, his daughter specialises in flowers. The artist himself paints rivers and classical ruins, as well as plants for the celebrated horticulturalist Agnes Block.

Saftleven does hollyhocks and child shepherds, tulips and travellers trudging through forests under the weight of their backpacks. He himself walked the length of the Rhine and every now and again a tiny alter ego stops to gape at the view in his art, opening his arms wide as if to say – behold! Saftleven was always very careful to date his drawings, so we know exactly when he went by canal from Utrecht to record the disaster in Delft, specifically on 29 October.

There are no signs of human life. The subject is pure devastation. He shows the remaining buildings as roofless boxes, a few beams standing to the sky. It is like a Paul Nash First World War battlefield. Windows are blown out, roofs have disappeared completely, or lost all their tiles to expose structures like wooden skeletons. The burghers of Delft afterwards clubbed together to buy immense quantities of tiles for their fellow citizens, that the roofs of their city might be reclothed.

Saftleven is a meticulous observer. He records the scene not just in images but also words, captioning everything you see:

A Is the hole or pool, 13 feet deep and full of water where the tower had stood when I drew it on 29 October.

B Is the Neue Kerk, where the glass was destroyed and a large hole torn in the roof and was very damaged, but the coats of arms and sepulchre and the ornament on his majesty's grave was not damaged.

C is the Oude Kerk where the glass and the walls were torn away. I saw a remarkable thing in this church that the wall behind the arms of Admiral Tromp was blown away but the arms were not damaged, also those of Admiral Piet Hein were similarly not damaged.

D Is the place where the Militia Hall stood and also where the maid of the Militia Hall was pulled out fully clothed from under the stones on 27 October so miserable from having been buried

It is a big drawing, two large pages spliced together to get the full extent of the destruction. There is the deep pool of black water, the rubble, timber and debris. Peer into the panorama and you can even see the remains of the little street where Fabritius lived. Yet the bridge right next to it still curves solidly over the canal, the great churches still rise on the skyline and trees

barely yards from the arsenal stand proud with their leaves intact. Saftleven turns out to be exactly correct.

For explosions are so arbitrary as to beggar belief. People marvelled then, as now, at the unexpected survival of apples and babies. I remember a patch of green wall framing a hotel sink that remained uncracked when the rest of the room had vanished in an IRA explosion.

It was the autumn of 1984 and I was working in Brighton in my first ever job. A time bomb had been planted in the Grand Hotel on the seafront three weeks before the annual Tory Party Conference. The aim was to assassinate Margaret Thatcher and as many of her MPs as possible. The explosion occurred just before three o'clock in the morning. It was another 12 October. Streets away, I was woken by a shudder of the bed in our shared basement flat on Adelaide Crescent. We did not understand what had happened for quite some time, having no knowledge of bombs. I found my way down to the beach with other dazed people and saw a tide of glass fragments glinting across the pebbles in the gathering dawn. The hotel was cored liked an apple, so neatly that you could see the toothbrushes in their holders halfway up the wall of a bathroom that had otherwise vanished entirely from the fourth floor. Curtains fluttered from windows that had shed their panes. A suitcase stood immaculate by a blown-out door. We noticed the still-remaining detail, just as they noticed the child supposedly safe in its high chair the morning after the Thunderclap, or the oddness, that Saftleven notices, of the coat of arms surviving in the Oude Kerk when the wall behind it fell.

Blasts are catastrophically random. This is also the way we shall some of us end – in a split second, consciousness ending. It will all be so sudden. We say we hope to die in our sleep, meaning peacefully unaware – catching no sight of our imminent fate, sensing nothing. We pray for blindness and unknowing.

But what about the conscious split second: what will be before our eyes? If we are blessed, it will be the faces of the people we love. But Proust gives his novelist Bergotte a painting instead, seats him in front of the *View of Delft* to gaze at its silent thunderclap, and my sense is that Proust might have hoped for the same. And I think about *Las Meninas*, and the story I was told of a dying woman who was taken all the way to Madrid on a stretcher because she wanted to look at Velázquez's great twinkling vision of life and mortality flashing up before her in the Prado; and of Théophile Thoré-Bürger, in his Paris apartment with the image of the bird. For some people nothing could be more calming and composing than the small, flat surface that is a picture; and perhaps nothing more wondrous, for him, than to leave this life looking at *The Goldfinch*.

The child with the apple, the *petit pan de mur jaune*, the goldfinch on its perch: motionless details, vignettes. All we can hold in mind in the end.

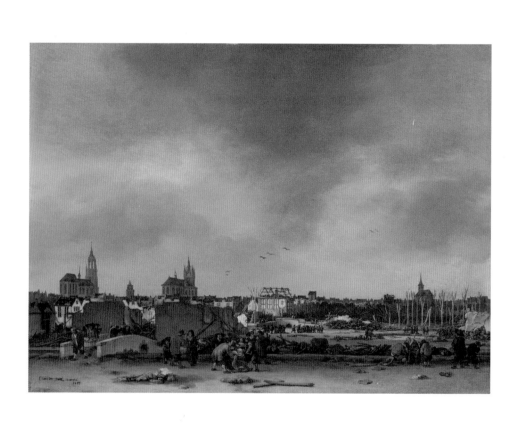

Three birds fly up, harbingers against the slate-grey sky, looking down upon the accidental destruction of Delft below. The picture shows a desert of dark ruins. Two men are helping a woman off the ground, a woman who appears not entirely alive, and there are figures sunk in ditches. Timber is strewn everywhere like a dangerous game of spillikins. One false move and more buildings will fall.

Egbert van der Poel, the artist, was Fabritius's neighbour on Doelenstraat. If he too was home working at his easel that day, the explosion entirely missed him out. For Van der Poel was able to pick his way through the devastation to the site of the blast, only three streets away, and make sketches which would later turn into a painting of Ground Zero.

It is a workmanlike picture, full of generalisations, as if he couldn't really see the horror for getting down the topographic details. His figures are slightly absurd, hats almost as big as their bodies, and the same expressionless configuration of two eyes, nose and mouth a child might paint. It is not obvious whether the woman at the front on the left is being hauled up from death or from life. At the same time that she is being rescued, men are carting bricks or tiles away in a basket, and what looks like the local buildings inspectorate is observing the scene in the middle distance. A trace of sunlight flitters down through the broken buildings, and behind them rise those powerful symbols of Delft's stoic and unbroken endurance – the old and new kirks.

The artist signs the picture, bottom-left, E van der Poel, with the date 12 October 1654.

He also signs and dates – you might say titles – the next one

12 October 1654; then the next, and the next. There are twenty known paintings in all. He cannot show the exact moment of the blast – although he does wind time backwards and imagine that split-second flash more than once, as a blaze of stiff white brushstrokes – but he paints numerous variations on the immediate aftermath. It is the same day, and almost the same painting, hour by hour, repeatedly for years to come. Van der Poel returns to the scene over and over again. But can he ever truly enter it?

I think of those suffering beings on the intensive care wards in the first spring of the pandemic, alone among the monitoring machines, their bodies turned by the nurses. The first picture I ever saw of it was a newspaper photograph taken somehow – but how, and by whom – of a man in a hospital in Italy, which seemed in those early days to be the doomed country of Europe, the land of Dante and Piero and love all decimated by a new plague, the plague that probably carried off Titian, reviving itself like a sleeping serpent five centuries later. And in this photograph lay a man on his front, half naked, one arm loose by his side, as masked medics moved about in some hell of which one knew nothing. The indignity was so terrible, it seemed to me, and the pose so apparently neglectful I wondered if he was in fact already dead. The ceiling hung low, the light was blue, irresistibly proposing the morgue where he might be heading. We saw this, and yet the picture could tell us nothing more. Who knew that it was in those days thought better to position patients on their front to increase their lung capacity? Who knew that the doctors and nurses were speaking quietly to him all the time, that they would bring him heroically through all this after many weeks and that he would one day return to his life as a postman?

Pictures are silent; too silent. At times, they show what they cannot explain. And so it is with Van der Poel's paintings.

Here is Delft on the first shattered day, and yet there is no

smoke and no fire, no choking dust, none of the chaos that he might have beheld. Here it is again, this time with the explosion actually occurring and people dropping to the ground, even as others are already trying to clear up the mess. And here it is again just after the blast, when the deafened are just about standing, dizzy and dazed, while other people gesture in amazement, run away or raise their hands to the skies as if begging God to stop. And here it is again on what is surely by now the following morning, dawn turning the black pool into a ring of glittering water. Van der Poel's paintings are not all the same, it is true; and he must have seen it all, since he lived right there. Yet there is a sense that everything is taking place in a fable.

Van der Poel is a figure in the wings. Without his disaster art we would understand less of this explosion, from which Delft took so long to recover: the citizens trudging back and forth with barrows full of rubble, the blackened beams, the despairing homeless. But he seems always to have been drawn to catastrophe. Fire at night was his forte, and there are even paintings with that very title. One shows the devastation of a nearby town earlier that same year, in which 800 homes burned to the ground. Another shows villagers rushing to a stream to fetch water in a doomed attempt to staunch the raging inferno that is consuming their houses. The painting hangs in the museum in Schwerin, alongside *The Sentry*; Fabritius and Van der Poel neighbours in art, as they once were in life.

The Delft Thunderclap was simply, you might say, a more internationally famous disaster to paint. European governments sent the city immediate letters of condolence, monarchs came to visit the spot, journalists began to arrive from around the world. But Van der Poel cannot simply have been churning it out like reportage for the market. One of his own children died as the street exploded. In the burial records of the Oude Kerk appears

the name of his young daughter, Cornelia van der Poel, laid to rest two days later alongside other victims, including Fabritius. She was two years old.

Van der Poel left Delft for Rotterdam the following year and never came back, except in his art. There is no way of knowing exactly when he painted each successive Thunderclap because he gives them all the same date, as if endlessly reliving 12 October 1654. To return to the devastation of that day, as he did, for the rest of his life must have involved far more than painting.

Dutch history is full of brave figures trying to halt disaster, the boy who puts his finger in the dyke to save the nation, the man who skates all the way from Amsterdam to Leiden to bring warning of the Spanish invasion. A widow who lived with her son on the Voldersgracht side of Delft market warned about a future devastation for years, although her premonition may hardly have required the gift of second sight. Gunpowder, so volatile, so lethal, was usually stored outside the walls of seventeenth-century cities for safety's sake, not right there among the streets and houses, perilously close to civilians. But like Soetens the clerk, who instantly vanished, the old widow is lost from the story. Perhaps she survived, or perhaps she too was taken. Some people thought the ground of Delft had opened to swallow up the sinners.

Even in a city so small, certain districts remained untouched as if by divine ordination. Saftleven's drawing shows autumn trees unbowed. The strange precision of explosives is readily visualised today. But even in Delft, in the 1650s, a sense of this outlandish disparity was already pictured by artists. Peaceful canal banks, undamaged houses, the perfect order of inner courtyards, where women look out upon streets as immaculate as the cleansed chambers indoors: the antithesis of Van der Poel, this too is Delft after the Thunderclap.

And none of what happened touches the art of Vermeer. He lived with his new wife and growing family in the heart of the old town, only two bridges and five streets from the site of the catastrophe. Even as builders and burghers and carpenters were still trying to shore up the ruins, Vermeer painted his only

other outdoor scene. *The Little Street* is the opposite of the Thunderclap; it is pure silence. It feels as if Delft has been through hell and returned to the other extreme, becoming a kind of paradise on earth in this painting.

The scene is so unassuming – rinsed cobbles, whitewashed walls, one woman stitching in a doorway, another carefully cleaning the side alley, the Dutch gable façade ascending in high steps towards those slow and steady clouds. Yet the composition is very nearly abstract, with its Advent calendar of open and still-to-be-opened windows and doors, its marquetry of rectangles and curves, the gentle crescent of self-contained figures balancing the geometries. How can it be so mesmerising, I keep asking myself, so inexhaustibly beautiful – so infinitely more than it shows?

The spell of this painting is an irreducible mystery. It is not about wishing to be there in person, in that street in Delft, however beautiful. It is not about cleaning and needlework, washing, brushing, or perfect Dutch order. It is not about the weather, although there is a marvellous steadiness to the sky with its heavy pressure. The day might be very slightly overcast; it is not easy to tell from the pigment all these centuries later whether there is a promise of blue above. The sky is becalmed in the paint.

It cannot be entirely about the brickwork, either, although Vermeer's bricks are spectacular, beautiful as a wall, every one of them declaring the history of its own making. It can't be about the lightly friable wall where shards have broken off, or the irregular cobbles on the washed street, or the gutter that runs out of the alley. And where is Vermeer himself? It is not about where he is standing to paint, not about his viewpoint or even his presence.

The ascent of the stepped gable ends and the partitions between them allow such an exhilarating jigsaw of sky and brick, sharp as the window frames of the house that hold all the dark panes in place. Each door or window is a picture within

the picture, its own intricate enchantment. And there is more light in this scene than any Delft day can give, a light that belongs to the art of Vermeer.

Stain and fade, inner darkness and outer brightness, the sense of circumambient air drifting evenly through the scene; the woman in the doorway is somehow advertising the beneficence of that atmosphere. The world can come and go as she sits there, and she might even look up on occasion. But the absolute stillness of this pristine scene, in all its beauty – every brick, every leaf, every shutter with its variegated colour like a tiny abstract painting – has its parallel in the painting itself: transcendent in its pure concentration.

Benches and seats run along the front of the house. The shutters open directly on to the street. This sense of the inside turned outside is part of the picture's fascination, as if you could open up the façade like a doll's house. The alleyway running up the side of the house, where the woman washes her brush, has no door to hide it from the eye. Everything that is ordinarily concealed is revealed.

Look at all the fresh whites: the newly bleached cap and shawl worn by the woman in the dark doorway; the chance patch of unblemished white paint on the wall beside her. A silvery trail of water runs out of the alley into the canal. How wry that Vermeer incorporates his signature as graffiti on a slightly discoloured patch instead, like a tarnish on his own painting.

Something about the way the paint is ageing on the walls, and wearing to rust as the bricks meet the ground; something about the shutters, so variable, mutable, changing from brighter blue to a greenish grey, duller, draws upon all of his gifts. He paints the paint of these shutters so respectfully, a loving imitation of time's effects on the very medium used by both builder and artist.

There is so much knowledge in this shining picture and all of

it laid out like a scene, a set, a *pièce de théâtre*. That it is not just a transcription of reality, any more than his other paintings, is self-evident. The figures are as tightly positioned, as interlocked in the geometry of absorption and pleasure as the marvellous stepped architecture of rectangles, verticals and zigzags. A kind of concentration and purpose is here enacted against a simple street of buildings in Delft.

Some years ago, after decades of dispute about the street's location, a Dutch art historian discovered a ledger that listed the widths of Delft house fronts to work out how much tax each resident should pay for the dredging of their portion of canal. From this he deduced that this might be Vlamingstraat, which runs parallel to Doelenstraat, four roads away. The house on the right, by his calculation, would have been inhabited by one of Vermeer's aunts, a widow who made her living selling tripe. But nobody imagines that the woman in the doorway is a real person. This is not a portrait and the painting refuses to be about geography. All conjecture about exact location feels irrelevant when you stand before it, mesmerised.

All through the years of the pandemic, I had a reproduction of Vermeer's painting pinned to the wall by my desk. It helped to sustain me through the shuttered lockdowns, transported me to a Netherlands of the mind, to a vision of harmony, diligence and order. I have stood in Dutch courtyards where women wash the flagstones beneath white clouds, tend their plants or simply stand watching other Dutch women with their backs to us, staring out at cleansed pavements. I have sat in the balmy light on that threshold, stitching in that doorway. These pictures amount to a habitable world, a next-door microcosm for the mind and eye. Vermeer's is not an art of soporific or healing tranquillity, as people like to say, so much as transfixing exhilaration. Looking at Vermeer's *The Little Street* clarifies my thinking, makes

me as still as the sewing woman he creates with such mysterious strokes, her concentration as deep as his.

Vermeer was barely twenty-two when Delft exploded. He had yet to paint even his earliest surviving pictures and there is no way of proving that he ever met or was even taught by Fabritius, an idea spun by Delft eulogists decades later. But Delft is so small, the houses so close, the sheer number of artists living all together there so disproportionately high as to compare with the Impressionists in Montmartre, or the Abstract Expressionists in Greenwich Village. To get to the corner where the musical instrument seller sits in *A View of Delft*, Fabritius only had to walk down Doelenstraat, turn left and pass three more little streets, one of them Vlamingstraat, a journey of no more than five minutes. To get from his house to the market square he too, like Pepys, passed Vermeer's front door. And there is no doubt whatsoever that the art of Fabritius was known to Vermeer.

He must have seen works by Fabritius in other people's houses, on the wall of The World Turned Upside Down or even in the possession of Agatha van Pruyssen. We know this because of the fact that Vermeer owned three paintings by Fabritius. They are recorded in the inventory drawn up after his death in 1675.

This inventory lists all of the many pictures in Vermeer's house. In the *voorhuys*, or front hall, alongside paintings of fruit, sea and trees, is this work: 'a painting by Fabritius'. And in the great hall, among family portraits, a picture of a peasant barn and a still life of gourds, are these: 'Two paintings, tronien, by Fabritius'. Vermeer was not just familiar with the work of Fabritius, he saw it in his home every day.

All the way back at the start, in the inventory of Fabritius's first wife Aeltje, are those tronies, or painted heads. Perhaps they were the work of Fabritius after all, and remained with him

through his second marriage to Agatha, who sells them to Vermeer after her husband's death. Of all the many artists whose paintings are cited in the inventory, Fabritius is one of only two whose names are actually given. Vermeer, master painter, master dealer, knew the worth of everything he bought.

The Fabritius in the front hall: what was it? Statistically, it seems entirely likely that it was one of the very few works by Fabritius that survive. Given the number of pictures crammed into the *voorhuys* – eleven in total, and one identified by its sheer size – it doesn't seem likely to have been any of the large religious or mythological works made by Fabritius when he was in Rembrandt's studio. It was definitely not the portrait of Abraham de Potter, which remained in that family; probably not *A View of Delft*, in those days no doubt still contained in its wooden box; and perhaps not *The Goldfinch*, more likely to have been identified as a bird than a Fabritius, in the way that fruit, gourds and peasant barns are singled out by the specificity of the subject they depict.

I used to wonder whether the early self-portrait, against a parched and cracking wall, might have been one of the heads upstairs; that unknown life, surfacing in the present with such in-turned sorrow yet strength. But I am going to guess that the painting in the front hall was another such image, a picture that a fellow painter might especially esteem, out of fraternal solidarity: that it was Fabritius's final self-portrait.

Three paintings by Fabritius were carried across a threshold and through a doorway just like that dark rectangle in Vermeer's *The Little Street*. One went hardly any further. Someone nailed it up on the wall of the front hall. You might almost be able to glimpse it if only you could see inside the painted house.

A man I knew and admired, and had just seen a few days before, and had no reason to suspect I would not see again, took his own life. He was smiling, speaking with all of his quick-fire engagement, and then he was not there any more. He went away. He took his mind away. He was gone so fast nobody could believe it. All the reasons you might imagine went through people's heads: he was tired, or disappointed, his heart was broken or he suffered fatal depression, or all of these. But in the passing moment he vanished and the suddenness was terrible and yet completely a part of the dreadful precariousness of daily existence. We live from moment to moment and have no certain knowledge what the next will contain unless, like him, we choose the hour of our end.

What is the span of our life: this terrible question. And how we are to continue in this terrible state of unknowing is an act of common fortitude. We will just have to trust to it. An artist makes a painting on the basis that it will still be there to work upon tomorrow, and the next day. That nothing will have taken it, or them, away. This immense leap of faith is so touching that I can hardly believe my fellow beings can sustain it. What a glorious thing is humanity. I remember the shock of a teacher presenting the arguments of Bertrand Russell in a secondary-school classroom, concerning the famous will-it-won't-it sunrise. There is no proof that the sun will come up tomorrow, only our faith or outright presumption, based upon past experience. We can merely hope. Or, in my case, hope that these dire discussions would stay remote from my mind, otherwise I would be stymied

and unable to continue. But what if death took everyone else away, leaving only you behind; how then were you to continue?

Somehow he did, Carel Fabritius. But how is anybody to know what it felt like to lose his whole young family in such a short time. You sense him falter in the judgements made on his behalf by his father and his father-in-law, and in the long lapse during the course of which no work seems to be made that actually survives. And you also sense him in the silence, and in the constant shifts of style that have eluded us, that have outwitted everyone's understanding of him. He sidesteps expectations, never to be pinned down even by death.

Fabritius was thirty-two when he died. Seurat was the same age when flu carried him off. Watteau was thirty-six when he died of tuberculosis. Egon Schiele was only twenty-eight. Others are reprieved to an immense old age, but are still desperate for one more day. A contemporary drawing shows the Japanese artist Hokusai hard at work in a tattered quilt, in his late eighties, surrounded by absently discarded food wrappers. An old man mad about drawing: so he called himself. Such was the inexhaustible power of art that Hokusai believed that he – and perhaps even we – could become one with an image. Every morning he drew a Chinese lion then threw it out of the window to ward off disaster. One of his most potent portraits – no other word will do – is of the imaginary demon-queller Shoki, driving out smallpox on our behalf with a kind of fierce generosity.

Hokusai's final image – wintry, transcendent – shows an inky-black dragon rising above the snow-capped circumflex of a tiny Mount Fuji. He gives his exact age on the page as eighty-nine. He is as we all should be when contemplating our end, our aspiration undiminished. These were his last words: 'If heaven will afford me five more years of life, then I might manage to become a true artist!'

When my father learned that he had cancer, he made a beautiful chart upon a piece of mounting card. It laid out all the paintings he intended to make. There were thirty to be finished in the first year, and a possible exhibition that he might aim to be working for in the next. He only ever made three of those paintings.

This was not his time. It could have been avoided. Just a cough, then a worse cough, for months of visits to a doctor in a small Borders town who always looked away: an irritable, tired, inadequate man whose own life must have had its disappointments, who kept ignoring my father's symptoms, who neglected to send him for the one thing he urgently needed, which was a scan.

The cancer that started in my father's lungs exploded in his brain and eventually took the sight of one of his grey-green eyes. He was rigorously brave until the last and I find in my mother's diary an entry in which he comes down to breakfast and tells her, with such dignity it makes me weep, and weep, that he is somewhat afraid that his light is darkening. I hold to him, to his bravery, I honour him in his extraordinary solitary struggle to keep on working and painting and seeing this world in which we rejoice. It is a hundred years since his birth, his origins in Scotland, and I only hope ever to hold myself up to his standards of looking and seeing. When he died, in his sixties, my mother had an emblem painted in the book of commemoration at the chapel – a single beautiful chromosome, taken from the painting that hangs forever in our house, never to be sold. It is the origin of everything: his life, the life he gave me, the art he made, including this very chromosome itself. The painter dies, though I still cannot believe it. He dies, but his painting survives.

Time is running out. This was the knowledge my father lived with. He looked it in the eye: the calendar, the hourglass, the hands of his watch; there is even a late painting where a mantelpiece clock stands at a minute to midnight. It made him profoundly courageous.

I, who am all haste, all the time, always sensing time's arrow at my back, always counting the days, have not kept my eyes still on the hour. Suddenly time will be up and I may not have seen the long fields of barley and of rye, or witnessed the philosopher's sun rising out of total darkness – but I have looked at art. And I have seen the day measured through its rituals in Dutch painting: the washing of the step, the polishing of the brass, the cleansing of the yard, from breakfast to the last church service by twilight. I think of the bells in the churches of Delft, still ringing out across the islanded city for Mass, and to keep the time for a public before the age of watches, and I look at my own timekeeper, on the computer here where I write and think of the doors opening to the people and the light filtering down through an Emanuel de Witte interior and the man sitting outside beneath the sign of The Swan.

Art can take you anywhere: in life, in the world. And now I am beginning to see that the same is true of art and time. I can look at the ice-skating in painting after Dutch painting and be back at Inverleith Park, where the boy gets pushed into the pond. I can see the Dutch gable houses on Chelsea Embankment, opposite Battersea Park where I walk with my dog, and think that I am there now in Holland, and its art, and the Thames is just some unusually vast canal.

The turn of a windmill on the east coast of England, and I think the same – that I am in the Netherlands, via its art. And I have even seen a painting that turns the view around: Ludolf Backhuysen's view of Huisduinen, which shows Lincolnshire just over the water from Holland. Does it work the other way round, do Dutch people really stand on the opposite coast excited to spot a fragment of England away in the distance over the grey waves? It is such a long journey out, this one, from where we came; this life, our life, the journey between the first and last shores.

I have been looking at *A View of Delft* for longer than Fabritius ever could. It seems piercingly unfair. So does the fact that I can see his brushstrokes, enormously magnified, as he never could, examining that wondrous little picture of the man and the city on my computer. I know the fate of his art and life as he did not: that the goldfinch would become so treasured; that his reputation would be buried for centuries when Delft exploded in the Thunderclap. He can have no foresight. And yet there is that last self-portrait, where he appears both manifestly present – making himself so available in person, as in paint, a man so traceless in life who now fills the frame with his being – and yet somehow so shy and in retreat in the smoky air. Where he was once back to the wall, like the bird, like the music seller, now he is released into freedom in this self-portrait, only to die in the strange atmosphere he paints around himself like an omen. These may be the last days of his life and career.

Two hundred years ago, a Mr George Rimington, engaged in business in the Low Countries, purchased the self-portrait for 400 francs from a dealer in Bruges. He brought it back to his austere neo-classical house in Cumbria, where it hung in the front hall. In the inventory of Rimington's pictures, it is for some reason given the title *Grumbo*, possibly because it was thought

to resemble a German general of that name. Fabritius's identity was already long lost. Mr Rimington bequeaths *Grumbo* to his youngest son Reginald, who marries a Miss Atkinson, who bequeaths it to her niece Mrs Brewerton, who leaves it to her son John, who sells it at Christie's, and thus the last self-portrait of Carel Fabritius finally comes before the public for the first time at the National Gallery in London in 1924. The work is carefully cleaned before presentation, and this is what the conservators discover. First that it had been relined in France, sometime in the early nineteenth century, as the remains of an old French sales catalogue had been used to paste up the edges. Second that the face had been damaged. Upon removing the dark and discoloured varnish, the conservator found grazes on the cheek and a hole beneath the lip, as if it had suffered an assault; as if it might have survived an explosion.

More recently it was discovered that the painting once showed the artist indoors, but that he later painted himself outside, a sombre, clouded air opening around him. The sun is behind a cloud; the light has its scotoma glare. But he is a free man out there, and in the brushstrokes too; nothing methodical, nothing like his contemporaries. Fabritius, perpetual student of the new, always goes his own way.

Fabritius was at work in his house on Doelenstraat on that morning of 12 October. The buildings in this narrow street were humble, but the room in which he worked was at least large enough for an easel, and for him to stand back from it to view the man who had come to sit for his portrait that day, Simon Decker, retired sexton of the Oude Kerk. Decker was in his seventies, a man of refinement and a friend to artists. He owned paintings by De Hooch, De Witte and Van Goyen, and now he would own a Fabritius too. Picture the portrait: the sexton in his dark ecclesiastical clothes against a luminous pale ground; or perhaps, by now, something even more advanced. Also in the room was Matthias Spoors, the artist's assistant, there to grind the pigments, learn from the master's example and so on. Perhaps Spoors was mixing a colour, or Fabritius was just laying in some early strokes; or maybe the painting was almost finished. Also in the house was Agatha's mother, Judith van Pruyssen. Every one of them would die that day.

Fabritius's house was so close to the gunpowder arsenal that its structure instantly collapsed, burying everyone in it beneath the roof tiles, broken beams and shattered walls. It took almost six hours for help to arrive, and by that time they were all dead except for Fabritius. They dragged him out, still alive, still breathing, and carried him to a makeshift infirmary near the churches. The route is short, but the journey must have been agonisingly long, through the burning rubble of Doelenstraat and the remains of Fish Street, over a miniature Bridge of Sighs, jammed with people on their way to find survivors, through the smoke and choking dust to the doctors who might help him.

When I think of Fabritius lying in the devastation of his house, I wonder if he had the capacity to understand what had happened in that deafening flash or how injured he was. Or did he just have unspent hope; did he wait for the rescue, believing in nothing but his continued existence, patient, incredulous, unimploring. I cannot hear him shouting and I cannot hear him weeping. Perhaps he is so injured that he has no sense of his terrible fate; I want him to suffer no pain. But Fabritius lies buried beneath the rubble, alongside the body of the once-living man in his painting, breathing the dust and smoke. We know what that looks like, not from the period paintings, but from the age of the camera. The dust-shrouded face in which no eyelid flickers, no bright pupil comes to light. The figures desperately searching, picking over the dust heaps and trying to move the concrete, in Delft, in Beirut.

I do not imagine him asking what happened. Whom would he ask? Everyone around him is already dead. Had Agatha gone to market day in The Hague, like so many other more fortunate citizens, or was she somewhere nearby? Does she rush to save him? Is she out in the street crying for help, or shielding herself from the beams and mortar and the shattered glass? The rescue party arrived far too late. Fabritius died of his injuries barely half an hour later, just before the last glisk of dusk on that day.

His corpse was wrapped in winding cloth and taken for burial two days after the explosion to the Oude Kerk, where Decker had been sexton. The others were all laid to rest there too, beneath that great box of light.

Visitors wander through the church today, with its soaring blue and silver organ pipes and its shifting sunshine, looking for the famous graves of Vermeer and his friend Leeuwenhoek beneath the black basalt flagons. They are both there, close to the altar,

commemorated with songs of praise. But Carel Fabritius is not. I have searched and searched for his grave, but I still have no idea where the remains of this nowhere man lie.

His paintings mean more to me now than they did when I first saw them; and part of what they signify is the existence of someone I can almost reach, but never touch. They are as novels to readers, perhaps – these worlds in which they meet the maker; or as poems are to the lovers of poetry who feel the sudden breathing presence, and the intimate mind, of the writer. His existence is incorporated in his art.

This art seems to follow some esoteric law of physics: it tends to the end, dematerialising, insofar as it ever existed, like the artist himself. It dies with him in the Thunderclap. Or so people have always said. There was a time when I gave up and almost came to believe that myself, until my eyes were sharpened.

Some years ago, the great Danish conservator Jørgen Wadum began to clean the painting of the goldfinch, with infinite care, millimetre by millimetre. The task took him almost two years. It was performed in full public view, in a glass studio in the well of the Mauritshuis in The Hague.

Day after day he cared for the painting, cleaning off the filth of time, attending to its tiny blemishes and sores, nursing it back to health. Layers of yellowing varnish were removed and he found once again the radiant light that was there all along – like opening a door to the sunshine, he said. And one of the things he discovered was that Fabritius was very prudent, reusing a jointed wooden panel by sawing it into smaller pieces; and that he was very slow and careful, remaking the entire image twice over, changing its borders, doubling the size of the perch, shifting the bird, repainting his signature. There was a deep sense of time passing, of exacting, meditative slowness.

One of the techniques Wadum used was unprecedented, and borrowed directly from medicine. *The Goldfinch* was the first painting in history to be given a CT scan. Wadum put the painting through a scanner to discover everything that could be learned about its inner life, just as we look inside our lungs or heads to see what is going on in the brain. There we might see the whitened areas where a cerebral infarct has occurred, or the small vessels that have the disease that we call – over the top of that poor head – dementia. Where we see a solid mass that might be a tumour or the rippling liquidity of a subcutaneous haematoma; everything that might go on exploding until it brings, as it did to my father, certain death.

The Goldfinch had been X-rayed before. Curators had at that time noticed some small indentations in the surface. But from the scans it is possible to see, and therefore to know, far more. What they show is that the painting bears the traces of a blast, the minuscule indentations of hurtling matter, broken shards, hard pellets blown scattershot through the air, across the room, pocking its surface in an instant. And the further revelation of these scans is that the explosion registered in a surface that did not split or shatter because it was not dry. *The Goldfinch* was still wet, still drying, a work in progress like its maker, a living thing in the studio when Fabritius was dying. I wanted to know one more thing about Fabritius, one certain truth, anything at all, and now I know from these scans, these visible records of life as it is lived, this embodiment of the art, that when I stand in front of this painting it carries the last of his energy as an artist painting a picture. The portrait of Simon Decker was lost, but not the bird. Somebody saved it from the wreckage of the Thunderclap that day and so the goldfinch, quivering in every atom, is kept before us for all time. The painting lives. The creator survives.

James Cumming
1922–1991

Carel Fabritius
1622–1654

Acknowledgements

'The dead are not absent,' writes St Augustine, 'they are only invisible.' My greatest thanks are to James Cumming for everything he continues to give in his art and his living example. This book is a salute to him and to all of these painters, through whose eyes I have seen and understood so much more of this life.

Thanks to my brother Timothy Cumming, for letting me wander through his memories, and to my cousin Jonathan Dowie for all the joyous recollections. To Kate Kellaway, dear friend of my youth, for generously reading the text with such insight for improvement; to George Bruce, Frank Cottrell-Boyce and Phil Watson for their words; to Sarah Baxter, Louise Cattrell and Lisa Forrell for their constant encouragement; to Jon Gray for the art of his cover.

I am grateful for twelve wintry writing days at the Hosking Houses Trust in Warwickshire; for the expertise of Dr Sam Rigby, of the Blast Department at Sheffield University, who so brilliantly analysed the Delft explosion in the context of Beirut. And to all of my cherished colleagues, particularly Carol McDaid, Sarah Donaldson and Jane Ferguson, who first asked me to write about art for the *Observer*.

My gratitude to Bart Cornelis and Gabriele Finaldi at the National Gallery; Alexander Sturgis at the Ashmolean; Marlies

Stoter at the Fries Museum; Michael Schweller at the Princely Collections in Liechtenstein; Caroline van Cauwenberge at the Leiden Collection; Sandra Kisters at the Boijmans Museum. To Larry Keith who conserved Fabritius's *A View of Delft*, and gave me his own views in turn; above all to the wise and benevolent master, Jørgen Wadum, who returned *The Goldfinch* to the light.

I could not have written on Dutch art without the writings of many others. I am particularly grateful to Jonathan Bikker, Christopher Brown, Norman Bryson, Quentin Buvelot, Frits Duparc, Ton de Jong and Huib J. Plankel, Pieter Roelofs, Gero Seelig, Ariane van Suchtelen, Paul Taylor and Arthur Wheelock; to the late Laurens Bol, C. Willemijn Fock and Zbigniew Herbert; to my incomparable and long-lamented friend Tom Lubbock.

Gratitude to all who have made this book possible: my great friend Patrick Walsh, peerless agent, and his colleagues John Ash, Margaret Halton and Rebecca Sandell, whose first response was so invaluable. At Scribner, the magnificent Nan Graham. At Chatto, a team of brilliant women: Rosanna Hildyard and Francisca Monteiro, who took infinite pains with words and images, Leah Boulton, Mia Quibell-Smith, Susanne Hillen and Linden Lawson, a most empathetic copy-editor. This is my third book with Clara Farmer, Chatto's outstanding publishing director, who gave so much of her meticulous mind and sensibility to the manuscript and its journey.

For their eyes, minds and observations, their presence at the heart of my life every day, Hilla, Thea and Dennis have all my unending gratitude and love.

List of Illustrations

Page 60: *Portrait of Saskia van Uylenburgh (1612–1642)*, c. 1633–1634, Rembrandt Harmenszoon van Rijn (© The Picture Art Collection / Alamy)

Page 62: *Hagar and the Angel*, Carel Fabritius (courtesy of The Leiden Collection, New York)

Page 66: *Landscape with a Windmill*, Jacob van Ruisdael (courtesy of Cleveland Museum of Art)

Page 70: *The Anatomy Lesson of Dr Nicolaes Tulp*, Rembrandt Harmenszoon van Rijn (© public domain, courtesy of Mauritshuis, The Hague)

Page 72: *Sailboat on an Estuary*, Jan van Goyen (courtesy of National Gallery of Art, Washington)

Page 75: *Haarlem Sea, 1656*, Jan van Goyen (courtesy of Städel Museum, Frankfurt am Main)

Page 78: *Portrait of the Painter Jan van Goyen*, Gerard ter Borch (© The Liechtenstein Museum, Princely Collections, Vaduz–Vienna)

Page 83: *Portrait of Abraham de Potter, Amsterdam Silk Merchant*, Carel Fabritius (© Rijksmuseum, Amsterdam)

Page 91: Photograph of James Cumming in Texas (© private collection)

Page 97: *The Brahan Seer*, James Cumming (© private collection)

Page 100: Photograph of James Cumming (© private collection)

Page 106: *Chromosomes II*, James Cumming (© private collection)

Page 114: *Portrait of Dr Johnson ('Blinking Sam')*, Joshua Reynolds (courtesy of the Huntington Art Museum, San Marino, California)

Page 118: *Woman at a Mirror*, Gerard ter Borch (© Rijksmuseum, Amsterdam)

Page 121: *Mother Combing Her Child's Hair, known as 'Hunting for Lice'*, Gerard ter Borch (© public domain, courtesy of Mauritshuis, The Hague)

Page 122: *Self-Portrait*, Gerard ter Borch (© public domain, courtesy of Mauritshuis, The Hague)

Page 124: Netherlands, Middenbeemster. Typical straight road in Beemster Polder, a UNESCO World Heritage Site (© frans lemmens / Alamy)

Page 130: *Mensen en twee honden in een boekenwinkel*, Dirck de Bray (© Rijksmuseum, Amsterdam)

Page 131: *Portrait of a Man, Possibly Nicolaes Pietersz Duyst van Voorhout (born about 1600, died 1650)*, Frans Hals (© public domain, courtesy of Metropolitan Museum of Art, New York)

Page 133: Detail from *Tree Trunk Surrounded by Flowers, Butterflies and Animals*, Rachel Ruysch (courtesy of Boijmans Van Beuningen, Rotterdam. Photography by Studio Tromp)

Page 135: *Flowers in an Ornamental Vase*, Maria van Oosterwijck (© public domain, courtesy of Mauritshuis, The Hague)

Page 138: *Still Life of Asparagus*, Adriaen Coorte (WA1940.2.22. Image © Ashmolean Museum, University of Oxford)

Page 142: *Still Life with Five Apricots*, Adriaen Coorte (© public domain, courtesy of Mauritshuis, The Hague)

Page 143: *Shells, 1698*, Adriaen Coorte (© public domain)

Page 145: *Two Peaches*, Adriaen Coorte (© public domain)

Page 149: *Man on Horseback*, Gerard ter Borch (© public domain)

Page 151: *The Avenue at Middelharnis*, Meindert Hobbema (© National Gallery, London)

Page 155: Théophile Thoré-Bürger, French art critic, 1807–1869, photographed around 1865 (© Pictorial Press Ltd / Alamy)

Page 158: *The Sentry*, 1654, Carel Fabritius (© public domain, courtesy of Staatliches Museum Schwerin)

Page 166: *A company in the Utrecht night barge*, unattributed (© public domain, courtesy of Stadsarchief Amsterdam)

Page 168: *View of Delft*, Johannes Vermeer (© public domain, courtesy of Mauritshuis, The Hague)